MARIANNE NORTH'S
TRAVEL WRITING

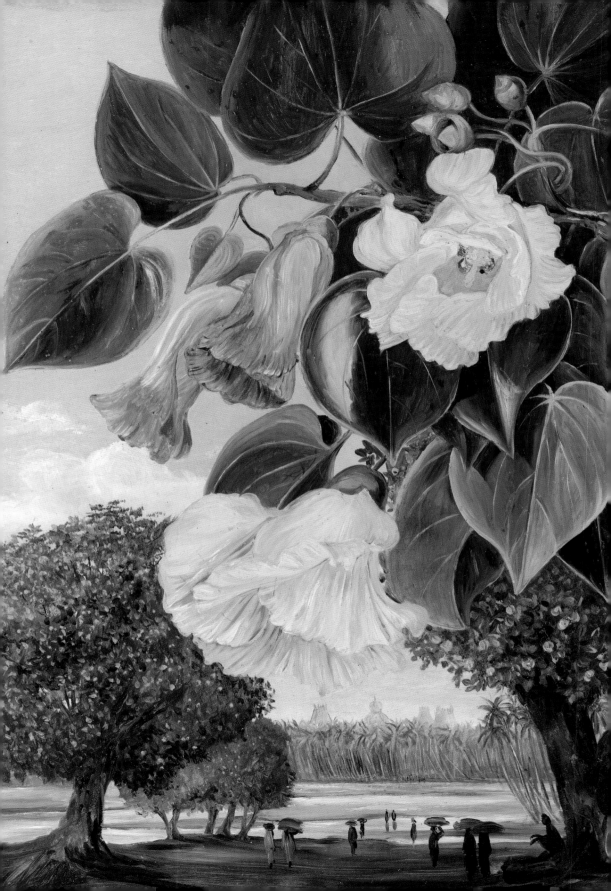

Marianne North's Travel Writing

Every Step a Fresh Picture

MICHELLE PAYNE

Kew Publishing
Royal Botanic Gardens, Kew

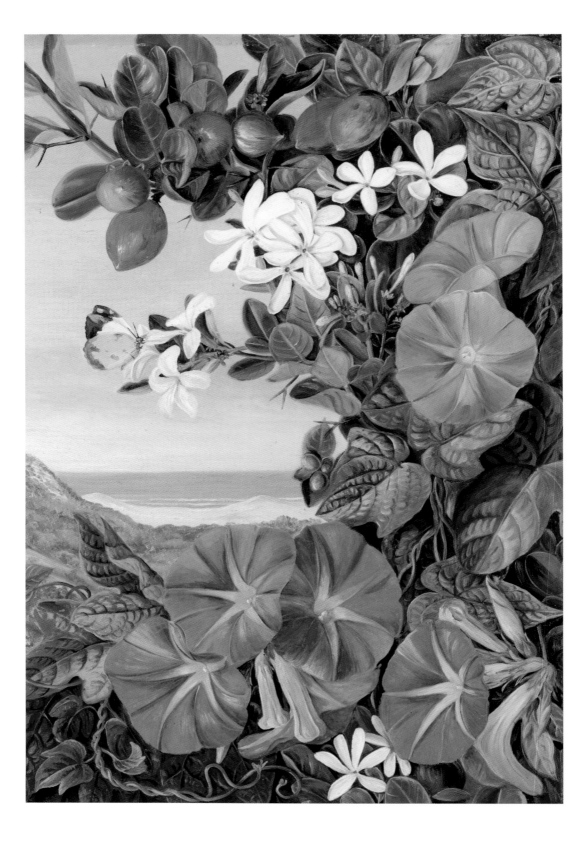

For Trevor,
with love and gratitude
– always.

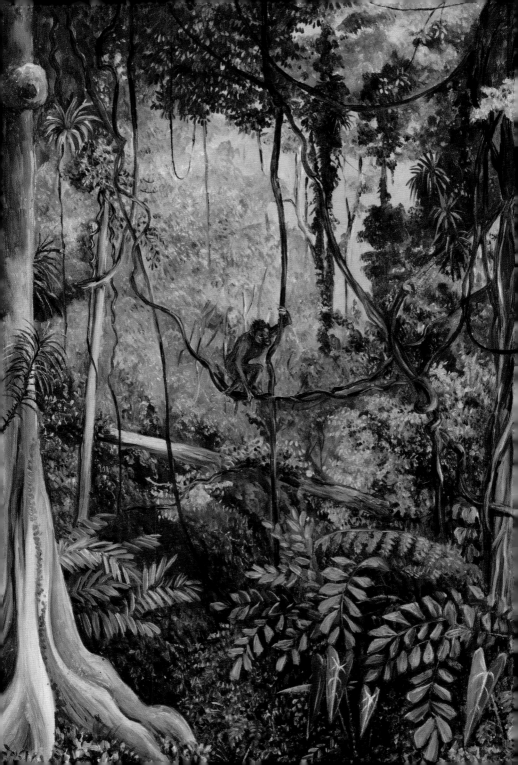

Contents

Notes on Materials and Presentation

The extracts from North's writing included in chapters 2–17 have been selected from her published autobiography and from correspondence held in Kew's archives. These extracts are presented alongside related paintings from Kew's Marianne North collections. Sources for the individual extracts and artworks are listed on page 271.

Autobiographical writings

Recollections of a Happy Life, Being the Autobiography of Marianne North (2 volumes. London and New York: Macmillan & Co, 1892), hereafter referred to as *Recollections*, was reprinted during the 1890s with minor revisions and alterations incorporated. The version used is the first printing. A third volume of autobiographical writings, *Some Further Recollections of a Happy Life, Selected from the Journals of Marianne North*, was published in 1893. Fifty-nine extracts have been selected from *Recollections* and one from *Some Further Recollections*. Minimal editorial interpolation has been applied, and where present this is enclosed within square brackets. The spelling of place names matches the original publication; where relevant these are elucidated in the chapter's introduction. The introductions also explain some terms that may be unfamiliar and, where possible, identify people referred to in the original by initials.

Correspondence

The principal correspondence collections used were the Shaen family letters and the Burnell letters. Transcriptions were produced from digitised copies of the handwritten originals – in the case of the Burnell collection in consultation with a typescript produced in the 1940s. North's correspondence is used in seven extracts; further letters are quoted or presented as illustrations, as are some of her pen sketches. Additional syntax has been applied, as North's originals contain very little punctuation or paragraphing. Her occasional use of underlining for emphasis has been retained.

The Shaen family letters are 13 letters written by North to the family. Nine letters are to her friend Margaret Shaen (1853–1936) and one is to Margaret's mother, Emily Shaen. The other three letters are to Margaret's aunt and uncle, the Allmans – George James Allman, the naturalist and president of the Linnean Society, and his wife Hannah Louisa. Margaret Shaen was the daughter of the radical lawyer William Shaen (1820–1887) and in later life became a published author and amateur photographer.

The letters date from November 1875 to November 1884 and include letters written in Japan, Sarawak, India, South Africa, the Seychelles, Chile and England.

The Burnell letters are 32 letters written by North to Arthur Coke Burnell (1840–1882), plus a letter from the artist and nonsense poet Edward Lear introducing North to Burnell, a letter from Burnell's great-nephew A. F. Burnell-Nugent, who donated the manuscript letters and their typescript to Kew in 1947, and a letter of thanks and acknowledgement from Kew's director Sir Edward James Salisbury. A. C. Burnell worked as a judge in the Indian Civil Service and was a Sanskrit scholar, an expert in southern Indian literature and co-author of the well-known Anglo-Indian dictionary *Hobson-Jobson*. The letters span from January 1877 to January 1880, with the majority written from January 1878 to February 1879 as North continued her travels in India.

Artworks and illustrations

Eighty-three of North's artworks from the gallery collection and twenty-two of her paintings from Kew's art collections are included, along with photographic and drawn portraits. The wording and spelling for the titles of artworks from the gallery collection come from the gallery's catalogue, the *Official Guide to the North Gallery*. The sixth edition dating from 1914 has been used; this was most recently published as a facsimile edition in 2009. The catalogue's extended captions were a supplementary source of information for chapter introductions and artwork captions. Variation in the spellings of place names in *Recollections* and the *Official Guide* has been kept.

[frontispiece] *Foliage and Flowers of the Suriya or Portia; the Pagodas of Madura in the Distance.* North painted this gallery collection painting at Madurai in Tamil Nadu, her first destination in India. As the figures sheltering beneath the tree suggest, the fast-growing portia tree is a common shade tree in south India. The 'pagodas' in the distance are gopurams (towering gateways) at entrances to the historically important Meenakshi Amman Temple, which North was guided around by her host in Madurai, a colonial judge named Mr Thompson. Her painting of a scene at the temple is reproduced on page 160.

[page 4, opposite dedication] *Amatungula in Flower and Fruit and Blue Ipomoea, South Africa.* This painting of the native South African amatungula, also known as the Natal plum, and blue morning glory flowers (an introduced species) was made by North in the garden of a hotel at the mouth of the Kowie River in the Eastern Cape, South Africa. At this point in her South African travels she was accompanied by Mary Elizabeth Barber, a noted naturalist (p. 209).

[page 6, opposite Contents] *Forest Scene, Matang, Sarawak, Borneo.* One of North's paintings from Matang in Sarawak, where she stayed at Rajah Charles Brooke's mountain-farm cottage, catered for by his staff. In *Recollections* she declared, 'life was delicious up there'. North recognised the mutual curiosity between humans and apes. She wrote of one occasion when an ape followed her party through a forest. 'When we stopped he stopped', she wrote, 'staring with all his might at us from behind some branch or tree-trunk; but I had the best of that game, for I possessed an opera-glass and he didn't.'

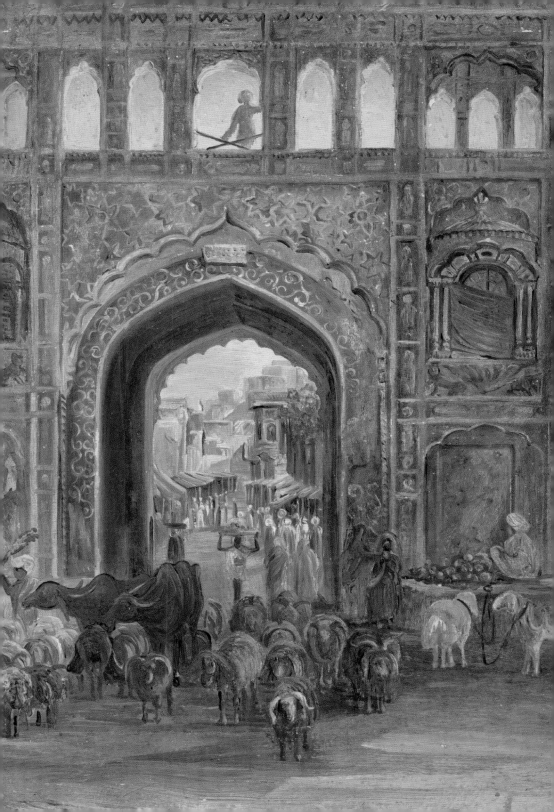

Foreword

Advolly Richmond, Plant and Garden Historian

[opposite] *Gate at Lahore* [Pakistan]. While in Lahore North stayed with the high-ranking colonial administrator and judge George Robert Elsmie and his wife Elizabeth, and was guided around the Lahore Museum by Gottlieb Wilhelm Leitner, a Hungarian educationist who founded educational institutions in the Punjab and in England. Her painting of the iconic Badshahi Mosque, as seen from a palace within the Lahore Fort, is included in the gallery collection. This painting of an (unspecified) gate in the city is held in Kew's art collection. In *Recollections* she wrote that at Lahore she found 'incessant ready-made pictures, if I had but had time to paint them.'

As a plant historian and a Royal Botanic Gardens, Kew, Champion, I am delighted to have been asked to write this foreword for Michelle's book. I first came across the purpose-built gallery which houses Marianne North's collection of paintings by chance a long time ago. Being late in the day I had the place all to myself. I was so completely astounded at the sight that greeted me that I half expected to start hearing the natural sounds of the Cordilleras of Chile. It was a truly immersive experience.

Historically North has been depicted as this Victorian adventuress who travelled alone, 'always alone.' This could not be further from the truth. North's undeniable accomplishments were supported by a whole cast of characters whom the author introduces us to in *Every Step a Fresh Picture* (which is a very apt title for this immensely enjoyable book). Michelle takes us on a journey of discoveries and along the way, in North's company, we meet high-ranking officials, interpreters, attendants and other people who hosted, facilitated, influenced and protected her throughout her travels.

North was an inspirational woman who dared to plough her own furrow. She lived a truly remarkable and, in her own words, 'a happy life', one which was enabled by her financial independence. Not forgetting her ability to take full advantage of the many letters of introduction into the imperial network, which cleaved a safe passage for her through at times difficult

conditions and awkward situations, giving her ready access to the natural world's wonders that she captured on her canvases.

Chapter 1, 'Revisiting Marianne North's *Recollections*', is full of notes on cultural history and offers new and interesting observations that do not shy away from North's rather candid and at times unpalatable views on the enslaved or indigenous people of some of the countries she visited. By contrast, North's honest comments on the negative impact of British colonialism on the local environment display a prescient awareness of the need for active conservation. I found North's vivid depictions of the deforestation of land in Borneo in order to facilitate the cinnabar mines really quite moving, along with her own, heartbroken reflections on the matter.

Whether on her travels or at her home in London, North's life was never dull and the author certainly makes North's adventurous spirit and unbound energy leap from the page as she describes her life on the road in the form of written extracts and their associated paintings. At times our focus moves beyond the beautiful plant portraits to the landscape of forests, temples, mountains, ruins and buildings, and to the places and people often identifiable through her letters and writing. The author sheds light on conversations that took place in the households of North's hosts, whose images, if you look carefully, have sometimes been included in the background in some of her paintings.

The people and buildings in the scenes have often been overlooked in favour of the botanical 'leading ladies' in the foreground. For centuries these only ever had to compete with the traditional, white contrasting background used in botanical illustration to isolate the specimen, thereby emphasising the plant's structure and enhancing its beauty. I think this book will make you pause and reflect on the experiences of Marianne North in a whole new light.

[opposite] **On the way from Tibet near Nagkunda, north India.** During North's travels in India, she went on a short expedition from Shimla to Narkanda (given as 'Nagkunda' in the gallery catalogue, and 'Markunda' in *Recollections*) accompanied and assisted by a chaprasi and a cook. Eight men carried the jampan she mostly travelled in. This painting was made on the road that ran from India to Tibet. The woman in blue trousers and a red jacket was herding the flock of sheep or goats, which have packages of tea and borax tied on them. In *Recollections* North wrote that the animals were 'perfectly composed in manner, with an air of responsibility about them, and did not scramble over the rocks, but walked straight along the paths.'

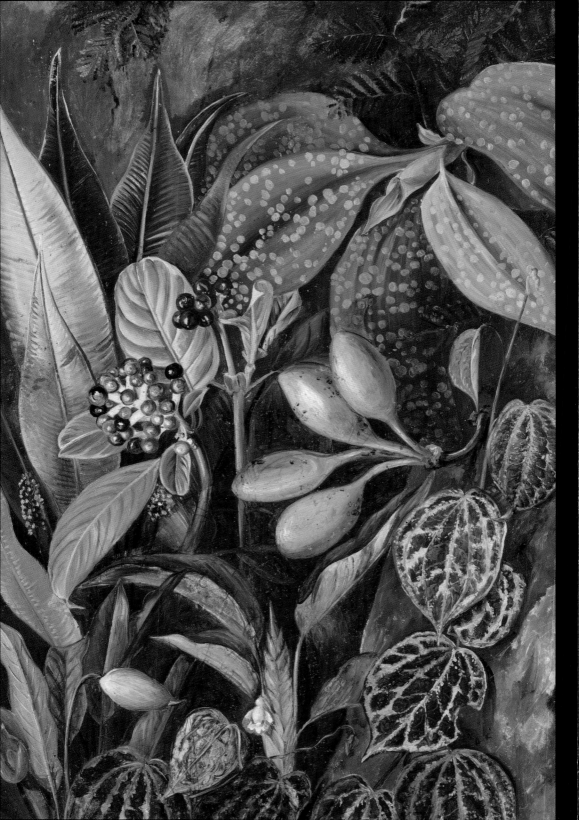

Introduction

The noted late-Victorian artist and traveller Marianne North (1830–1890) is best known for the distinctive, vibrant oil paintings she produced during extensive travels from 1871 to 1885 and for the unique and ambitious gallery she established at the Royal Botanic Gardens, Kew. From the 1880s until the present day, the Marianne North Gallery has – to striking effect – displayed 848 of her paintings and 246 related wood specimens according to the aesthetic and curatorial schemes devised by North, inside a specifically commissioned and designed gallery building. North's idiosyncratic gallery and characterful pictures have long charmed viewers into imagining the woman behind the pictures and the place. Popular narratives published over the last 40 years have drawn on her posthumous autobiography to present her to readers in various guises: as a stalwart lady traveller, a fearlessly intrepid woman, or as a Victorian rebel breaking societal constraints to fulfil her particular artistic ambition. She is imagined striding away – alone, always alone – far beyond the stifling confines of buttoned-up Victorian Britain to some place unequivocally other: an Edenic floral paradise, or an unsettling, untamed wilderness.

Curiosity about the nature of North's travels and a desire to look beyond misty-eyed romances of the past have shaped this book, as has my interest in the ongoing national debates concerning history, heritage and the lasting legacies of Britain's imperial past. Why did North visit the particular places she did?

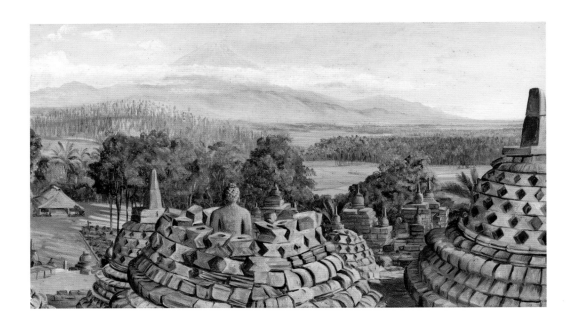

[above] ***The Soembing Volcano, Java.*** North's title for this gallery collection painting suggests that her main focus was Mount Sumbing, the active volcano in the painting's background, but the caption in the official catalogue notes that the foreground shows stupas from the world-famous Borobudur, which was the focus of her expedition to this area, and that the small triangular-roofed building in the mid-left was the hotel where she stayed for ten days, on the advice ofArthur Coke Burnell. North's painting of the hotel is reproduced on page 137. The trees depicted were plantation plantings of teak.

What were these places like at the time – and what are they like now? How widely did she travel within each country? Where did she stay? Who were her hosts? How was she guided and assisted? How, in short, were her travels conducted? Further research is required to fully reassess North's work and legacy. This anthology hopes to take an initial step towards renewed understanding by engaging with the colonial aspects of her travels openly and honestly without excuses or denial.

The opening chapter discusses the publication history of North's autobiography and considers the ways her travels have been understood and represented over time. Subsequent chapters presenting her travels each include an introduction and narrative captions that link her visual and written work, situate the extracts within the trajectory of her travels, and offer context informed by wider research (cited in Further Reading, page 262). While *Recollections* offers insights when read as a stand-alone literary work, it benefits from being considered as a written complement to North's artworks, along with the gallery catalogue. Fusing the multiple strands of North's work illuminates easily overlooked details such as people and houses – sometimes painted vanishingly small, tucked away, or enveloped by the primary vegetative subject –

and helps identify painting locations, bringing both paintings and written narrative to fuller life.

Her travels are presented in four parts, reflecting development in her artistic project. North gave voice to her earliest expression of artistic intent while grieving her father's death, with her plan to devote herself to painting from nature. **Part I** begins in mid-1871, when she began travelling specifically to paint tropical vegetation, 'on the spot in natural abundant luxuriance'. **Part II** considers her 'twenty months wandering amongst strangers' from mid-1875 onwards, and **Part III** her extensive travels in India from late 1877 to early 1879 – during which her subject matter broadens to incorporate wider facets of natural history (notably volcanoes in Java) and cultural history, particularly evident in her interest in temples in Japan and India. **Part IV** covers her travels from 1880 onwards when, with plans for her Kew gallery under way, she sought to produce a 'representation of the vegetation of the world'. The closing chapter considers London: a significant place for her personal life and artistic career and, for surprisingly lengthy periods of time during her travels, her home.

In a newspaper-published account of her experiences in the Seychelles, North wrote 'all round is lovely – every step a fresh picture', a comment that speaks of her sensitivity to the natural environment. And yet, given the smallpox epidemic and related hardship and food shortages that the islands' inhabitants were then enduring, it reads as a blithely indifferent assessment. As this book's subtitle, the phrase is also intended to suggest how the anthology traverses North's work in 'steps' formed by written extracts and associated paintings, encouraging us to pause, consider, and reflect upon, specific scenes and experiences she rendered in ink and oil paints.

Chapter 1

Revisiting Marianne North's *Recollections*

In January 1880, Marianne North sent new year greetings to her friend Arthur Coke Burnell, recalling the time they had spent time together in Tanjore (Thanjavur) in India two years before, and filling him in on all her latest news. She was at a turning point in her career. Her artistic reputation had blossomed following two successful London exhibitions. Her 'Kew scheme' – the establishment of a purpose-designed gallery in the gardens for the permanent display of her botanical artworks – had been approved, and she was contemplating future travels to complete the gallery's painting collection as it was being built. 'It will be a great pleasure', she wrote, 'to leave behind something which will be a help and a pleasure to others, as the world goes on.' She confided in Burnell that she had embarked on a related project, a written complement to the gallery's pictorial record of her travels:

> When it is dark and yellow fog, I scribble. I am writing "recollections of a happy life" and putting all my journals and odds and ends of letters together – it is most amusing work even if it never comes to anything more. It is curious how new and fresh some years of my life come back which I had entirely forgotten, while other and more distant events often are quite clear in my head still.

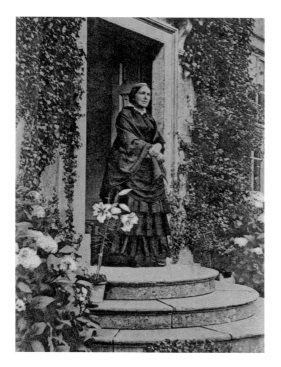

[above] ***Marianne North at Home.*** Frontispiece to the second volume of *Recollections*. North inscribed prints of this portrait showing her at the door of Mount House and sent them to friends as an open invitation to come and stay. North grew up moving between her family's multiple estates, Rougham Hall (Norfolk), Gawthorpe Hall (Lancashire), and Hastings Lodge (Sussex), with the 'social season' spent in London. Her father acquired a flat in London in the mid-1850s, which North soon felt to be 'more like home than any other'; after her father's death it became her sole home for 16 years, until her move to Alderley.

Her travels were not yet complete, and it is unclear how far her manuscript had progressed at this time. The coming spring saw her leave Europe for Australia and New Zealand, via a second visit to Sarawak. Separate trips to South Africa, the Seychelles and Chile followed. She returned from Chile in early 1885, aware that her declining health signalled the end of her journeys. By mid-1886 her distinctive gallery at Kew stood as complete as she could make it, with an expanded and reorganised painting collection and a new catalogue. She retreated from London to Alderley in Gloucestershire, renting an old property with extensive grounds named Mount House. There, away from the city's clamour, she resumed work on the manuscript begun years earlier.

For two years she devoted herself to her memoir, drawing on journals for her life story up to 1870 and on letters, returned for the purpose, that she had written during her travels from 1871 to 1885. Her approach was to reproduce some passages directly, while reconstructing and enriching others. Working in this manner her manuscript grew. And grew. In spring 1888, she consulted her friend Sir Joseph Dalton Hooker, who had retired his post as director of Kew a few years previously, and his wife Lady Hyacinth for advice and assistance in securing a publishing deal. Hooker declared himself to be at her service, further remarking 'it might be worthwhile to make the book in some sort a running commentary on the gallery & that the illustrations ... should include a considerable number from amongst those in the gallery that show "plants in their homes". This would give a living interest to the scenes and a high scientific one too.' Unfortunately, the manuscript's excessive length caused problems with publishers from the start, and the cost implications of significant illustrations were perceived as a further barrier to publication.

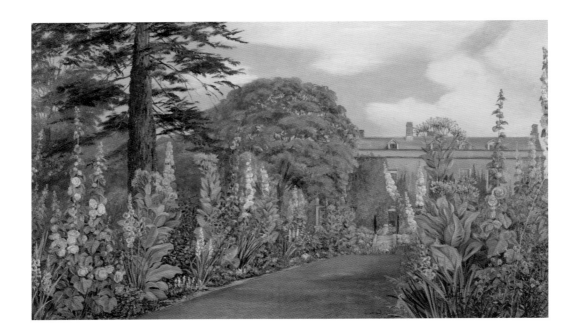

[above] *Alderley Garden, Gloucestershire.* The rear gardens and grounds of Mount House, which can be seen in the distance. North's sister Catherine Symonds was enchanted when she first visited Alderley from Switzerland in 1887, writing in her postscript to *Recollections* that the fernhouse and garden were furnished with rare specimens gifted by Kew, the garden with donations from florist friends, and the rockery with alpines collected by Catherine's daughters.

The Hookers showed the manuscript to the influential publisher John Murray, who estimated it would form three or four published volumes and felt that, to be viable, it should be just one. He admitted feeling perplexed how best to proceed, given her memoirs' 'very great extent and 2ndly their very peculiar character ... among many interesting and original passages occur details so purely domestic that I doubt whether the Reading Public could be induced to take an interest in them'. But North was becoming too ill to significantly condense the manuscript herself. Fearing she would not live much longer she passed the original manuscript back to Murray in December 1888, asking him to do his best with it. Eventually, Murray reported he could see no way to reduce the manuscript to one volume. In early 1889, the Hookers took the manuscript to the Macmillan publishing house, whose response echoed Murray's: 'Miss North's travels were remarkable in themselves and they are very attractively recorded. The great drawback of the book is its immense bulk ... We think that in its own interests the bulk should be diminished by at least one half.' Messrs Macmillan further stipulated that allusions to living people should be removed where they might cause offence and that illustrations

[above] *Pages from* **Edward Lear's letter to Arthur Coke Burnell,** introducing North as 'a great draughtswoman and botanist', who is 'altogetheraciously clever and delightful'. North was clearly much taken with this linguistically playful coinage, later applying it to Lady Lytton in a letter to Margaret Shaen. The traveller, artist and nonsense poet Lear was one friend who North first came to know through her father.

could not be justified. On these grounds they would publish the book, but would not undertake to reduce the manuscript themselves. With North in no condition to undertake revisions herself, the impasse lasted until her death on 30 August 1890.

A few months later, North's younger sister Catherine Symonds picked up the metaphorical scissors. Over the course of 1891, she worked intensively to cut the narrative into the form in which it was first published, excising North's travels from 1859 to 1870, pruning the whole to remove details, anecdotes and opinions deemed too personal, and adding a preface and postscript. An unillustrated two-volume work entitled *Recollections of a Happy Life; being the autobiography of Marianne North* was published by Macmillan in 1892, containing one condensed chapter on her life up to 1870 and otherwise forming an account of the years from 1871 to 1885. A third volume covering the earlier travels was published the following year as *Some Further Recollections of a Happy Life*.

Reviewers of the 1892 volumes were broadly positive about the book and flattering towards the woman whose life it recounted. Pains were taken to distinguish North's travels from mere 'globetrotting' by attributing a serious purpose

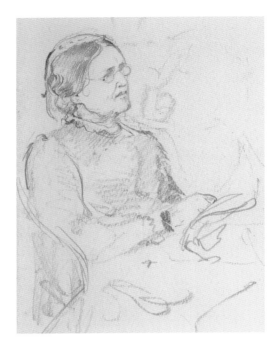

[above] **Detail from Theodore Blake Wirgman's pencil drawing showing North stitching while engaged in tea and conversation.** *Recollections* indicates North's interest in textiles, dressmaking and embroidery, and records several projects undertaken during her travels. En route to South Africa, she tasked herself with embroidering a great swathe of gold satin, onto which she had transferred a tracing of the pattern carved into a wooden door at the Lahore Museum. Less appealingly, though surely to striking effect, her homeward voyage from India was passed by sewing 2,000 iridescent beetle wings onto silk (three stitches per wing) to trim into a dress.

to her travels and scientific value to her artworks. *The Illustrated London News* added weight to its comments by evoking the names of two of North's longstanding friends: Joseph Dalton Hooker and Francis Galton, founder of the now widely discredited eugenics movement. *The Field* noted that 'from her position in society, and the reputation she had achieved by her work as a botanical artist, she was enabled to secure introductions to the best society and the most influential persons in all parts of the world, and she made the best of her opportunities'. This position, and the manifold opportunities it provided, can be seen from the opening pages of *Recollections* onwards. Its first five pages recount a family lineage that, despite striking an irreverent tone, leaves readers in no doubt that the North family had occupied the upper realms of British society since the early 1600s – leading North's friend Augustus Jessop to rhapsodise in his review for *The Nineteenth Century* periodical:

> The blood of the Montagus and the Norths was in her veins, and in herself she united the genius and vigour of both those illustrious races ... Her extraordinary musical gifts and her enthusiasm for pictorial art came down to her in the same way by hereditary transmission.

Spurious late-Victorian notions of innate inherited superiority aside, it nevertheless is the case that North's privileged background bequeathed her both the financial means to fund her travels and the social gravitas required to carry them out. Her father Frederick North, Liberal MP for Hastings, had facilitated friendships between his daughters and his literary and scientific friends, cementing connections that were not only intellectually formative but directly influenced North's travels, as these prominent individuals were among the suppliers of personal letters that introduced North to others in

their colonial networks, ensuring that her passage and artistic endeavours were supported wherever she chose to travel.

Remarks by reviewers on North's writing style were polite, describing it as 'charming', 'pure' and 'artless'. In private comments made while working on the manuscript, Catherine Symonds was more forthright, complaining that it read 'too much like an interminable tape wound off a wheel'. Like the letters from which it originated, *Recollections* has a swift prose style that, in common with her rapid painting method, arguably reflects her restless mind and growing perception that time was against her, as well as the constraints of her itinerant life. Her writing is exuberant, digressive – and at length can feel relentless. Attentive reading is required to catch incidental details that illuminate her character, such as her tastes in reading and interest in dressmaking and embroidery, or to recognise her self-awareness of her limitations in depicting people and complex architectural structures, and her experiments to capture transient colours accurately.

Among reviews of *Recollections* published in British papers, there is perhaps some veiled criticism in *The Illustrated London News* reviewer's cautious remark that 'to some readers, the Brazilian experiences, including rather arduous journeys to the highlands, to Minas Geraes, the Morro Velho goldmine

[below] ***Red Sea.*** Travelling through the Suez Canal while returning from Ceylon (Sri Lanka), North attempted to capture in words the mesmerising colours she saw, wondering why 'great artists' did not paint there. It appears North turned her hand to what others neglected: Kew's art collection includes four related colour studies, two labelled 'Red Sea' and two labelled 'Near Suez, Red Sea'.

and that of Rossa Grande, may bring acceptable information', which could be read as a tacit reference to North's disturbing attempted justification of the enslavement practised by the British St John d'el Rey Mining Company until the end of the 1870s (see Chapter 4). Even before North reached the Morro Velho gold mine, her writing from Brazil indicates an acceptance of slavery. Early in her narrative she wrote:

> Almost all the menial work in Rio is done by slaves ... for though laws are passed for the future emancipation of these slaves, it will be a very gradual process, and full twenty years will elapse before it is entirely carried out. It would have been better perhaps if our former law-makers had not been in such a hurry, and so much led away by the absurd idea of "a man and a brother." I should like some of the good housewives at home who believe in this dogma to try the dear creatures as their only servants.

These comments dismissing abolition as a 'dogma' believed by 'good housewives' and labelling the key abolitionist slogan an 'absurd idea' are not only unpalatable today, they would also have been highly contentious to many people at the time of *Recollections*' publication, particularly as the earliest date they could have been written was 40 years after the 1833 Slavery Abolition Act.

The most open criticism of the wider racism evident in passages of North's writing came from the reviewer for the US periodical *The Nation*, who observed that 'she was very decidedly of opinion that, except in unfavorable climates, the white man must inevitably drive out the colored – a view which it would be difficult to maintain successfully'. Pseudo-scientific theories on 'race' were a growing influence on intellectual thought at the time North travelled and wrote, and were developed and espoused by some of her friends such as Louis Agassiz and Francis Galton; figures whose legacies have recently been brought to public attention in widely read publications exploring the history of science. It seems likely such ideas influenced North's understanding of her travel experiences, informing passages that broadly categorise and characterise populations in a racist and hierarchical manner.

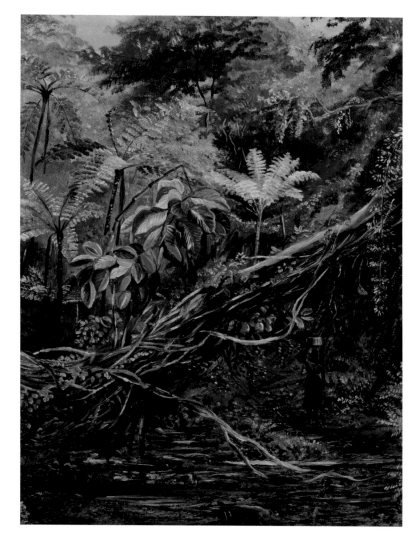

[right] *View under the Ferns at Gongo, Brazil.* The only information we have about the unnamed woman in this painting is that she carried North's painting equipment over eight miles of forest track during North's expedition to Gongo Soco in Minas Gerais, Brazil, and that she was enslaved by a gold mine manager or owner named 'Mr D.'. It is likely she was one of several enslaved labourers sent by Mr D. from his productive mine to the abandoned Gongo Soco gold mine during North's fortnight stay there. As well as the enslaved workers who were compelled to attend her, Mr D.'s wife stayed with North during this excursion to 'keep house', along with her infant son.

Recollections contains passages that compare non-Europeans to children, and even more offensively monkeys, suggest biological differences in intellectual capability, and dismiss those who oppose the extreme subjugation of Native Americans as sentimental idealists. *Recollections'* emotionally detached portrayal of people in southern India drowning in the floods that followed the devastating Great Famine of 1876–78 (see Chapter 11) cannot easily be explained as shock or suppressed distress if seen in the context of her correspondence. In a letter to Burnell she writes of his famine relief work without

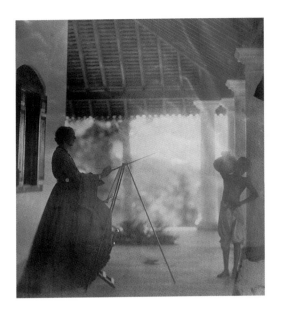

thought for, yet alone empathy towards, the people afflicted: 'I do grudge wasting your strength that way, though doubtless you do good, yet I would have you do good to those who are nearer yourself and farther from monkeys.'

North's attitudes towards the people whose countries she travelled to vary considerably and are inconsistently expressed – which is perhaps unsurprising given the extended timespan of her travels and writing and the great number of different individuals and circumstances she encountered. Complicated, intertwined class and racial prejudices appear to influence some of her negative portrayals, including those of some individuals who played crucial roles in practically supporting her travels and painting excursions, such as Tungake, whom North hired as a translator and guide in Japan, and her Indian intermediaries and organisers Alex and John. Characterisations of other facilitators such as Betsy and Stewart, who attended to her domestically in Jamaica, and Emile, who sailed her around the Seychelles, are notedly less negative – albeit they often contain the same racialising language and assumptions that permeate her writing more broadly.

Side-stepping the difficult subjects of North's prejudices and the colonial nature of her travels has led previous modern accounts of her life and work to neglect both the people North met and those who assisted her – and as they fade into the background, the idea of 'independence' that has long characterised her travels has become further heightened. That she travelled unaccompanied has been emphasised from the time her travels took place up to the present day. Her journeys were independent in that she travelled in her own name as a private individual, choosing her own destinations and, so far as we know, largely making her own itineraries, unaccompanied by a husband or male relation and mostly without a female companion. But far from being conducted 'absolutely alone',

[above] *This photograph of Marianne North was one of several taken by Julia Margaret Cameron during North's stay at the Camerons' home in Kalutara, Ceylon (see Chapter 10).* Their time together did not result from a letter of introduction but from an invitation issued by Cameron upon hearing North was in Ceylon. North's account in *Recollections* does not recount the staging of this portrait or refer to the young man who is modelling, but it seems likely he was one of the Tamil workers on the Camerons' estates, many of whom Cameron photographed for a portrait series she was working on at the time of North's visit.

as Symond's postscript to *Recollections* states, North's own narrative shows her reliance on many people. British (or European) colonial officials, prominent businessmen and private individuals accommodated her in their homes and organised her painting excursions. Her hosts often accompanied her on her painting expeditions and either acted as guides, or arranged for other local guides. Many Indigenous people also acted as sources of botanical and cultural knowledge, on-the-ground organisers, translators, porters, sailors and domestic assistants. In the published volumes of *Recollections*, the names and

[right] ***Road Making in the Tegora Forest, Sarawak, Borneo.*** The subject of this gallery collection painting would most obviously be taken to be the forest trees or the Tegora mountain looming over them – but the painting's title draws attention to the small figure of a man clearing a path through the vegetation, albeit focusing on his function rather than his identity. No caption is given in the gallery catalogue, but North's letter to Margaret Shaen shows he was one of several unacknowledged Indigenous men who supported North's painting expedition to the Tegora mines.

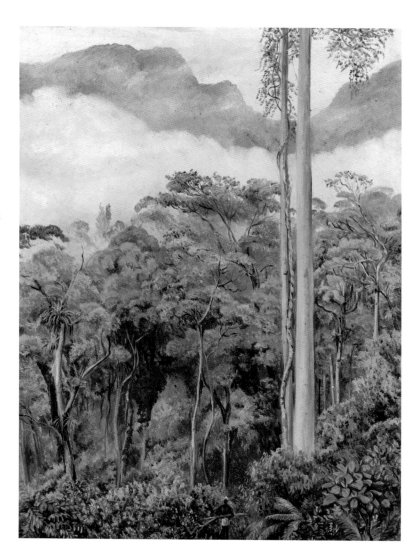

[opposite] *The Second Anglo-Afghan War took place during the period of North's travels.* In a letter to Burnell written in October 1878 (partially reproduced as Ex. 41, p. 166), North commented on the anticipated British invasion of Afghanistan that provoked the war, drawing a racist contrast between 'good Englishmen' and 'savages ... at Cabul'. 'There will be no Calcutta "season" if this war takes place,' she wrote. 'What a stupid affair Dizzy has made of this so-called peace. He deserves to have some trouble, but I grudge good Englishmen losing their lives against such savages as those at Cabul, with all the mountains against them as well as climate.' The war did eventually cause trouble for Disraeli ('Dizzy'). In Britain, atrocities committed by British troops in Afghanistan during 1879, along with mounting war costs, became general election issues in 1880, contributing to both the Conservative defeat and Lytton's resignation as viceroy.

identities of North's European facilitators were mostly omitted, obscured or redacted to initials at the publisher's request, while Indigenous facilitators are often unnamed and relegated to a peripheral narrative presence. Even so, as this anthology hopes to show, North's writing contains more information about both the people who assisted her and those whom she was introduced to than is evident in previous modern accounts. Where names and identities have been established they are included here in chapter introductions and image captions, and it is hoped that further research will identify more individuals to add to the record.

Modern presentations of North's travels have tended to frame them as 'world travels' that were global in scope, resulting in a lack of acknowledgement that the places she travelled to and painted in were, at the time North visited them, territories of the British Empire or countries where Britain had close ties and significant informal influence. Jamaica, Singapore, Ceylon (Sri Lanka), India, Australia, New Zealand, South Africa, and the Seychelles were all British colonies, while in Chile and Brazil Britain's economic influence was so extensive the term 'informal empire' is sometimes used to characterise relations. Sarawak (Malaysian Borneo) was not an official part of empire but its rule by the Brooke family had strengthened Britain's influence in the region by the time of North's travels: 'wherever the Sarawak flag is planted', North's host the second Rajah declared, 'there English interests shall be paramount'. In *Empireland: How Imperialism Has Shaped Modern Britain*, Sathnam Sanghera points to the absence of empire in school history curriculums as a contributing factor in Britain's imperial amnesia. Without elucidation of the colonial context, writing such as that North produced – addressed to contemporaries and assuming knowledge many of us today lack – appears full of difficult-to-grasp, opaque comments delivered in a rapid prose style that does little to encourage readers to pause and dwell upon their meaning. Her references to 'anarchy' and 'rebellion' in Jamaica, for instance, and to her host, Governor Sir John Peter Grant, coming 'to put things straight', can only be understood if you are aware of the Morant Bay Uprising of 1865, its brutal suppression

gets the suns rays after the lesser but nearer fiend – J was still a cold peak white, when the cloud over it was such a vivid salmon that the cotton wool clouds in which the lower ... was parked reflected the upper brightness – a lazy way of becoming conspicuous. I have two visits to pay nearer Darjeeling Jr than ... Calcutta – about the 20th from there to Benares – Muttra ? Delhi. Where letters will be most acceptable – do not return the poetry book – I heard from Mrs Lyall the other day she ... there will be no Calcutta "season" if this war takes place her husband will have to spend his winter at Peshawur with the Viceroy – What a stupid affair Diggs ... made of this so called peace! he deserves to have some trou... but I grudge good englishmen losing their lives against such savages as those at Cabul – J with all the mountains against them as well as climate conspiring

Marianne North

under Governor Edward John Eyre, and the introduction of direct rule from London, resulting in Grant's appointment as the new governor. Eyre's actions sparked controversy in Britain, where the Jamaica Committee called for his prosecution while an opposing group, the Eyre Defence Fund, advocated his defence. Similarly, in India, her repeated references to 'the mutiny' are underscored with anxiety, but her words offer little that helps readers today to identify this as the Indian Rebellion (1857–58), a major uprising against British East India Company rule that led to the establishment of the British Raj.

Charles Kingsley (a supporter of the Eyre Defence Fund) was one of the many prominent Victorians who wrote letters introducing North to their overseas contacts. Kingsley was an academic, author, clergyman and keen naturalist with family links to the Caribbean through his Barbados-born mother Mary and her father Nathan Lucas, a judge in Barbados and the owner of inherited sugar plantations prior to the abolition of slavery. His letters were written to support North's travels in Jamaica. He also provided letters for Brazil, as did her father's friend, the physicist and president of the Royal Society Sir Edward Sabine. North accumulated additional letters whenever the opportunity arose, such as when she met the biologist and geologist Louis Agassiz in the United States (see Chapter 2) and acquired letters to his contacts in Brazil. The support elicited from Joseph Hooker while he was Kew's director can be seen through his 1880 letter to Australian colonial governors, requesting broad assistance and specifically that North be guided by government botanists 'for the purpose of indicating the best subjects for the brush and above all things of giving her accurate information in respect of their names and uses'. Their relationship, and the specific ways North's

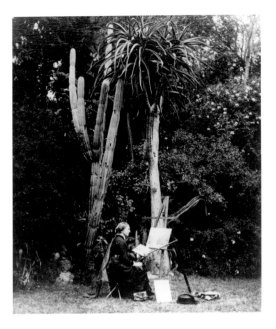

travels benefited from Kew's links to the network of colonial botanic gardens established over the nineteenth century, will be a focus of future research.

Generally, North sent her letters of introduction to colonial governors soon after reaching a new destination, invariably prompting swift invitations to stay at Government House. These invitations were often, but not always, accepted, although her writing indicates antipathy towards staying in official residences and a disinclination to attend the associated formal social events. Her discomfort at being guest of honour at a grand dinner at Buitenzorg (Bogor) Palace in Java is palpable, while her account for India shows her unsuccessfully trying to excuse herself from Government House in Bombay (Mumbai) until the day after an opulent ball, on the grounds of lacking a suitable dress. Whatever her personal feelings, attending such occasions further eased her path. The dinner in Buitenzorg resulted in a letter from the Governor General of the East Indies to all Dutch and Javanese officials, ensuring food, lodging and safe passage wherever she travelled, while the Government House ball in Bombay drew her to the attention of the regional governor Richard Temple, who then facilitated her travels throughout the Presidency. Just before she left India, Temple reviewed all her paintings – and handed her a list of all the British governors and generals who had held posts in India to add to her formidable contacts.

North benefited significantly from colonial networks and administrative apparatus, but this does not mean she was enthralled by all the personalities she encountered, nor did she wholly accept all of empire's manifestations. Some of her writing and paintings point to the negative environmental consequences of colonisation, highlighting the squandering of natural resources, the destruction caused by land clearance, and the invasive nature of ill-considered introductions of

non-native species. While North occasionally used the biased stereotype of 'civilised' (Europeans) and 'savage' (Indigenous peoples), at times her usage works against the standard associations by calling into question the wisdom and morality of the purportedly 'civilised' colonisers. In California in 1875, for instance, she watched giant redwoods being chopped down for firewood and noted that, given the rate of felling, the species would soon risk extinction. 'It is invaluable for many purposes,'

[right] ***Ghost of a Big Tree, Calaveras Grove, California.*** One of the first studies North made when she reached California in 1875. The gallery catalogue records that the pale 'ghost' tree was stripped of its bark up to a height of 116 feet, and was then shipped to Britain and exhibited at the Crystal Palace in Sydenham, London.

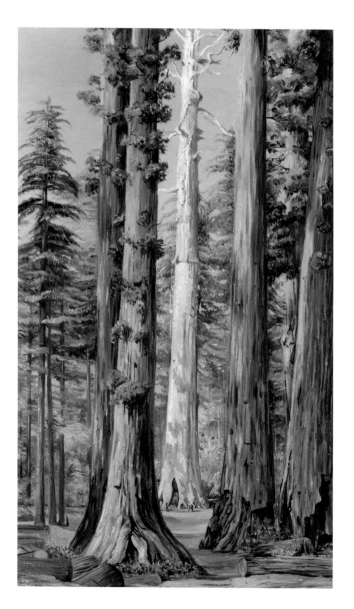

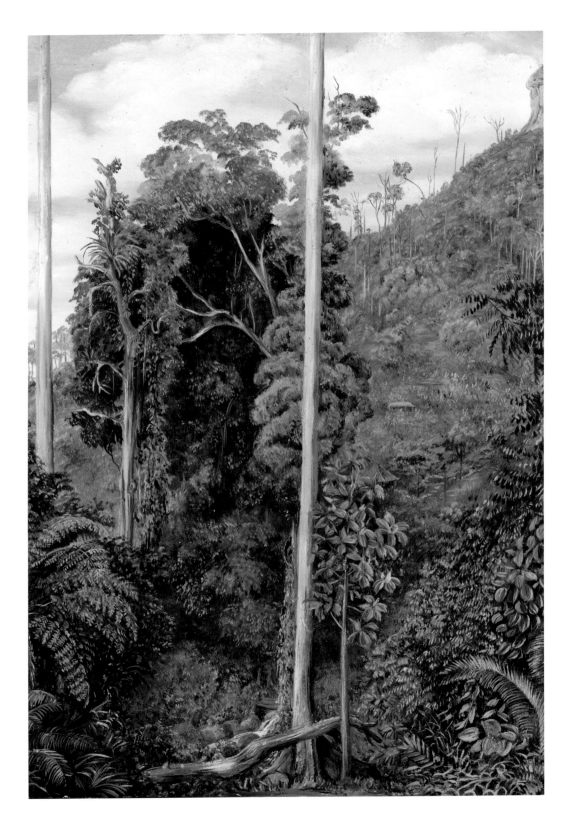

she wrote, 'and it broke one's heart to think of man, the civiliser, wasting treasures in a few years to which savages and animals had done no harm for centuries.' In Queensland, Australia, she reported seeing 'great piles of sawdust and chips, with some huge logs, told that the work of destruction had begun, and civilised men would soon drive out not only the aborigines but their food and shelter'; and in New South Wales 'miles of tall dead trees all ringed or burnt to death purposely by civilised man, who will repent some day when the country is all dried up, and grass refuses to grow anymore'.

In Sarawak for a second time in 1880, North revisited the British quicksilver (mercury) mining operation at Tegora, where she had first stayed four years earlier, and found the forest near the bungalow had gone, save for a few scorched individual trees. She painted the tall, bleached white trunks and wrote a stark caption for the gallery catalogue: 'Tall trunks of trees left standing here and there, showing the character of the forest before the quicksilver mines tempted civilised men to come and destroy it.' What North experienced in her travels and depicted in her written and visual records was not untouched wilderness, not visions of Eden, but places – and people – undergoing profound and accelerated changes wrought by 'the ever advancing settler or colonist'. The quoted words come from Joseph Hooker's 1882 preface to the gallery catalogue. Today, 140 years later, there is a growing awareness that historic colonisation is one factor driving the vulnerability of specific places and people to climate change, as recognised in the latest IPCC report. With the devastating effects of climate change becoming more apparent with each passing year, there is now arguably a more urgent need than ever to reflect upon, and reconsider, our understanding of this history.

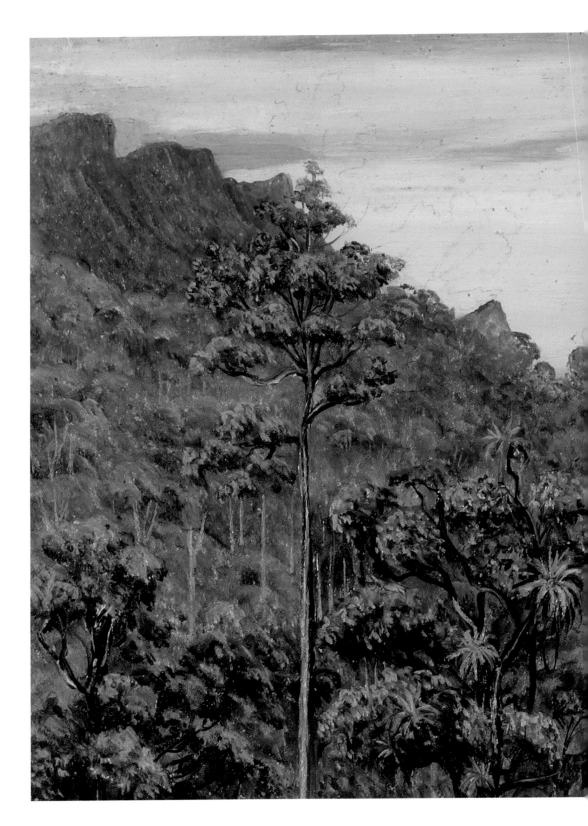

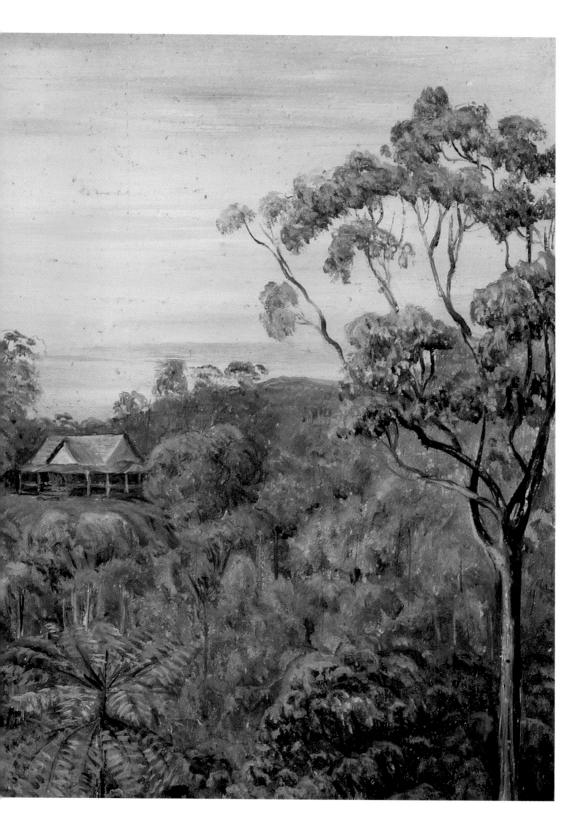

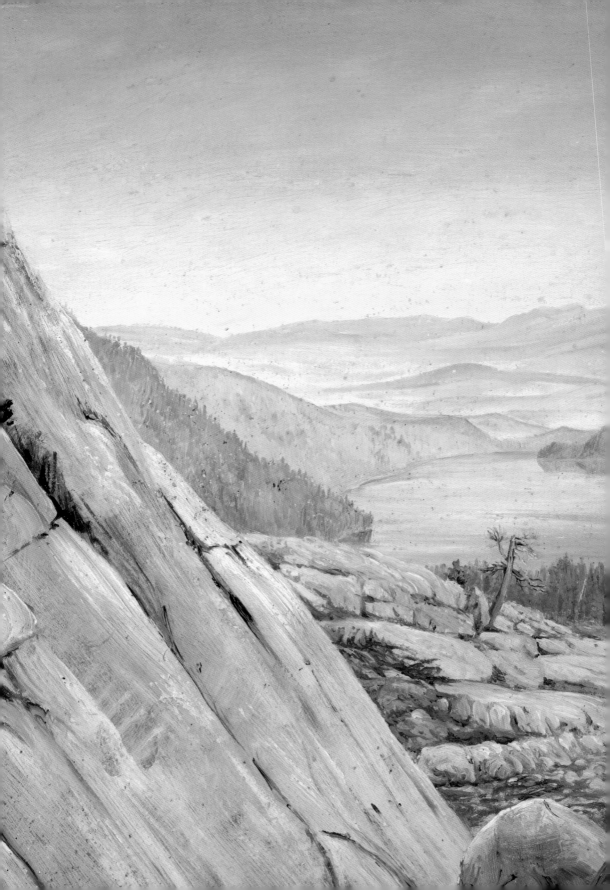

PART I. 1871–1875

Painting on the Spot

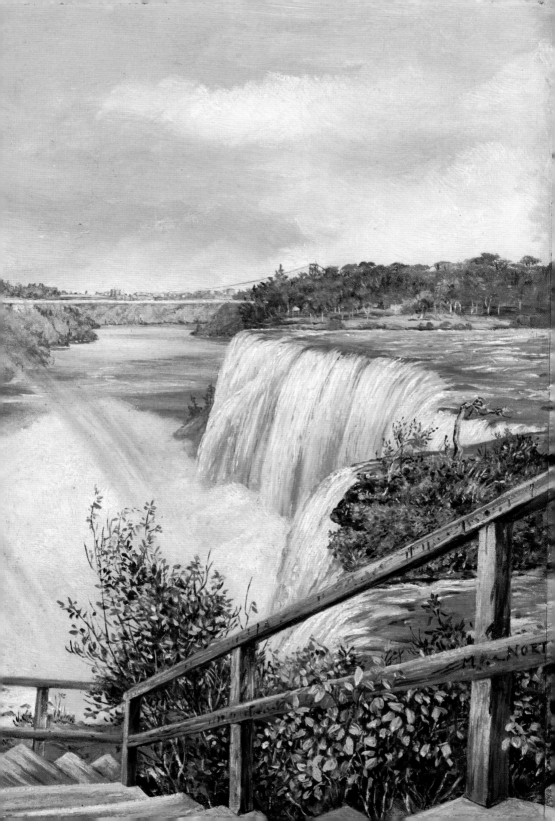

Chapter 2

North America by Rail

AUGUST–DECEMBER 1871 (RETURN VISITS IN 1875 AND 1881)

References to rail travel abound in Marianne North's written accounts of her travels in North America: purchasing tickets, dealing with luggage, porters and guards, changing – and missing – trains, travelling in Pullman cars (sleeping carriages) and, once, riding a freight train. Her second and third journeys, which took her across the US, were possible due to the Pacific Railway, the first transcontinental railroad, which opened in 1869 and cut the overland journey time from 25 days by stagecoach, or several months in a wagon, to less than a week. The Pacific Railway caused profound change across North America, aiding settler colonisation of western territories and undermining Native American nations such as the Lakota and Cheyenne, whose lands were seized and trade customs disrupted by the vast government land grants that were handed to the railway companies.

At the start of her five-month trip in 1871, however, North was settled in New England, the house guest of her friend from Boston, Mrs Skinner ('Mrs S.'), who had accompanied her during the Atlantic crossing from Liverpool, England. The two women had been friends since meeting in Egypt during North's travels with her father to Egypt, Palestine and Syria in 1865–66. At Mrs Skinner's house in West Manchester, North bathed in the sea (Ex. 1), painted her

surroundings and socialised with New England's intelligentsia, such as the naturalist, writer and future co-founder of Radcliffe College in Cambridge, Massachusetts, Elizabeth Cabot Agassiz ('Mrs. A.'). Elizabeth's husband Louis Agassiz ('the Professor') was a professor of zoology and geology at Harvard, whose work promoted scientific racism and racial segregation. North's interest in the couple's 1865–66 expedition to the Amazon was well rewarded when they showed her their photograph collection and supplied letters introducing her to their contacts in Brazil. Elizabeth also gave North a private tour of the museum that her husband had founded at Harvard, called the Museum of Comparative Zoology today but at the time commonly known as Agassiz's Museum (Ex. 2). Eventually, North and Mrs Skinner left West Manchester for Niagara Falls, from where North struck out by herself, travelling by train to scattered friends and relations who had emigrated from Britain. In December 1871, she left for the West Indies onboard a steamer to Jamaica.

North returned to the US twice, both times for around six to eight weeks. The Liberal MP and shipping magnate Thomas Eustace Smith and his wife Eustacia, a prominent art patron, accompanied North on her outward Atlantic crossing in 1875 and the cross-continental rail journey from Quebec to California with brief stays at Chicago and Salt Lake City. In California, a cabin misallocation on the onward Pacific steamer to Japan won North a month alone to explore the state (Ex. 3, 4). In 1881, returning to Britain from New Zealand, she effectively reversed her east–west journey of six years earlier, landing in San Francisco and taking trains through to New York with stops at Kansas City, St Louis, Washington and Philadelphia. Of the 33 North America artworks in the gallery collection, 22 relate to California, with redwood forests a prominent feature. But cities had their attractions too – not least New York, where North enjoyed the busy cultural life and significant access to scientific institutions, including the American Museum of Natural History and Columbia University (Ex. 5).

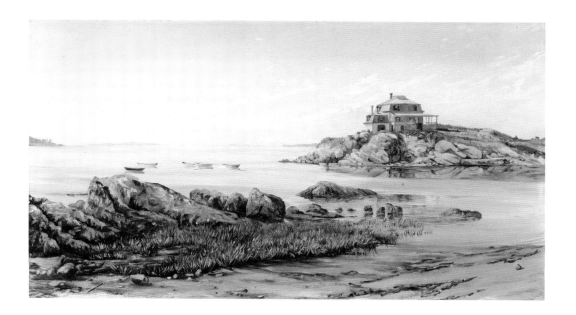

1.

AT MRS SKINNER'S HOUSE, *1871*

[above] **On the Rocks, near West Manchester, Massachusetts.** In *Recollections* North satirised the appearance of Mrs Skinner and herself bathing in their scarlet serge and blue-gray bathing-dresses, writing 'we looked much like two large lobsters in the water, one boiled, the other unboiled'.

After three days Mrs. S. and I settled ourselves in the house she had taken near West Manchester. It was built on the foundation of a fort or tower on the rocks, against which the sea washed on three sides at high water; the rocks were tinted with pink, red, brown, and gray, and above high-water mark with soft gray, green, and yellow lichens, wild grass, and scrub: there was no garden, and we wanted none. On the west side the sea ran up into a little sandy bay, the very ideal of a bathing-place; a few steps would take us down into it from the back door. On the east side were holes under the steep rocks, where we could find water at the very lowest tides, and these were almost as easily reached for bathing. [...] Boats, with their clear reflections, were constantly passing over the bay, and the sea was an exquisite blue in the hot noondays, when I used to sit in the balcony or piazza which ran all round the outside of the house, as in most New England houses: on one side there was always shade and cool air, even on the hottest days. Our landlord's Newfoundland dog used to pay us many visits, and stand any length of time in the water watching me, in hopes of a stone being thrown in and giving him an excuse for a swim. The house had only just been built, and was furnished with clean new-polished fir-wood or basket-work, with Indian matting on the floor. Mrs. S.

used to go up to her town house and bring down pretty things, brackets, and books, until she soon made it look most home-like. We had a fat cook, who had imported herself from Ireland twenty years before, but had not yet exchanged the brogue for the twang; a housemaid, who left her husband to come back to her old mistress; and Marguerite of France, who looked pretty and waited well, saying continually, "que je suis bête moi!" and "quelle horreur!" at everything new, especially grasshoppers and spiders, occasionally jumping on chairs to avoid them.

We used to go for a drive of an evening, and bring home great bunches of scarlet lobelia, which they called the "Cardinal Flower," white orchids, and grand ferns, smilax, sweet bay, sumach, and meadow flowers, to dress up our pretty rooms. The railway station was about four minutes' walk from our house – a shed with three chairs and a red flag, which we stuck up on the end of a bamboo placed there for that purpose if we wanted the train to stop. Newspapers and letters were thrown out by the guard as he passed; whoever happened to be going that way picked them up and distributed them, tossing ours in at any door or window that happened to be open: we had also a post-box, No. 115, at West Manchester, in which letters were sometimes found and brought over by friends.

2.
A PICNIC AND A PRIVATE TOUR, *1871*

He invited me to meet Mrs. Agassiz at a picnic one day, and called for me in his pony carriage, picked up Mrs. A. at the railway station, and drove us to one of the many beautiful high headlands on the coast; then we walked over the cliffs to find a most curious old cedar-tree, perfectly shaved at the top like an umbrella pine by the sea winds, with its branches matted and twisted in the most fantastical way underneath, and clinging to the very edge of the precipice, its roots being tightly wedged into a crack without any apparent earth to nourish it. It was said to be of unknown antiquity, and there was no other specimen of such a cedar in the country; it looked to me like the common sort we call red cedar. We sat and talked a long while under its shade. Mrs. Agassiz and I agreed that the greatest pleasure we knew was to see new and wonderful countries, and the only rival to that pleasure was the one of staying quietly at

[page 38] **The American Fall from Pearl Island, Niagara.** At the Niagara Falls the Head Guide personally showed North all the best views. She sketched for this painting from the boulders between the two Falls, In *Recollections* she commented that she got 'sufficiently soggy' while sketching, and that it was after finishing the initial sketch that she 'went farther under the spray of the American fall and saw three quarters of a circle of rainbows on it.'

[right] **An Old Red Cedar on the Rocks near West Manchester, Massachusetts.** The red cedar tree beneath which North and Elizabeth Cabot Agassiz sat and became acquainted.

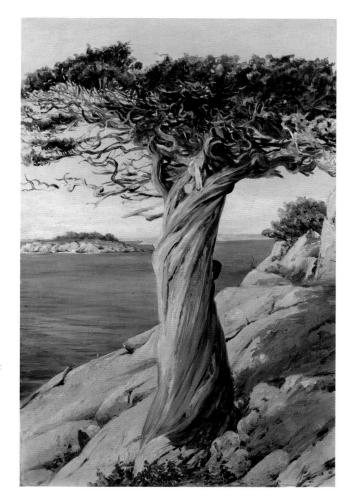

home. Only ignorant fools think because one likes sugar one cannot like salt; those people are only capable of one idea, and never try experiments.

Mrs. A. was a most agreeable handsome woman; she had begun life as a rich ball-going young lady, then, on her father losing his fortune, she had started a girls' school to support her family, and finally married the clever old Swiss professor, whose children were already settled in the world. She made an excellent stepmother as well as travelling companion, putting his voyages and lectures together in such a manner that the Americans had a riddle, "Why were *Agassiz's Travels* like a mermaiden?" "Because you could not tell where the woman

ended and the fish began!" The Professor was a great pet of the Americans, who were then just fitting up a new exploring ship for him to go on a ten months' voyage to Cape Horn and the Straits of Magellan to hunt for prehistoric fish in comfort. She told me much of the wonders and delights of her famous Amazon expedition, and promised me letters there if I went. [...]

I found her and the Professor even more to my mind; he spoke funny broken English, and looked entirely content with himself and everybody else. They showed me photographs and told me of all the wonders of Brazil, and what I was to do there, then gave me a less poetical dinner. Then Mrs. Agassiz took me to the Museum and made Count Pourtalèz take us up to the attic to see the most perfect collection of palms in the world (all mummies), intensely interesting, as illustrating the world's history. Mrs. Agassiz showed me the great sheath of one of the flowers, which native mothers use as a cradle and also as a baby's bath, it being quite water-tight. The flowers of some of the palms were two to three yards long. She said, though she had wandered whole days in the forests, she had never seen a snake nor a savage beast. One day she heard a great crashing through the tangle and felt rather frightened, when a harmless milk-cow came out. After seeing the palms she caught a German professor and made him show us a most splendid collection of gorgeous butterflies: I never saw any so beautiful; they were all locked up in dark drawers, as the light faded them. Then came corals and madrepores.

3.

THE PACIFIC RAILWAY SUMMIT, 1875

The day after that I started back to the "Summit Station," Colonel and Mrs. M. going with me as far as Sacramento, where there was a fair at which he hoped to see fine horses and cattle, but was disappointed. I continued in the train, which slowly climbed its 8000 feet and landed me at midnight at the top of the pass, in the midst of the Nevada Mountains, and I settled for a week in a very comfortable railway-hotel. One could go ten miles on either side under cover of one long snow-shed, east and west. The trains only went through in the middle of the night, except a few wood-trains for short distances; there was no village, so it was a most quiet locality. My other window

looked over the bright rocks and trees and mountain-tops, with a few small lakes here and there, like the top of some Swiss pass. The house was still well filled with San Francisco people doing "Vileggiatura". The food was excellent, popped corn and cream being the thing for breakfast. Half-an-hour's climb took me to the highest point near, from which was a most magnificent view of the Donner Lake below, and all its surroundings. Of this I made two large sketches, taking out my luncheon, and spending the whole day on those wild beautiful hills, among the twisted old *arbor vitae*, larch, and pine trees, with the little chipmunks (squirrels) for company, often not bigger than large mice. The sunshine was magnificent; I could trace the long snow-galleries and tunnels of the railway, high along the projecting spurs of the mountains, into the far horizon. It was a most quiet enjoyable life, with few adventures beyond my cold tea being put into an unwashed Hervey-sauce bottle one morning. I took a good drink before discovering it, and did not like it, then sat down and laughed till the tears ran out of my eyes again – that air made one feel so happy.

My landlord drove a drag, four-in-hand, down to Lake Tahoo most days, and at the end of the week took me on there, driving down the steep descent to Lake Donner. We went along the whole length of its clear shore to Truckee, then followed the

[below] ***Snow Sheds at the Summit of the Great Pacific Railway, California.*** This painting showing snow sheds built to protect the railway was inspired by North's week-long stay in a hotel at the summit of the transcontinental railway on Donner Pass.

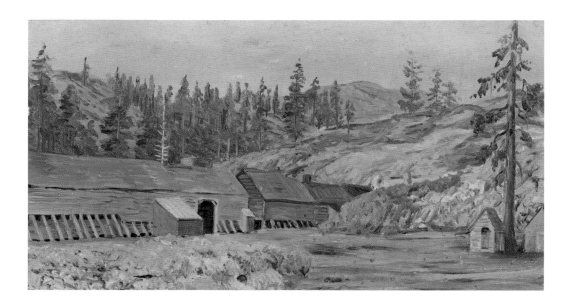

lovely clear river to its source in the great Lake Tahoo, a most lovely spot with noble forests fringing its sides. There was another capital wooden hotel there, where I could work again in peace. Behind the house were noble trees, fast yielding to the woodman's axe; huge logs were being dragged by enormous teams of oxen, all smothered in clouds of dust. They made fine foregrounds for the noble yellow pines and cypress-trees, with their golden lichen.

4.
CALAVERAS GROVE, CALIFORNIA, 1875

The next morning I drove on to Calaveras Grove, found myself the last guest of the season in the comfortable hotel under the big trees, and stayed there a week. That was indeed luxury, to be able to stroll under them at sunrise and sunset without any delay or trouble. A stag with great branching horns was my only companion; he had a bell round his neck, and used generally to live in front of the house, but liked human company; and when I appeared with my painting things he would get up and conduct me gravely to my point and see me well settled at work, then scamper off, coming back every now and then to sniff at my colours. One of my first subjects was the great ghost of a tree which had had a third of its bark stripped off and set up in the Crystal Palace; the scaffolds were still hanging to its bleached sides, and it looked very odd between the living trunks of red plush on either side. The sugar-pines were almost as large, and even more beautiful than the sequoias, their cones often a foot long, and so heavy that they weighed down the ends of the branches, making the trees look like Chinese pagodas in shape. They are called sugar-pines from the white sweet gum which exudes from the bark, and drops on the ground like lumps of brown sugar; it is much eaten by the Indians. The cones of the "Big Trees" were small in proportion. About six miles from the Calaveras Grove was another with 1300 big trees in it. I rode there one day on an old cart-horse, and found that one hollow tree was used as a house by an old trapper. He was out, but his dogs strongly protested against any entrance in his absence. On a tree near were a quantity of rat and other skins. I was told that he had probably eaten the animals, and was not over-particular as to

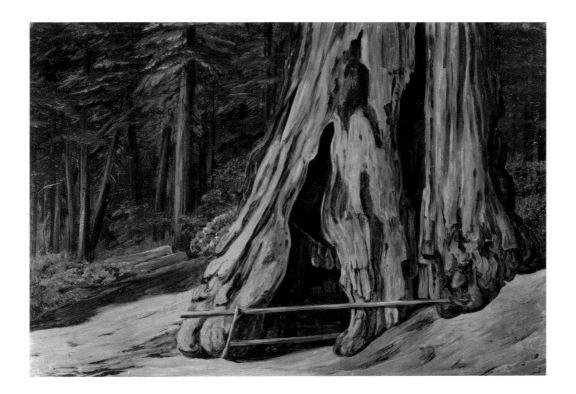

how he lived. He had been there three years, cut sticks and nick-nacks of "Big Tree" wood to sell, then, when he had made a little money, he would have a regular drinking-bout and drink it all up. My guide to those trees was an Alsatian who had left his country to avoid the Prussian conscription; he said many of his friends had run away for the same purpose to America, and never meant to go home to do soldiering for the Germans.

5.
THE AMERICAN MUSEUM OF NATURAL HISTORY AND COLUMBIA UNIVERSITY, 1881

The first morning she [Mrs Botta] sent for a friend to come to breakfast, and take me out for a hunt after things I wanted. First we went up the "elevated" rail, one which leads from the sea into the country, over one of the principal streets, with iron lace-work resting on iron arches and pillars. Every kind of traffic goes on underneath, and the horses take no notice of it. Pretty little stations, with ornamental covered staircases up to them, also stand on pillars at every fourth "block," and one always finds two trains within sight on each line of rails. They follow one

another every five minutes, sixpence being the fare from end to end. We left the rail at the other side of the great Central Park, and walked across some waste ground to the Natural History Museum, of which only the eighteenth part is finished.

We fell in with the Director, and "had a good time." The birds are exquisitely kept and arranged, and the whole building well lighted. We saw an interesting collection of things from Mexico, also a model of the curious Indian settlement near Puebla. I wanted to make out more about the strange plants of Arizona, particularly the *Fouquier[i]a splendens*, so we went on to Columbia College, and visited first its president, Dr. Bernard, in his den, talking with him through an ear-trumpet and tube:

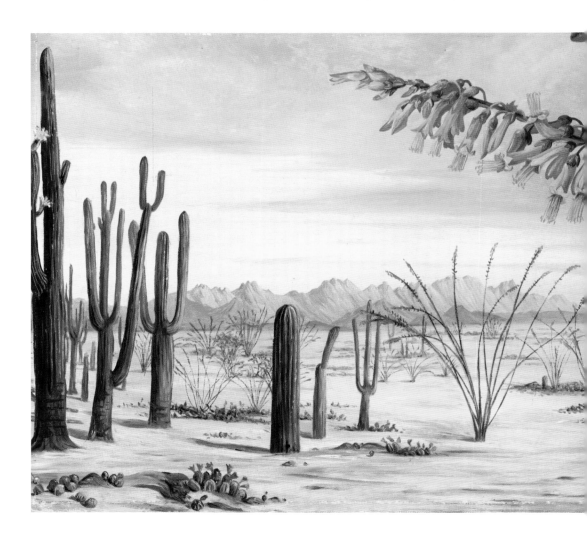

a girl was sitting in a corner doing telegraph work for him. Then we went to Dr. Newberry, who hunted over all his books, finally taking us to the herbarium, where we found not only engravings, but a dried flower. He took the greatest pains to help me, and his secretary, Mr. B., arranged to go on his half-holiday, Saturday, to hunt for flowers in the woods on Staten Island with me. The ferry and rail took me to his appointed station, where he met me in a buggy, with an old horse to drag it, and we spent a long day driving from wood to wood, and wandering about after cypripediums, magnolias, azaleas, kalmias, andromedas, and other nice things. The sarracenias and dionaeas were also to be found in another part of the island, which was full of pretty villas and gardens belonging to the rich people of New York. Mr. Heald, the artist, took me for a flower-hunt on the other side of the city one day, and we got frightfully hot walking through the woods from noonday till four, like two old fools; but the masses of pink azalea were worth some trouble to see. Solomon's seals, arums, and flowering ferns abounded there.

[left] **Vegetation of the Desert of Arizona.** The plant in the centre with slender, long stems is *Fouquieria splendens.* In 1881, North visited Columbia University, New York, to learn more about this species and was shown books, engravings and a dried specimen.

Chapter 3

Jamaica, At Last

DECEMBER 1871–MAY 1872 (RETURN VISIT IN 1885)

'*In the West Indies at last! Christmas Eve!*' This jubilant exclamation opens Marianne North's account in *Recollections* of her five months in Jamaica. The months she had just passed in the United States were but a stepping-stone to achieve her long-cherished dream of visiting the tropics. Her words also paid tribute to a recently published book, Charles Kingsley's *At Last: A Christmas in the West Indies* (1871) which, for North, 'added fuel to the burning of my rage for seeing the tropics'. More prosaically, it prompted her to ask Kingsley for letters of introduction to his contacts in the West Indies and Brazil.

North landed at bustling Kingston, the most populous city in the West Indies, which would shortly (in 1872) replace Spanish Town as Jamaica's capital. At a cost of four pounds per month, she rented a house in the abandoned botanic garden in nearby rural Gordon Town. North employed two elderly servants for six shillings a week: Betsy, a formerly enslaved domestic maid, and Stewart (Ex. 6). While North's descriptions of Betsy and Stewart are racialised and focused on difference, she notes that in their care she felt 'as safe there as I do at home, though there was not a white person living within a mile'. Ecstatic at finally experiencing first-hand the lush abundance of tropical vegetation, her overwhelming concern was what to paint first.

For impoverished Black Jamaicans such as Betsy and Stewart, such idyllic wonderings were far removed from everyday life. Full emancipation in 1838 did not transform Jamaican society. Gross inequalities remained entrenched, leading to the Morant Bay uprising of 1865. The colonial army, acting on the orders of Governor Edward John Eyre, suppressed the uprising brutally: five hundred Black Jamaicans were killed and at least a thousand homes destroyed. Jamaica was put under direct rule as a Crown Colony in 1866 (until independence in 1962), with John Peter Grant appointed as the first new governor: these events are the 'rebellion' and 'anarchy' to which North refers (Ex. 7). While Governor Grant saw the uprising as an indictment of government by the white planter-dominated Jamaica Assembly, he justified unelected Crown Colony rule with his belief that Black Jamaicans were 'ill-suited' to self-government. North became well-acquainted with Governor Grant, writing that he was 'always my ideal of a governor'. She stayed as a guest at both his country residence, Craighton, ('Craigton') and his official residence, King's House, in Spanish Town (Ex. 8).

At Craighton, North befriended Gertrude Schalch (Ex. 9), sister of the Attorney General Ernest Alexander Clendinning Schalch, a friendship that endured until the siblings' untimely deaths from yellow fever three years later. Craighton Estate in Jamaica's Blue Mountains was established in 1805 as a coffee plantation, and from the 1840s was owned by a succession of Jamaica's governors. North's stay at another Blue Mountain coffee estate, Clifton Mount, prompted her to record her time there with paint and words (Ex. 10). Coffee production was re-established at both Craighton and Clifton Mount in the 1980s and continues to this day.

North revisited Jamaica in early 1885, when returning to England from Chile. In poor health, she stayed with Mrs Campbell ('Mrs. C.' in extract 6) in for a month to convalesce, visiting the graves of the Schalchs at Craighton's church, and producing a painting of the Blue Mountains for a friend.

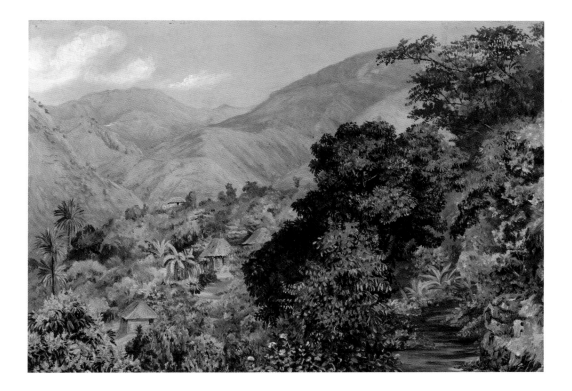

6.

A HOME IN GORDON TOWN

[above] **Distant View of Newcastle.** One of three paintings in the gallery collection that North produced at her rented house in Gordon Town.

[page 50] **The Garden of King's House, Spanish Town.** Partway through her time in Jamaica, North gave up the house she called home in Gordon Town to be the guest of Governor John Peter Grant at Craighton and King's House, Spanish Town.

One day Mrs. C. took me a drive up the Newcastle road; when it came to an end we walked on, and I saw a house half hidden amongst the glorious foliage of the long-deserted botanical gardens of the first settlers, and on inquiry found I could hire it entirely for four pounds a month. It had twenty rooms altogether, and offices behind, and had been a grand place in its day. So I did hire it, and also furniture for one bedroom. I put all but the bed and washstand in the long outside verandah, which occupied all the front of the upper floor, open to the lovely views (with occasional Venetian shutters), and pinned up my sketches on the opposite wall, keeping a little room at the end to sleep in, and another locked up for my storeroom. [...]

Mrs. C. found me an old black woman, Betsy, to look after and "do" for me. She used to sit on the stairs or in the doorway and watch me, eating little odds and ends, and sleeping between whiles. She prided herself upon being "one of the Old Style Servants," which meant, I believe, old enough to have begun life as a slave; consequently she had a contempt for all

newfangled notions about dress. She wore *one* and a turban, and at night untwisted the latter article and put it on rather differently, that was her whole undressing. A second dress made her sole luggage. There was also a man attached to the house, old Stewart, a coal-black mortal with a gray head and tattered old soldier's coat, who put his hand up to his forehead with a military salute whenever I looked at him. I gave these old people six shillings a week to take care of me, and felt as safe there as I do at home, though there was not a white person living within a mile. I had a most delicious bath: a little house full of running water, coming up to my shoulders as I stood in it; it was the greatest of luxuries in that climate.

From my verandah or sitting-room I could see up and down the steep valley covered with trees and woods; higher up were meadows, and Newcastle 4,000 feet above me, my own height being under a thousand above the sea. The richest foliage closed quite up to the little terrace on which the house stood; bananas, rose-apples (with their white tassel flowers and pretty pink young shoots and leaves), the gigantic bread-fruit, trumpet-trees (with great white-lined leaves), star-apples (with brown and gold plush lining to their shiny leaves), the mahogany-trees (with their pretty terminal cones), mangoes, custard apples, and endless others, besides a few dates and cocoanuts. A tangle of all sorts of gay things underneath, golden-flowered allamandas, bignonias, and ipomoeas over everything, heliotropes, lemon-verbenas, and geraniums from the long-neglected garden running wild like weeds: over all a giant cotton-tree quite 200 feet high was within sight, standing up like a ghost in its winter nakedness against the forest of evergreen trees, only coloured by the quantities of orchids, wild pines, and other parasites which had lodged themselves in its soft bark and branches.

7. AT CRAIGHTON

I reached Craigton just after sunset; and the views over Kingston Harbour, and Port Royal stretching out into the sea beyond, were very fine. The house was a mere cottage, but so home-like in its lovely garden, blazing with red dracaenas, *Bignonia venusta*, and poinsettias looking redder in the sunset

[below] *View over Kingston and Port Royal from Craigton.* North painted this view on one of her stays at Craighton, the governor's summer residence in the Blue Mountains. The Craighton estate was established in 1805 as a coffee plantation, then from the 1840s became associated with many of Jamaica's ruling elite. Since the 1980s, it has been owned by Japan's largest coffee company, Ueshima Coffee Company, which re-established coffee production on the estate.

rays, that I felt at home at once. The Governor, Sir John Peter Grant, was a great Scotchman, with a most genial simple manner, a hearty laugh, and enjoyment of a joke. He was seldom seen till dinner-time, except sometimes when he came out for a game of croquet about five o'clock with any people who happened to collect themselves on the pretty green lawn which was always open to all the neighbours. Two sheep were kept tethered on it to nibble the grass and make it fine, and they had learned to stand on their hind-legs and beg for sugar at tea-time. After the anarchy succeeding the rebellion, Sir John was persuaded to leave Bengal and come to put things straight. He worked enormously, pulling down old machinery and putting up new everywhere. He was never tired, and could work day and night without rest or exercise, trusting no one, and looking into the minutest details himself. His right-hand and secretary, Captain Lanyon, had no sinecure, and helped him gallantly, besides doing all the honours of the house; for the Governor hated "company," and never gave himself the least trouble to

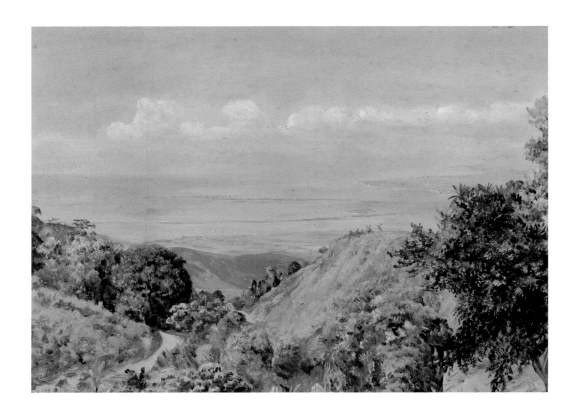

be civil to people unless he liked them. He told me to come and go just as it suited me, and to consider the house my home. He never took any more notice of me, and I did as I was told, and felt he had treated me in the way I liked best. He is always my ideal of a "Governor."

I begged to be let off formal breakfasts, went out after my cup of tea at sunrise as I did at home, and worked till noon. My first study was of a slender tree-fern with leaves like lacework, rising out of a bank of creeping bracken which carpeted the ground and ran up all the banks and trees, with a marvellous apple-green hue. The native children used to take plunges into it as English children do with haycocks, and it was so elastic that it rose up after them as if nothing had happened. In the afternoon I could paint in the garden, and had the benefit of the tea and gossip which went on near me, sitting under a huge mango, the parson, his wife, and people coming up on business from the plains with three or four neighbours and idle officers from Newcastle [...] In the evening Sir John always came into the drawing-room with the ladies (like all those who really do work in the tropics, he drank next to no wine). He used to curl himself up on the sofa amid a pile of books, kick off his shoes, and forget the existence of every one else, or he played a game of chess if he found a partner worth fighting. When he discovered I could sing he said he would have that other trunk up the hill, even if it took six men to carry it, so that they might find more songs to keep my voice going; and it was a comfort to think I could give him some pleasure in return for all his kindness.

8.
A STAY AT KING'S HOUSE, SPANISH TOWN

I reached Spanish Town in the dark, barely in time for dinner, and enjoyed all the more looking out at my window the next morning on the lovely convent-like garden below, full of the richest trees and plants. A tall spathodia-tree was just opposite, covered with enormous flower-heads, pyramids of brown leather buds piled up and encircled by a gorgeous crown of scarlet flowers edged with pure gold. They came out freshly every morning and fell off at night, making a dark crimson carpet round the tree. A great waxy *Portlandia* was trained just

underneath it, and Cordeas with heads as big as cauliflowers (Robineas, and *Petraea scandens* with wonderful masses of lilac-blue bracts). Larkspurs, with blue and white flowers and leaves like sandpaper, were in their fullest beauty. I never saw so many treasures in so small a space. Arches surrounded it leading to the different rooms of the ground floor, where the Governor and his A.D.C. [aide-de-camp] had their office open to the fresh air of the gardens on either side. When the day's work was over, Gertrude and I used to go and sit there too: I still painting in a corner, she and her brother and friends swinging in hammocks and talking nonsense, till the great heat was over, and we could go for a ride or drive. The first morning she took me for a lovely walk down to the beautiful sandy river-bed, with the bamboos and big tree branches dipping into the waters, long-legged birds of the heron or stork kind walking in and out, fishing and pluming themselves with their long bills, and making their morning toilettes. There were many curious and grotesque old tree trunks down there, with snake-like roots

[below] *View of the Sandy River at Spanish Town.* North sketched at this river regularly while in Spanish Town, after being taken there by Gertrude Schalch the morning after her arrival.

stretching over the ground, and arched buttresses, from which the floods had washed away the sand and earth at different times. Graceful little black children were running in and out of the water, bathing and splashing one another. Fish, too, were jumping out of the clear water, which ran rapidly over the golden sand. I went there very often afterwards to sketch, with the old bloodhound to take care of me; he used to gallop on in front till he found some solid yards of shade, where he would sit waiting till I came up, and then run on to another good halting-place. [...]

King's House was a most inconvenient building, internal comfort sacrificed to its classical outside, and to a huge ballroom which took up one wing of two storeys in height. The piano was there, and when the house was full we used to sit there as the coolest place. The Governor had a habit of waiting till the second bell rang, and then saying: "God bless my soul! I must go and dress." We used to get all sorts of strange and excellent dishes; everything seemed new. Fresh ginger-pudding, tomato toast, fried "okkellis" [ackee], mango-stew, stewed guavas, cocoanut cream and puddings, and many other things not heard of in Europe, as well as roast turtle and other strange fish, the former rather unattractive food.

9.
GERTRUDE SCHALCH

Gertrude S., the Attorney-General's sister, soon rode down to see me; she lived only half a mile from Craigton, and was the person I liked best in Jamaica. As a young girl she had been taken out with her brothers and mother by a stepfather to Australia, where she had had no so-called "education," but had ridden wild horses and driven in the cattle with her brothers; had helped her mother to cook, wash, make the clothes, and salt down the meat; and till seventeen she could barely read; then her mother's health broke down, and she accompanied her back to England, nursed her through a long illness, and educated herself. Her eldest brother soon took great honours at the Bar, and was sent for by the Governor to help him in starting the new Constitution of Jamaica. I never knew a more charming brother and sister! so entirely happy together, and helpful to one another. Gertrude had taught herself German,

[above] *Bermuda Mount.*
This was the home of
North's friends Gertrude
and Ernest A. C. Schalch.

French, and Italian in those few years, and still read much, though she did all the finer kinds of cooking with her own hands, and saw her horse and cow fed regularly. She rode like Di Vernon, and shocked the conventionalities of the country by taking no groom with her. No one more thoroughly understood the management of a horse. She had a noble face and figure, with beautiful expressive dark eyes, and was a most perfect gentlewoman in spite of her rough training; another of the many examples I have known that a really distinguished woman needs no colleges or "higher education" lectures. Her brother was witty and bright, and when he went into the Governor's room at Craigton we were sure to hear the great laugh come rolling out over and over again. Three years later these dear people both died in the same hour, of yellow fever, and a letter to me was the last Gertrude wrote, telling how she and her brother had been nursing the master of the new college, who had come up for his Christmas holiday to them bringing yellow fever: he was better, and was on his way home, and I must

come back with him and pay them a visit. The next day I read a telegram in the papers: "Attorney-General of Jamaica dead of yellow fever, sister dead also." It was too terrible! This is a long story, but I could not think of my friend without her curious history: her life was short, but I think a happy one, for she was always busy, and used to sing over her work, making all near her happy too. We took to one another at once with our whole hearts, and I well remember that afternoon when she rode down the hill to see me, and I walked nearly home with her afterwards, her horse following like a dog without any leading.

10.
CLIFTON MOUNT COFFEE PLANTATION

I rode up to the church, and asked Mr. B. to get me leave to go and stay at Clifton Lodge, which he did. The house belonged to a gentleman who had lost his wife there, and never cared to see it again; he did not let it, but lent it for a week at a time to different people, who wanted a dose of cool air, 5,000 feet above the sea, beyond the lovely fern walk and in the midst of the finest and oldest coffee-plantations in Jamaica. It was a

charming little well-furnished house, surrounded by a garden full of large white arums, geraniums, roses, fuchsia fulgens in great bunches, sweet violets, hibiscus, great pink and blue lilies, orange-flowers, sweet verbena, gardenias, heliotrope, and every sweet thing one could wish for. Opposite was the real Blue Mountain, with clouds rolling up across it as they do in Switzerland. There was a village just below, with a great coffee-growing establishment, and bushes of it for miles on the hillside in front – all pollards, about four feet high, full of flowers and different coloured berries. It seemed an ill-regulated shrub; its berries had not all the same idea about the time for becoming ripe, and the natives had to humour them and pick continually. It was a wonderful little house: I found plate, linen, knives, a clock (going), telescope, piano (best not to try it I thought), and a nice tidy woman and family in the yard to get all I wanted. I had brought old Betsy, and she did holiday and "lady out visiting," as all maids do when away from their usual homes. She said it was very cold, and shivered, but I did not find it so, though blankets and counterpanes on the beds looked as if it might be sometimes.

A great blue-bottle fly buzzed, and a bird whistled two notes, scientifically describable as the diminished seventh of the key of F, an E natural and B flat alternately, always the same and in perfect tune. A lovely little apple-green bird with a red spot on his breast also came into the garden, called the Jamaica Robin, which burrows a tunnel in the bank like a kingfisher; but after going in straight for eight inches it makes a sudden bend at an acute angle, and thus hides the actual nest from strangers outside. The Banana-bird, as yellow as the canary but bigger, and the Doctor hummingbird, with green breast and two long tail-feathers, used to dart about the garden in company with his wife, who was, like him, minus the tail, and the mocking-bird sang sweetly in the woods behind, having a vast variety of notes and trills. What nonsense people have written about the silence of the tropics; they only go out at noonday, when the birds have the sense to take their siestas. If they went out early, as I did, they would hear every sort of noise and sweet sound; then after sunset the crickets and frogs strike up, and a Babel of other strange talk begins.

[opposite] *Coffee Plantation at Clifton Mount, and the Blue Mountains beyond.* North also produced a study of the coffee plant while at Clifton Mount.

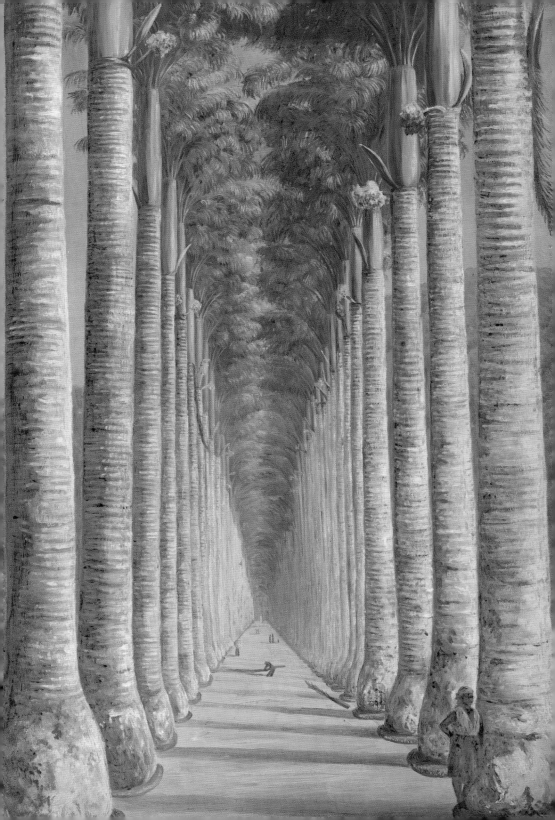

Chapter 4

Brazil with the Baron

SEPTEMBER 1872–AUGUST 1873

Marianne North's time in Brazil was divided between travels in Rio de Janeiro and Minas Gerais. During the first two months of her trip she painted regularly in the botanical garden in Botafogo, Rio; nine paintings in the gallery collection are studies of the garden's views and plants. Short trips to Paquetá and Tijuca also led to paintings, as did rambles to the hills behind Rio (Ex. 11). In October 1872 she met James Newell Gordon, superintendent of the Morro Velho gold mine and Vice-Consul of Great Britain to Minas Gerais, and accepted his invitation to stay at the mine near Nova Lima, Minas Gerais. They embarked on the arduous journey inland from Petropolis, travelling with Gordon's daughter Mary and Antonio Marcos Da Rocha from the St John d'el Rey Mining Company, whom North refers to as 'the Baron' and credits as 'a very important person in these pages'. Throughout this long journey, James Gordon was attended by a groom named Antonio, and North and Mary Gordon by a young groom named Roberto.

The British St John d'el Rey Mining Company owned and operated Morro Velho. The company recruited British miners, encouraging them to bring their families to live at Morro Velho. But these officers and miners were only a small proportion of the overall workforce. The vast majority of labourers were Brazilian or African,

and included around 500 enslaved men, women and children. These enslaved labourers were either 'owned' by the company, or – to circumvent legislation prohibiting British citizens from purchasing enslaved people irrespective of their country of residence – were 'rented' from failed mining ventures elsewhere in the region. North's account of Morro Velho states that enslaved labourers were emancipated after seven years. Contemporary scholarship shows that the agreement created in 1845 for 'rented' enslaved labourers covered a 14-year period. Upon the expiry of this period, the St John company did not uphold the clause granting freedom. Furthermore, to retain these labourers after the passing of Brazilian legislation in 1871 that required the registration of all enslaved people, Gordon falsely registered them as 'belonging' to a long-defunct company, which he claimed to represent. In October 1879, mounting pressure from the Brazilian abolitionist Joaquim Nabuco resulted in a court case that ruled the enslaved labourers must be freed – although the company did not act on this until December, after months of revolt by the illegally held labourers.

North's account of Morro Velho's enslaved workforce (Ex. 12) does not criticise the degrading and inhumane system of slavery she lived among for much of her time in Brazil. On the contrary, her repeated references to the happiness of the enslaved people, including the 'happiness' she claims they felt at (theoretically) being able to 'buy themselves at a fixed price', are attempts to justify their enslaved status by depicting them as lacking intellect, ambition and foresight. The closest her account comes to expressing discomfort or disapproval is her description of living there as being an 'odd sensation', and through her contrast of the 'fortress-looking piles of buildings' that housed enslaved labourers with the 'pretty cottages', 'strong countrymen' and 'extravagant luxuries' in what she terms the 'Cornish village', where the British miners lived. The mine's guest house for official visitors was her base for eight months. Da Rocha facilitated her painting excursions, such as the trips to Gongo Soco

and to Lagoa Santa ('Lago Fanto') and the Curvelo Caves, where she met the Danish palaeontologist Peter Wilhelm Lund and painted in his garden (Ex. 13). In early July 1873, she left Morro Velho with Da Rocha and Roberto; Gordon accompanied them as far as the Caraça Sanctuary (Ex. 14). Upon reaching Juiz de Fora, North boarded a train to Rio, 'squeezing the good old Baron's hand for the last time with real regret'.

On her return to Rio, she visited Emperor Dom Pedro II, and, in Petropolis, an elderly naturalist named Mr Weilhorn (Ex. 15). For her final expedition, she went to the Serra dos Órgãos mountains, guided by Jose Luis Correa, whose knowledge of the local flora was so impressive that North, unusually, made a point of explicitly acknowledging him in the text (Ex. 16).

[page 62] *Royal Palm Avenue.* During her first weeks in Brazil, North painted in the Rio Botanical Gardens daily, storing her equipment at the home of Karl Glasl, the garden's Austrian director. 'Of course,' she wrote in *Recollections,* 'my first work was to attempt to make a sketch of the great avenue of royal palms.' Her writings do not refer to the people depicted in this painting.

11.

OBSERVATIONS
FROM THE
AQUEDUCT
ROAD, RIO

I spent some days in walking and sketching on the hills behind the city; its aqueduct road was a great help to this enjoyment, being cut through the real forest about a thousand feet above the town and sea. A diligence took one half-way up to it every morning; the road itself and the grand aqueduct by its side were made two hundred years ago by the Jesuits, and the forest trees near it have never been touched, in order to help the supply of water which is collected there in a great reservoir. In this neighbourhood I saw many curious sights. One day six monkeys with long tails and gray whiskers were chattering in one tree, and allowed me to come up close underneath and watch their games through my opera-glass; the branches they were on were quite as well worth studying as themselves, loaded as they were with creeping-plants and grown over with wild bromeliads, orchids, and ferns; these bromeliads had often the most gorgeous scarlet or crimson spikes of flowers. The cecropia or trumpet-tree was always the most conspicuous one in the forest, with its huge white-lined horse-chestnut-shaped leaves, young pink shoots, and hollow stems, in which a lazy kind of ant easily found a ready-made house of many storeys. The most awkward of all animals, the sloth, also spent his dull life on the branches, slowly eating up the young shoots and hugging them with his hooked feet, preferring to hang and sleep head downwards. Some of the acacia-trees grow in tufts on tall slender stems, and seem to mimic the tree-ferns with their long feathery fronds, whose stems were often twenty to thirty feet high. Mahogany, rosewood, and many less known timber-trees might be studied there; the knobby bombax, gray as the lovely butterfly which haunted them, were planted at the edge of the road in many places, and under them one got a really solid shade from the sun.

It was the favourite home of many gorgeous butterflies, and they came so fast and so cleverly that it was no easy task for a collecting maniac to make up his mind which to try to catch and which to leave; before the treasure was secured more came and tempted him to drop the half-caught beauties for other, perhaps rarer ones, which he would probably miss. [...]

[above] *From Aqueduct Road, Rio.* North was as fascinated by wildlife as she was by plants, and recorded her encounters here with monkeys, sloths, butterflies and snails.

The common snail of Brazil introduced itself to me on that road; it was as large as a French roll, and its movements were very dignified. It had a considerable appetite for green leaves (as I afterwards found after keeping one as a pet in a foot-pan for a month), and its eggs were nearly as large as a pigeon's; the first I met was taking a walk on the old aqueduct amongst the begonia and fern-leaves, and moved on at least fifty yards whilst I made a two hours' sketch.

12.

AT MORRO VELHO: ENSLAVED LABOURERS AND A 'CORNISH VILLAGE'

It was an odd sensation living in an English colony which possessed slaves; but this company existed before the slave-laws, and was with some others made exceptional. As far as I could see, the people looked quite as contented as the free negroes did in Jamaica, and, thanks to the new Brazilian regulations, they have the happiness of being allowed to buy themselves at a fixed price, if they can save sufficient money.

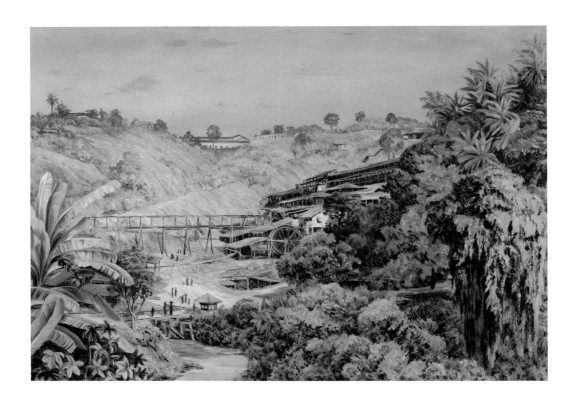

The girl who brought me my coffee in the morning had bought two-thirds of herself from her own father, of whom she was hired by Mrs. G., as he was said to be such a brute that it was a charity to keep her out of his hands. After five o'clock her time was her own, and she did embroidery and other work to sell, so as to complete her emancipation fund. She and another girl used to squat on the verandah close to my window working, generally with their feet poked through the balustrades. Mary told them one day if they did so I should paint them, toes and all, which would be a disgrace; after which there was always a great scuffle to tuck away their feet whenever I looked that way. Every other Sunday there was a revista or review of the blacks in front of the house, and they were all dressed in a kind of uniform; the women in red petticoats and white dresses, with red stripes for good conduct, bright orange and red turbans and blue striped shawls, which they arranged over their heads in fine folds; the men had red caps, blue jackets, and white trousers, with medals pinned on for good conduct, and

a general grin passed over the faces as Mr. G. and his officers passed by. I could not see much discontent or sadness in these poor slaves, and do not believe them capable of ambition or of much thought for the morrow. If they have abundant food, gay clothing, and little work, they are very tolerably happy: seven years of good conduct at Morro Velho gave freedom, which they had just sense enough to think a desirable thing to have. [...]

There were two fortress-looking piles of buildings on the hills opposite my window, where these poor creatures lived and were shut in every night.

On the other side of the valley stood the Cornish village – such a contrast! All its pretty cottages standing in their own well-fenced gardens, with pure water running through each, roses and other familiar English flowers, and fair English children with clean faces playing at hop-scotch and other British games in the road. All the head-work in the mines was done by those strong countrymen, who were well paid, and could soon put by considerable savings if they had the sense to content themselves with the food of the country. The beef was abundant and cheap, so was Fejão farinha, coffee, and sugar. Most vegetables and fruits were grown without difficulty; but the miners, who could not do without beer, champagne, horses, and other extravagant luxuries, of course soon found their pockets empty, and got into debt besides.

13.
PETER
WILHELM
LUND

At sunset we came in sight of the Lago Fanto, a shallow sheet of water getting gradually filled up [...] An air of indescribable dulness [sic] seemed to hang over it and the poor straggling village on its banks, and we wondered more and more what the charm was which had kept the famous Danish naturalist Dr. Lund here for more than forty years. He was now nearly eighty years old, and had made several collections of natural curiosities and plants, which had gone to Copenhagen. He had corresponded with many of the scientific men of Europe, but always lived entirely alone, and since the death of his secretary he seldom had an educated man to speak to. Once the Danish Government sent a man-of-war to Rio to fetch the doctor home, and he rode as far as Morro Velho, then

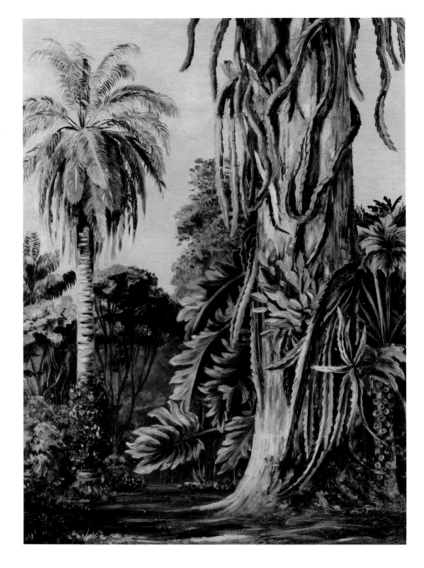

lost courage, and returned to his dear lake. In former days he used to pass the heat of the day in a room he had built and fitted up as a laboratory over his boat-house on the lake; but now his habits were those of an invalid, and he seldom went outside his garden, and never left his room till after midday, when he liked to sit in his arbour and talk, which he did well in many languages. His English was astonishing, considering he had only learned it from books. He had a good library, and several times in the course of conversation he hobbled off into

the house to seek some book, and to show us the authority for what he was saying. He seemed full of information on general subjects and on what was going on in Europe, as he read many foreign journals. His garden was full of rare plants and curiosities, collected and planted by himself. The trunk of one large date-palm was covered with a mass of lilac Laelia flowers, and a beautiful night-blooming cactus hung in great festoons from another tree, or climbed against a wall like a giant centipede, throwing out its feet or roots on each side to cling on by – it seemed to change its whole character by force of circumstances. I had made a painting during the morning of a rare blue pontederia which the doctor had persuaded with considerable difficulty to grow on his lake, and he was much delighted with it, and declared I was "one very great wonder" to have done it. The *Philodendron Lundii* was another of his most curious plants, a sort of great cut-leaved and climbing tree-arum, whose leaves are almost as good as a sundial, showing by their temperature the time of day.

Thirty years before our visit Dr. Lund had discovered the stalactite caves of Corvelho, and, as we were now on our way to them, was much interested in giving us directions how to find parts of them unknown to any but himself. Few persons had been far in since he first found them. He told us of the large apes, lizards, snakes, and other antediluvian beasts whose bones he had found there, as well as those of men with retreating foreheads, whose teeth showed they lived on unground corn and nuts.

14.
THE CARAÇA SANCTUARY

The college of Caraça reminded me somewhat of the Great St. Bernard, minus the snow. We found the Superior Padre Julio expecting us, and after dismounting in the court he walked down to a lower building and introduced me to a stout old lady with a black silk handkerchief tied over her head, whom I afterwards found to be the Chief of the washerwomen; he left me to her care, taking his other guests to be entertained in the convent itself. The smallest little room I ever saw had been prepared, but after seeing me the old lady seemed to think it would be too tight a fit, and she moved the bed into her own

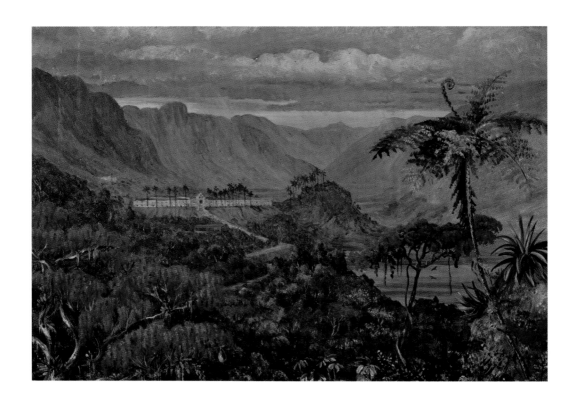

[above] *View of the Jesuit College of Caracas, Minas Geraes.* The Superior, Padre Julio, assisted North with botanical books and personally reviewed her Brazil artworks, identifying many plants.

comfortable apartment, where I spent a pleasant evening with a heap of valuable botanical books sent down from the library by the good Padre, who also took care to feed me well. He was a most fascinating character, full of general information and knowledge of the world; moreover, a thorough gentleman. The next morning he was down before seven o'clock looking at my drawings, and giving me the names of many of the strange plants I had been hunting for so long. He took me to see the library and garden, and told me I was the first woman who had entered there for seventeen years. There are about two hundred and fifty students in this college, and nine padres, besides my friend; but what a difference there was in those men! I was told there was one other who would have interested me, as he was a naturalist, but he was away. Padre Julio told me he wanted to start a museum and classes for natural history, but the Brazilians did not see the good of it, and did not care to inquire into such things. This same absent priest was a good carpenter, and they showed me a beautifully finished flageolet he had

made out of the heart of the Araucaria pine, using up his old spurs for the silver parts. The boys at this college paid only £30 a year, and were taught French, English, and Latin, as well as mathematics and Portuguese.

The neighbourhood abounded in rare orchids and other plants, but the rain never ceased to pour, and at this time of year it generally did pour on these mountains; so there was little use in staying, and I resisted all the kind wishes of the Superior that I should stop on at the washerwoman's, and said good-bye to him and to Mr. Gordon, who had loaded me with such continual kindness and hospitality for the last eight months. He now returned to Cocaes, while I rode after the Baron in the opposite direction.

15.
THE EMPEROR AND THE NATURALIST

Meanwhile I made two visits to Rio, the chief object of which was to see the Emperor, to whom I had a letter from my father's old friend Sir Edward Sabine. The Emperor is a man who would be worth some trouble to know, even if he were the poorest of private gentlemen; he is eminently a gentleman, and full of information and general knowledge on all subjects. He lives more the life of a student than that to which ordinary princes condemn themselves. He gives no public entertainment, but on certain days he and the Empress will receive the poorest of their subjects who like to take their complaints to them. He kindly gave me a special appointment in the morning, and spent more than an hour examining my paintings and talking them over, telling me the names and qualities of different plants which I did not know myself. He then took the whole mass (no small weight) in his arms, and carried them in to show the Empress, telling me to follow. She was also very kind, with a sweet, gentle manner, and both had learned since their journey to Europe (of which they never tired of talking) to shake hands in the English manner. They had both prematurely white hair, brought on by the trouble of losing their daughter and the miserable war in Paraguay. On my second visit to the palace the Emperor was good enough to show me his museum, in which there is a magnificent collection of minerals. He took especial delight in showing me the specimens of coal from the

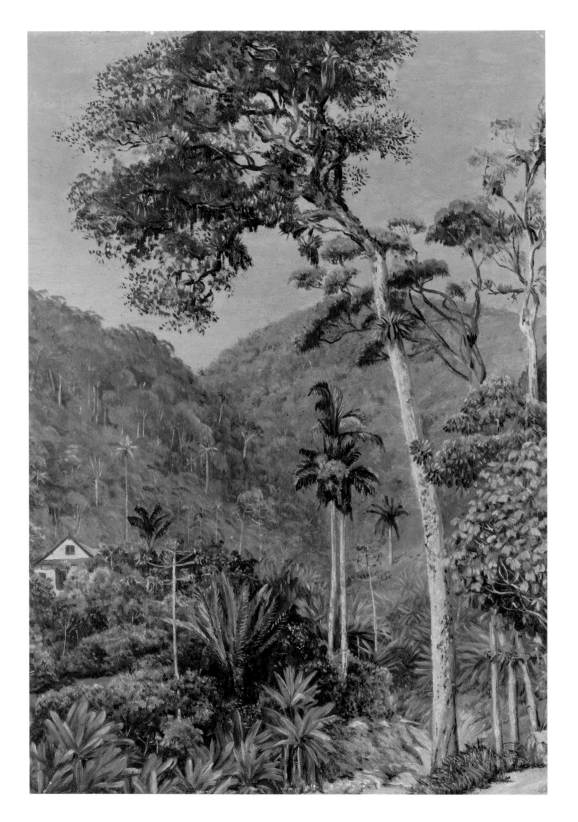

MARIANNE NORTH'S TRAVEL WRITING

[opposite] *Glimpse of Mr. Weilhorn's House at Petropolis.* Mr Weilhorn had been a friend of the famous naturalist and explorer Alexander von Humboldt (1769–1859). North visited the elderly naturalist at his home in Petropolis and featured his house in two gallery collection paintings.

province of Rio Grande do Sul, which promise to be a source of great riches to the country if his schemes of facilitating the transportation can be carried out. At present, though the coal itself is close to the surface of the ground, there are so many transhipments necessary in bringing it to Rio that it is cheaper to bring it from England or the States. I have not the slightest knowledge of mineralogy, but I blacked the ends of my fingers with a wise air, and agreed heartily with the Emperor's opinion, that if the precious stuff could be brought into consumption cheaply, it would be of more use to Brazil than all the diamonds of Diamantina. Then he showed me many of the most precious books in his library, some views of the San Francisco river, etc.

The palace is not in a good situation; but the Emperor passes a great part of the year at Petropolis, around which there are endless beauties. One spot there especially attracted me, where an old companion of Humboldt's had settled himself in an unpretending cottage. He had planted all sorts of rare plants and palms around it, and the real virgin forest sloped down to it at the back, while a glorious view of blue mountains was seen from the front windows, with some few great forest giants left as foreground, their branches loaded with parasites and festooned with creeping plants. This little house was the highest inhabited house of the neighbourhood, the path up to it sufficiently steep to keep off ordinary morning visitors, though I am told it is a favourite walk of the Emperor's, who found the old German naturalist a pleasanter companion than many in the world below. When I was there this old man was dying, and his pretty place would soon be a ruin. Already his treasures of moths, books, birds, and butterflies were half destroyed by mould and devouring ants; even the bridge which crossed the cascade and the path up to his house were falling away. I never felt anything more sad.

16.
JOSE LUIS CORREA AND THE SERRA DOS ÓRGÃOS

Petropolis seemed full of idle people and gossip, and it was thought rather shocking and dangerous for me to wander over the hills alone; wild stories were told of runaway slaves, etc. I felt out of place there, and got more and more home-sick, but determined to have at least a glimpse of the Organ Mountains

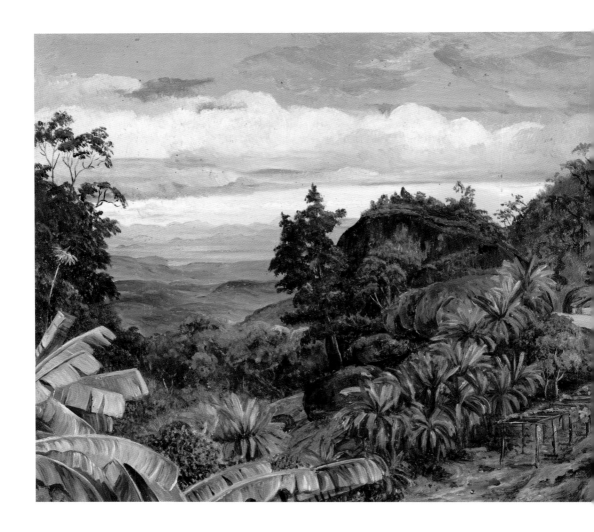

[above] *View from the Sierra of Theresopolis.* North described her trip to the Serra dos Órgãos mountains in rapturous terms: 'Did I not paint? – and wander and wonder at everything? Every rock bore a botanical collection fit to furnish any hothouse in England.'

before I went. I was told the way was most difficult, and even dangerous; neither mules nor guide could be got. Still I persevered, and finally heard of a mason at Petropolis who knew the way and would like a change of air and a holiday, but he could only spare four days. [...] The only danger on our path was from the hanging wreaths of bamboo, and the acacia called "cat's paw," which had been long untrimmed, and might easily do serious damage to the faces of unwary travellers. My guide used his long knife, and I met with no accident, and soon reached the top of the pass, having left all rain and humidity at Petropolis. It was a curious view, and well worth some trouble to see; but the "difficulties and dangers" we in vain searched for.

We arrived at Theresopolis by two o'clock, went on for another two leagues, and put up at a quaint and lonely house on the sierra. The boulders there had fallen all round it; they propped it up, and seemed to rest on its roof, and the stables were built under one huge hanging boulder. Great trees and all sorts of rich vegetation grew over and round these big blocks of granite. Beyond all were the most splendid distant views of Rio Bay and its mountains, and over our heads strange obelisks of granite. It was a spot for an artist to spend a life in. [...]

At last we reached the sea, stopping every now and then to chat at different roadside cottages, where my guide bought different refreshments for himself, as he was always hungry when travelling, he said. Sometimes he bought a paper of boiled prawns very large and pink, then oranges or sweet lemons, or a beautiful sort of cornucopia of dazzling white made of the thinnest paste of mandioca flour rolled out and baked; it was a fit food for gods. [...]

A few more hours of swamp and a most roundabout road brought us to the foot of the Petropolis sierra, up which I rode, though in time for the train of passengers from Rio. It was such a glorious evening; and while the poor animals were resting after their thirty long dusty scorching miles of road, I sat near some running water in the shade of a grand tree and enjoyed a rest also, where the mason brought me a tray of good coffee and bread, without any orders; and for this one kind thought alone deserves to have his name recorded – "Jose Luis Correa." He was as good a guide as could be wished for on such a journey, and had more than a common knowledge of plants and other things of the country, and I regretted much that I did not better understand his language to benefit by his information.

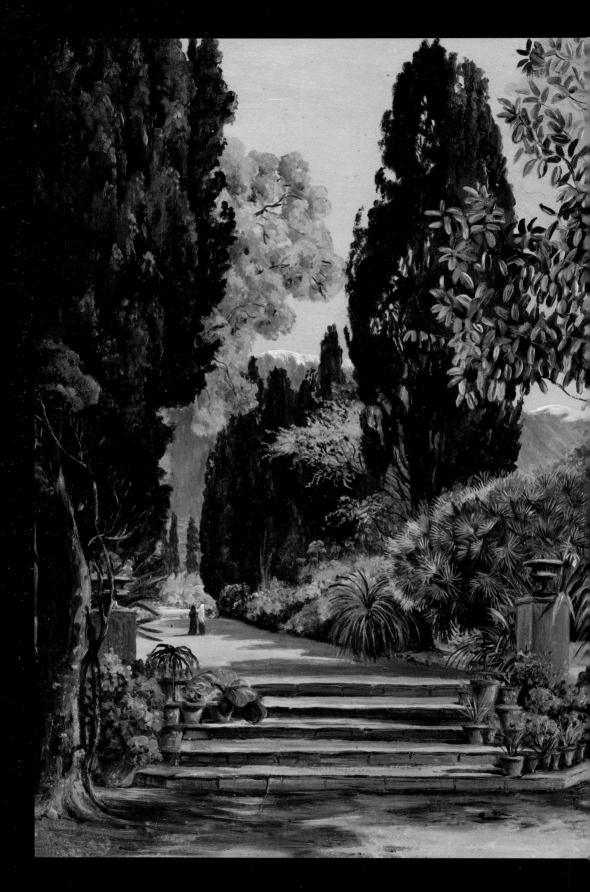

Chapter 5

Wintering in Tenerife

JANUARY–APRIL 1875

Marianne North escaped the particularly bitter winter of 1874–75 by sailing from Liverpool to Tenerife, departing on New Year's Day in the company of her longstanding friend Mary Anne Ewart ('M.E') who stayed with North for a fortnight. Ewart was the eldest daughter of the radical-leaning Liberal MP William Ewart. Like North, she had been bereaved by her father's death in 1869, and they had spent time together in Italy during North's grief-stricken travels in Italy from late 1869–70. During the early 1870s, she became a patron for women's higher education, donating £1,000 to the building fund for Newnham College in Cambridge, and in her will she bequeathed Newnham £30,000 to establish a scholarship fund.

North had evidently read and admired Alexander von Humboldt's descriptions of Tenerife but she found the island's vegetation had altered strikingly during the intervening 76 years. Journeying from Santa Cruz to La Orotava on her day of arrival, she observed that 'the palms and other trees had been cleared away to make room for the ugly terraces of cacti, grown for the cochineal insect to feed on, and which did not like the shade of other trees' (Ex. 17). The cochineal cactus and insect had been introduced to Tenerife in 1835. When vine disease devastated the island's wine industry some years later, its vineyards were turned into cochineal plantations. The cacti were

cultivated to feed the cochineal insects, from which a brilliant red dye was extracted. As her report of seeing the cacti uprooted from terraces and replaced with tobacco crops suggests, by the mid-1870s the cochineal dye industry had declined, due to the development of synthetic aniline dyes produced from coal tar, a by-product of the gas lighting industry ('gas-colours').

North and Ewart stayed at a hotel in La Orotava, painting at times in the Jardin de Aclimatación de la Orotava. A letter from Joseph Hooker at Kew introduced her to the Swiss botanist and gardener Hermann Wildpret, the garden's manager from 1860 to 1894. At least two of the Tenerife paintings in the gallery collection are views from this botanic garden. Wildpret may have organised the three-day excursion from La Orotava to an area now called Rambla de Castro (in Los Realejos) that North took after Ewart's departure (Ex. 18). She travelled there by riding a donkey over steep cliffs ('Barenca da Castro' [Barranco de Castro]), and she stayed in the sixteenth-century manor house known today as La Casona de Castro. The manor was founded by Don Hernando de Castro following the division of lands carried out by the Spanish military leader Alonso Fernández de Lugo, after the 1490s Spanish Conquest of Tenerife.

After leaving La Orotava, North stayed at Sitio Litre, an eighteenth-century mansion and gardens in Puerto de la Cruz, until she left Tenerife (Ex. 19). This property and fine garden had been purchased by Charles Smith ('Mr S.') from the Little family in 1856. Both owners hosted many travellers, including Humboldt in 1799 and the astronomer Charles Piazzi Smyth in 1856. The Smiths nurtured the garden over generations, retaining ownership until the 1990s. North's three months in Tenerife are represented by 29 paintings in the gallery; by comparison her written account is slight, forming just six of *Recollections*' pages.

17.
COCHINEAL GARDENS, SANTA CRUZ TO LA OROTAVA

[page 78] *A View of the Botanic Garden, Teneriffe.* Tenerife's botanic garden was established in the late-18th century as an acclimatisation garden to aid the transfer of plants from Spanish colonies in the Americas to Spain. During his tenure as the garden's head gardener and manager, Hermann Wildpret widened the variety of plantings significantly.

[previous page] *Teneriffe.* North's three months in Tenerife are depicted in 29 paintings in the gallery collection, and at least two paintings held in Kew's art collection.

On the morning of the 13th we landed at Santa Cruz. We drove on the same day to Villa de Orotava, creeping slowly up the long zigzags leading to Laguna, where every one (who is anybody) goes to spend the hot summer months; in the New Year's time it was quite deserted, and looked as if every other house was a defunct convent. All had a most magnificent yellow stone-crop on their roofs, just then in full beauty; ferns too were on all the walls, with euphorbias and other prickly things. After passing Laguna, we came on a richer country, and soon to the famous view of the Peak, described so exquisitely by Humboldt; but, alas, the palms and other trees had been cleared away to make room for the ugly terraces of cacti, grown for the cochineal insect to feed on, and which did not like the shade of other trees. Some of the terraces were apparently yielding crops of white paper bun-bags. On investigating I found they were white rags, which had been first spread over the trays of cochineal eggs, when the newly-hatched insect had crawled out and adhered to them; they are pinned over the cactus leaves by means of the spines of another sort of cactus grown for the purpose. After a few days of sunshine the little insect gets hungry and fixes itself on the fleshy leaf; then the rags are pulled off, washed, and put over another set of trays. The real cochineal cactus has had its spines so constantly pulled off by angry natives who object to having their clothes torn, that it sees no use in growing them any longer, and has hardly any. When I was in Teneriffe people were beginning to say that the gas-colours had taken all their trade away, and had begun to root the cactus up and plant tobacco instead but they could not re-grow the fine trees. These cactus crops had done another injury to the island besides that of causing it to lose its native trees. The lazy cultivators when replanting it, left the old plants to rot on the walls instead of burning them, thereby causing fever to rage in places where fever had never been before; they were now planting eucalyptus-trees with a notion of driving it out.

The roads were very bare, and the much-talked-of Peak with its snow cap was spoiled for beauty by the ugly straight line of the Hog's Back on this southern side. Nevertheless the long slant down to the deep blue sea was exceedingly beautiful, and a

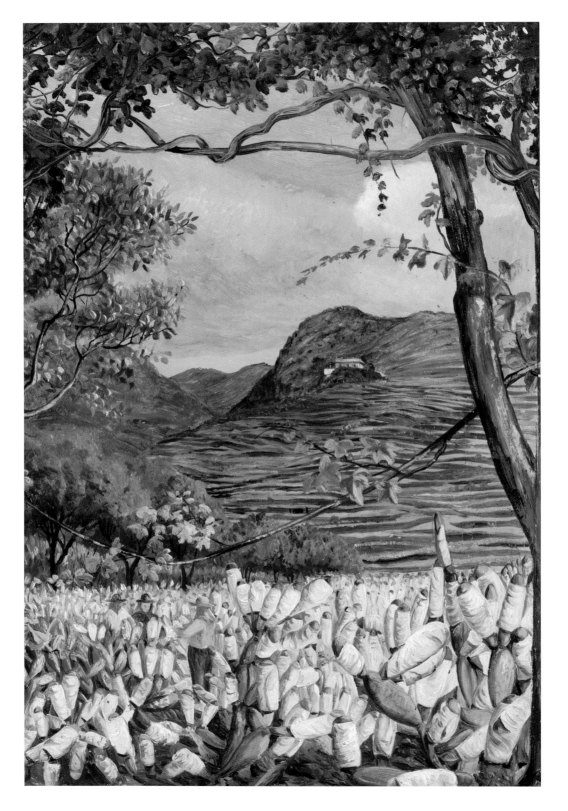

MARIANNE NORTH'S TRAVEL WRITING

certain number of date-palms and dragon-trees, as well as the euphorbia and other fleshy plants, gave a peculiar character to the scene I have not seen elsewhere.

18.

RAMBLA DE CASTRO, LOS REALEJOS

After M. E. left, the landlady gave me a smaller room opening into the big room with a good view of the street, where I could live in peace and quiet, without fear of interruption, and they fed me there very kindly too. Any one who likes bread and chocolate can live well all over Spain; I did not care if I got nothing else. My friend the gardener arranged with the farmer at the Barenca da Castro to take me in for three days; so I took some bread and a pillow, mounted my donkey, and rode thither through lovely lanes, mounting over the high cliffs till I came to my destination – an old manor-house on the edge of one of those curious lava cracks which run down to the edge of the sea, filled with large oaks, sweet bay-trees, and heath-trees thirty feet high. Half-way down was a stratum of limestone, from which a most delicious spring burst out. People came from all the dry hills round to fetch the water, and to wash and water their cattle. The ground was covered with sweet violets. There were green beds of water-cresses all about the sweet clear pools on the little theatre of green at the mouth of the cave, and then some pretty falls to the lava rocks on the beach some thousand feet below. People and animals were always coming and going, and were very picturesque. The men wore high top-boots, blankets gathered in round their necks, and huge Rubens hats. The women had bright-coloured shawls draped gracefully over their heads and shoulders, with red and black petticoats; sometimes hats on the top of their shawl-covered heads. They were all most friendly.

[opposite] **View in the Cochineal Gardens at Santa Cruz.** North was dismayed that native trees had been cleared to make way for terraces dedicated to growing cacti for cochineal production.

[overleaf] **Barranca de Castro.** North depicted the landscape of Rambla de Castro, including the La Casona de Castro manor house, in two gallery paintings. This landscape, rich in both biodiversity and history, is now a legally protected Natural Space of the Canary Islands.

My quarters at the old house above were very primitive. A great barn-like room was given up to me, with heaps of potatoes and corn swept up into the corners of it. I had a stretcher-bed at one end, on which I got a very large allowance of good sleep. The cocks and hens roosted on the beams overhead and I heard my donkey and other beasts munching their food and snoring below. From the unglazed window I had a magnificent view of the Peak, which I could paint at my leisure at sunrise without

MARIANNE NORTH'S TRAVEL WRITING

disturbing any one. The family much enjoyed seeing me cook my supper and breakfast in my little etna morning and evening – coffee, eggs, and soup; soup, eggs, and coffee, alternately. I returned by a lower road, close to the edge of the sea, under cliffs covered with sedums, cinerarias, and other plants peculiar to the Canary Islands.

19.
AT CHARLES
SMITH'S,
PUERTO DI
OROTAVA

After this little excursion I remained quietly working in or about Orotava till the 17th of February, when I moved down to Mr. S.'s comfortable home at Puerto di Orotava. Mr. S. when I stayed with him had a second wife, a most lovable Scotchwoman. He was seventy years old, and talked quite calmly of taking me up

[right] *Scene in Mr Smith's Garden.* North painted many of her Tenerife studies during her two months at Sitio Litre. Although it remains a private residence, the current owners have opened the gardens to public visitors.

[above] *A note from North to her former servant Elizabeth Morley ('Annie'), sent from La Orotava.* After Frederick North's death, Marianne broke up the Hastings household and let out the property, retaining only her maid Elizabeth Morley, who travelled with her to Italy but not on subsequent travels. This short, affectionate note from North, enclosing money in lieu of a wedding gift, is the earliest of her correspondence in Kew's collections.

the Peak, not minding fifteen hours on horseback; but the weather fortunately remained too cool for such an attempt. I believe he knew every stone on the way, and had shown it to Piazzi Smyth and all the travellers one after the other. The latter gave me a letter to him.

I had a room on the roof with a separate staircase down to the lovely garden, and learned to know every plant in that exquisite collection. There were myrtle-trees ten or twelve feet high, bougainvilleas running up cypress-trees (Mrs. S. used to complain of their untidiness), great white lancifolium lilies (or something like them), growing high as myself. The ground was white with fallen orange and lemon petals; and the huge white cherokee roses covered a great arbour and tool-house with their magnificent flowers. I never smelt roses so sweet as those in that garden. Over all peeped the snowy point of the Peak, at sunrise and sunset most gorgeous, but even more dazzling in the moonlight. From the garden I could stroll up some wild hills of lava, where Mr. S. had allowed the natural vegetation of the island to have all its own way. Magnificent aloes, cactus, euphorbias, arums, cinerarias, sedums, heaths, and other peculiar plants were to be seen in their fullest beauty. Eucalyptus-trees had been planted on the top, and were doing well, with their bark hanging in rags and tatters about them. I scarcely ever went out without finding some new wonder to paint, lived a life of the most perfect peace and happiness, and got strength every day with my kind friends.

Twenty Months Wandering Amongst Strangers

Chapter 6

Tours and Troubles in Japan

NOVEMBER 1875–JANUARY 1876

North records awaking on the last day of her voyage to Japan
and seeing the sun rise over Mount Fuji, 'as I have seen it so well
represented on so many hand-screens and tea-trays'. The rage for
Japanese and Japanese-inspired goods that North refers to had been
gathering momentum in Europe for well over a decade – and North
was not immune, cautioning readers of *Recollections* that 'Kioto was
a terrible place for emptying purses', and rhapsodising to Margaret
Shaen over the beautiful ceramics and embroideries, asking 'how
can I resist them?' Japan was still relatively novel to European
travellers, and North's sense of unfamiliarity and cultural dislocation
is evident. She wrote to Shaen that Japan was, 'a most bewitching
land', and to Joseph Hooker admitted finding herself 'enchanted with
its oddities'. Instead of referring to the writings of other naturalists
in her travel narratives, in Japan North turns to the Lilliputians and
Brobdingnagians from Swift's novel *Gulliver's Travels*.

Japan was undergoing a period of reinvention at the time of
North's visit, following the restoration of imperial rule under
Emperor Meiji in 1868. Meiji reformers instituted radical changes,
including the dissolution of the samurai aristocracy, the development
of constitutional politics and rapid industrialisation. North alludes
to these societal changes, observing 'the upper classes seem to have

melted away in Japan since the new state of things there'. But her ridicule of Japanese adoption of European clothing (prescribed by the emperor for himself and his court) displays little cultural understanding, and many of her comments on the Japanese people are disparaging.

Soon after arriving in Yokohama, North took a train to Yedo (Tokyo) with Mr Cargill, director of the railroads, and his daughter ('Miss C.', Ex. 20). Upon her arrival in Yedo she visited the graves of Japan's former rulers, the Tokugawa Shōgun family (misnamed as 'tombs of the Hogans') with Miss Cargill, and experienced travelling in a jinrikisha for the first time (p. 98). At the British Legation she met Consul General Sir Harry Parkes and his wife Lady Fanny Parkes ('the master and mistress of the house'), whom North had hoped to join on their upcoming tour of lighthouses. This would have given her an opportunity to paint parts of Japan not commonly seen by westerners – but, not for the last time, poor health disrupted her plans.

Owing to her acquaintance with Mrs Cargill, once recovered from her illness North was able to hire a Japanese man named Tungake as an attendant and translator. 'I am told I have a treasure in Tungake as he speaks a little English and likes going about with travellers,' she wrote to Shaen, adding in *Recollections* that 'he was very useless, and anxious to make little percentages out of every bargain; but the language was so impossible to make anything of in a short time, that I could not have done without some such attendant' – a telling comment which simultaneously belittles Tungake while tacitly acknowledging her reliance upon his

[opening spread] *From a Gate in Kyoto.* Eleven paintings in the gallery collection and three in Kew's art collection depict scenes from Japan; of these fourteen, ten were painted in or around Kyoto.

[page 92] *Study of Japanese Chrysanthemums and Dwarfed Pine.* North was fascinated by the Japanese art of bonsai, and while the chrysanthemums take the foreground of this painting, her caption for the gallery catalogue is devoted solely to the bonsai pine. In a letter she wrote to Joseph Hooker from Japan (p. 103) she asked whether he has bonsai trees at Kew, suggesting that they 'would look well in your cool houses amongst the gaudy flowers. If you cared to have some sent Mrs Lowder's husband would know how to get them and send them to you as well as anybody, if you asked her to write for them.'

linguistic skills and labour. They travelled together by steamer to Kobe, where they met the Parkes and travelled on to Kyoto.

While still officially closed to Europeans, Kyoto was gradually opening, for instance by hosting annual exhibitions that permitted foreigners from 1872 onwards. The emperor ('the Mikado') granted North a stay of three months' duration (Ex. 21), but she was driven away after a month by a flare of rheumatism. During her time in Kyoto she painted Lake Biwa, the view of the city from the window of her accommodation, and the Maruyama, Chion-in and Nishi Hongan-ji Buddhist temples (Ex. 22). Chion-in and Nishi Hongan-ji are head temples for Jodo Shinshu Buddhism; the Nishi Hongan-ji temple is now a UNESCO World Heritage Site. The temples at Maruyama are no longer extant and the area has been turned into an expansive park famed for its cherry blossom.

FROM YOKOHAMA TO THE ENGLISH LEGATION, YEDO (TOKYO)

As Sir Harry and Lady Parkes were said to be soon going away on an expedition round the coast, I started to pay my respects to them at eight in the morning. The railway went alongside of the famous Tokado road much of the way to Yedo, and was always full of interest. The rice and millet harvest was then going on, and the tiny sheaves were a sight to see. They piled them up against the trees and fences in the most neat and clever way, some of the small fan-leaved palm-trees looking as if they had straw petticoats on. There was much variety in the foliage; many of the trees were turning the richest colours, deep purple

maples and lemon-coloured maiden-hair trees (*Salisburia*), with trunks a yard in diameter.

[...] At the last station one of the Japanese ministers got into our carriage in the costume of a perfect English gentleman, chimney-pot hat included. He invited me to come and see his wife at his country-house, and at Yedo packed Miss C. and myself into two jinrickshas, a kind of grown-up perambulator, the outside painted all over with marvellous histories and dragons (like scenes out of the Revelation). They had men to drag them with all sorts of devices stamped on their backs, and long hanging sleeves. They went at a trot, far faster than

North wrote to her friend Margaret Shaen while onboard a steamer from Yokohama to Kobe with Tungake, who she employed as a translator and assistant. Her letter describes her first weeks in Japan and includes swift pen sketches depicting the serving of tea, a jinrikisha, cliffs and the coast, and a flower seller. The jinrikisha was a recently developed form of human-driven transport much used in Japan. The party in which North and Tungake travelled from Kobe to Kyoto (around 40 miles) comprised a fleet of fifteen jinrikishas, each driven by two men.

holding tea tray on the palm of their hand like waiters — can you understand the coock illustrated? then the way of going about the country in jinrickshas (cabs) is most amusing — they are just big perambulators much begilded & painted & drawn by men, at a trot as quick as ponies, who never stop to take breath & delight in going quicker than their neighbours — you may go all across the island night & day in these things with two men — to take turns at dragging in the shafts — the look of the thing from behind is very funny a big british head & shoulders & little legs below for you do not see the Japanese head which is bent forward & the legs do not go exactly under the other body —

I foresee when rain before the fascinating pots & pans — one might easily commit bankruptcy on tea pots alone — their forms & colours & materials are of such endless variety — & so exquisite & then the bronzes! & Laka's & embroideries! how can I resist them! — I bought yesterday two little bamboo cages for keeping pet grasshoppers in! made like two little baskets with wheels & pulleys to hang in a window — so useful! — but I could not resist it for a few shillings — the very idea of keeping grasshoppers at all, is worth the money — it is a most beautiful land

English cabs, and answered to the hansoms of London, but were cheaper. So we trotted off to the tombs of the Hogans [*sic*], most picturesque temples, highly coloured and gilded, half buried in noble trees, under a long low ridge or cliff. We left our cabs, and wandered about amongst them attended by a priest, a wretched mortal who would have sold even Buddha himself for a few cents if he dared run the risk of being found out. We then mounted the ridge above, and went to a famous tea-garden on the site of an old temple, with grand views over the city and sea, where we had tiny cups (without handles) full of yellow sugarless tea, ate all sorts of delicate cakes made out of rice and bean flour, finishing up with cherry-flower tea, which is made by pouring boiling water on dried blossoms and buds of the cherry-tree. The smell was delicious, the taste only fit for fairies, and very hard for big mortal tongues to discover. The tiny girls who served us were very pretty, and merry over our gigantic and clumsy ways. I felt quite Brobdingnagian in Japan.

[...] The English Legation was very new and very ugly, with many rare and beautiful Japanese and Chinese things in it, but the master and mistress of the house so genuine in their kindness and hospitalities, that one forgot the ugly shell. They kindly offered to take me with them in the Government steamers to inspect lighthouses all round the coast, thus giving me opportunities of seeing parts of the islands never visited by Europeans, taking a month or more to do it in. It was a great chance, but alas! that same night, on my return, I had a terrible attack of pain, so fearful that I sent for an American doctor, who injected morphia into my arm, and put me to sleep for twenty-four hours. The people in the hotel thought I was dead, and when I woke I was too weak to think of starting on any expedition for some time.

21.

A TEMPLE HOTEL FOR EUROPEANS, KYOTO

The next day Sir Harry and Lady Parkes and their suite departed, leaving me in sole possession, with a special order from the Mikado to sketch for three months as much as I liked in Kioto, provided I did not scribble on the public monuments or try to convert the people; for it was still a closed place to Europeans.

Sir Harry himself had been nearly murdered on his last visit there, and Sir Rutherford Alcock was never even allowed to enter. But I was perfectly safe all alone, and comfortable too, in the old temple building some centuries old, which had been turned into an hotel for Europeans, with the addition of a few chairs and tables. It was kept by a Japanese named Julei, who was always dressing himself up in native or European costumes, the latter being of a monstrous plaid pattern, with a prodigious watch-chain and breast-pin. He spoke a little English and kept a French cook. My room was made of paper, with sliding-panels all round, two sides opening to the frosty air and balcony, the other two only going up about seven feet, leaving abundant ventilation between them and the one great roof of the whole house, with the advantage of hearing all my neighbours' conversation beyond. I had a pan of lighted charcoal on a chair to warm me, and two quilted cotton counterpanes on the bare floor to sleep between. When I complained of cold, they brought me in gorgeous folding screens, and made quite a labyrinth around me, all painted with storks, cherry-blossom, bamboo, and all sorts of lovely things, to keep the draughts out. The worst of my quarters was that I could not see through the paper windows to paint without opening them and letting in

[below] *Lake Biwa.* When she reached Kyoto, North toured Lake Biwa together with Sir Harry and Lady Parkes and others. After the Parkes left, North dined and socialised with the five other Europeans in the city, who, she tells us, included a Russian doctor, a German engineer and an English teacher.

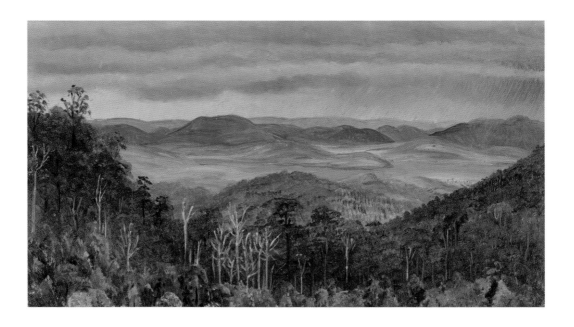

MARIANNE NORTH'S TRAVEL WRITING

the half-frozen air or damp rain; but I much preferred my quiet life in Kioto among the purely Japanese people and picturesque buildings, to that in one of the European settlements.

One of the screens in my room was especially beautiful. It had a gold ground with red and white pinks, and pink and white acacia painted in the most lovely curves on it, as well as two kingfishers and a stork. There was also most fascinating crockery. One large creamy and crackled vase of modern Satsuma had beetles, grasshoppers, mantis, and moths carrying flowers, drawing a coach, holding mushrooms as umbrellas, etc., as well as lovely borderings of flowers and leaves. In that vase were chrysanthemums of different colours, tied on an invisible bamboo stick, so that the bouquet was a yard and a half high. From my windows, when I pushed back the paper sliding shutter, I saw a most exquisite view (for the house was perched up high on the side of the hill, with the most lovely groves and temples all over it), and below the great city of over 200,000 inhabitants. Nearly all the houses were one-storeyed, and great high temple-roofs rose among them like Gulliver amongst the Liliputians [sic]. Beyond the city were beautiful purple hills with tops sprinkled with fresh snow.

22.

THE NISHI HONGAN-JI AND CHION-IN TEMPLES, KYOTO

The great temples of Nishihongwangi belonged to a set of reformed Buddhists. One of them, who called himself the "Canon of the Cathedral," had been two years in England, and spoke our language remarkably well. He was really a most charming person, and gave me much interesting talk about his religion while I sketched. He called it the Protestantism of Japan, and it seemed as pure and simple as a religion could be. He said he believed in an invisible and powerful God, the Giver of good, but in nothing else – not even the sun or the moon, they were both made by that same God. His priests (including himself) married, and drank wine. He had been to hear all sects preach in England, and thought the Unitarian most like his own. There were no sort of idols in his temple. He introduced me to many old priests in gorgeous robes, who did not look as full of brains as he did. He had a table brought out beside me with tea and cake, and a pan of charcoal to warm my hands over, and

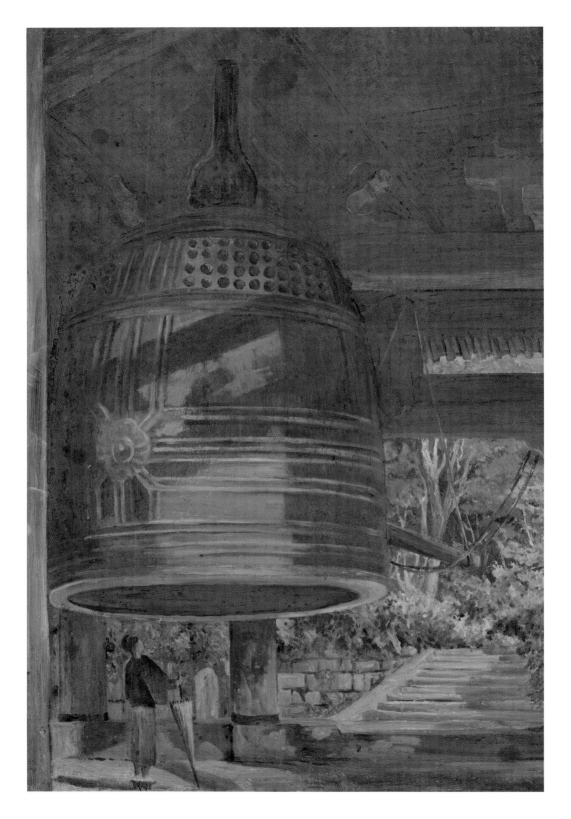

[opposite] *Great Bell of the Cheone Temple, Kyoto.* North included one study of the Chion-In bell and a separate painting of the temple's interior in the gallery collection. This painting is in Kew's art collection.

took the greatest interest in my work. He gave me two of the usual conventional drawings of a woman and a piece of bamboo, done by his little daughter. The mile of street which led me home was one succession of fascinating shops. I never passed through any of those streets without picking up some beautiful little "curios." The hill behind the hotel was covered with temples, tombs, and bells, some of them very large. The great bell of the Cheone was eighteen feet in height, and made a fine subject, surrounded as it was by trees dressed in their autumn colours. Whenever any one felt devout, he used to go and strike one of those bells, by means of a kind of weighted battering-ram fastened to the scaffold which supported the bell (for they are generally hung in buildings by themselves). Through all the dark hours of the night these devout fits seemed to seize people, and did not improve the sleep of others on that hill of temples.

[right] *While travelling from Japan to Singapore, North wrote to Joseph Hooker*, explaining that she 'was enchanted with the oddities of the strange islands and hoped to have been able to stay for the beautiful spring and summer there, but a month in Kyoto gave me rheumatism enough for life. My hands are only just able to hold a pen, and my feet are still useless – so I am fleeing to Singapore and hope there to regain the use of my limbs and be able to carry out my original plan of going to stay in Java.' Her letter and two rare lily roots were taken to Kew by Lady Alcock's daughter-in-law, Mrs Lowder, who like North was 'fleeing the cold' in Japan.

Chapter 7

Singapore Stopovers

JANUARY–FEBRUARY 1876 (RETURN VISITS IN MAY 1880 AND JULY 1880)

Marianne North first visited Singapore in early 1876, arriving from Japan on 19 January after a period of convalescence in Yokohama, and staying for one month. At the time, Singapore was the administrative centre of the Straits Settlements, a Crown Colony formed in 1867 and comprising Singapore, Penang and Malacca. In Singapore, British rule had effectively begun in 1819 with Stamford Raffles's treaty with Tengku Hussein and Temenggong Abdul Rahman, and was formalised in 1824; it ended in 1959 when Singapore gained self-governance. Singapore quickly became the region's definitive economic centre for import and export trade, particularly after the opening of the Suez Canal in 1869, with an expanding, often transient, cosmopolitan population of Chinese, Malays, Indians, Arabs and Europeans.

In Singapore, North met and stayed with the island's trading and administrative elites: prominent members of the community with seats on the legislative council. Her first hostess, Elizabeth Alcock Scott ('Mrs. S'), was the eldest daughter of (John) Frederick Adolphus McNair ('Major MacN.'), a colonial engineer and former controller of convicts in Singapore, who by the mid-1870s was Singapore's surveyor-general. Elizabeth's husband, Thomas Scott, was then senior partner and later head of Guthrie & Co, the most successful British (Scottish) trading company in Singapore, with expanding interests

in banking, insurance and, in decades to come, coffee and rubber plantations. North particularly delighted in the mature fruit trees in the Scotts' garden and the family's many pets – but her otherwise amusing observations on them include a racist comparison between the Scotts' Malay butler and a pet orangutan (Ex. 23). The Scotts introduced North to Dr Robert Little, an Edinburgh surgeon resident in Singapore since 1840, leading to further paintings from his garden and coconut plantation in Serangoon. North also wrote of her visit to the famous private garden of Hoo Ah Kay ('Mr Wampoa'), a highly successful and respected Chinese businessman and the first Asian resident with a seat on the legislative council (Ex. 24). Hoo Ah Kay played a pivotal role in the creation of Singapore Botanic Gardens, today a UNESCO World Heritage Site, by liaising with the colonial authorities and granting the 22-hectare plot of land on which the gardens were established.

The published account of North's month in Singapore is just five pages in length. Her fortnight as the guest of Governor Sir William and Lady Elizabeth Jervois ('Jervoice') at Government House, for which Frederick McNair was the architect, receives just half a page, largely devoted to her painting the *Poinciana regia* growing in the front garden. William Jervois wrote North's letter of introduction to her next hosts, Charles and Margaret Brooke, the (English) Rajah and Ranee of Sarawak; and, aside from brief interchanges while travelling to Java and Ceylon later in 1876, it was with the Brookes that North returned to Singapore four years later, when travelling with them from Marseille to Sarawak for a second visit. By July she was back in Singapore for the final time, staying for one week before sailing on to Australia.

[page 104] *View of Singapore from Dr Little's Garden.* North painted this view of Singapore and a study of the namnam ('nyum-nyum') tree in Robert Little's garden and coconut plantation in Serangoon.

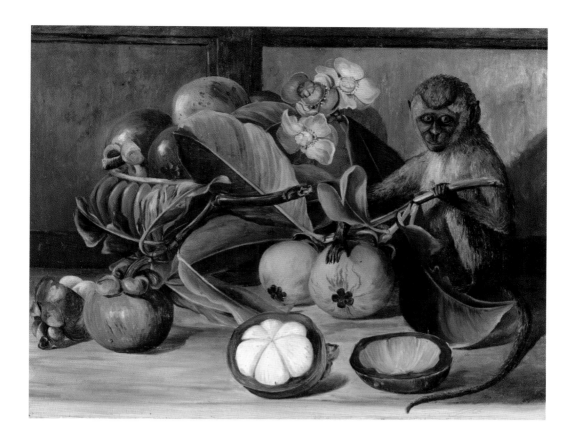

23.

THE SCOTTS' GARDEN AND ROBERT LITTLE'S COCONUT PLANTATION

[above] *Flowers and Fruit of the Mangosteen and Singapore Monkey.* One of North's studies of tropical fruits, painted during her stay with Thomas and Elizabeth Scott and featuring their pet monkey, Jacko.

Mrs. S., the banker's wife, and her father, Major MacN., came to see me. The former insisted on my moving at once to her comfortable house outside the town. Like all the houses of Singapore, it stood on its own little hill, none of these hills being more than two hundred feet above the sea; but they were just high enough to catch the sea-breezes at night, and one could sleep with perfect comfort, though only three degrees from the equator. This house had belonged to the House of Guthrie for two generations, and was surrounded by every sort of fruit-tree. Of these there were perhaps more in Singapore than in all the rest of the world. The lovely Mangosteen was just becoming ripe, and the great Durian, which I soon learnt to like, under the teaching of the pretty little English children, who called it "Darling Durian."

No garden could have been more delighted in than that one was by me. Every day I was sure to find some new fruit or

Abu Bakar, Maharaja (and later Sultan) of Johor, resided in Tyersall Park, Singapore. North painted the view towards his estate from the garden of Elizabeth Scott's father, Frederick McNair.

gorgeous flower to paint, Mrs. S. working beside me all the hot day through in her deliciously airy upper rooms. Then we drove out among the neighbouring gardens in the late afternoon and evening, and went to bed soon after dinner; for Mr. S. and the other gentlemen came home far too tired after their days in the hot bank in the town for playing at company or sitting up at night. They had a delightful little monkey called Jacko, who considered that all dogs were made to be teased; and it was strange to see how the big creatures submitted and humoured it. This monkey was a bad sitter, and seemed to have a malicious pleasure in throwing itself upside-down whenever I looked at it. Then if I scolded, it held out its paw to shake and be friends. There was also an ourang-outang who used to be led in by the hand by the Malay butler. They were exactly alike. Both had the most depressed expression, which the small one never varied. The big one grinned sometimes – when he looked even more like a monkey than he was before.

The Botanical Garden at Singapore was beautiful. Behind it was a jungle of real untouched forest, which added much to its charm. In the jungle I found real pitcher-plants (*Nepenthes*) winding themselves amongst the tropical bracken. It was the first time I had seen them growing wild, and I screamed with delight. One day we drove out to have luncheon with the Doctor and his family, who had a country house about five miles off, near the coast, in the midst of plantations of cocoa-nuts. The Doctor showed me all the process of crushing and clearing the oil – not a particularly agreeable one. But the pictures of people at work, the glorious trees, and certain plants under them, were very interesting. One wild plant I saw there for the first time, the *Wormia excelsa*, which abounds in the different islands of "Malaysia," and is often planted as a hedge. It has a glossy five-petalled flower of the brightest yellow, and as large as a single camellia, with large leaves like those of the chestnut, also glossy, and separate seed-carpels which, when the scarlet seeds are ripe, open wide and afford a most gorgeous contrast of colour with its waxy green and scarlet buds. I know few handsomer plants. All the tribe of Jamboa fruits (magnified myrtles), too, were magnificent in their colours. There were said to be three hundred varieties of them. Some of them had lovely

rose-coloured and pink young leaves and shoots. The nyum-nyum was another curious fruit coming out from the trunk and branches like the blimbing, with tiny red flowers and pink young leaves which looked like blossoms in the distance. That cocoa-nut plantation was a most enjoyable place. A narrow path led in five minutes through its shady groves to a quiet sandy bay, where one might bathe all day long without fear of interruption.

24.
HOO AH KAY ('MR. WAMPOA') AND 'A MOST ABSURD MISTAKE'

One day we went to have tea with Mr. Wampoa, the famous Chinaman, whose hospitality and cordiality to the English have been so well known for half a century in the Straits. He showed us all his curiosities; but his garden was to me the great attraction, rare orchids hanging to every tree, and the great *Victoria regia* in full bloom in his ponds, as well as the pink and white lotus, and blue and red nymphaeas. Many of his plants were cut into absurd imitations of human figures and animals, to me highly objectionable, but amusing to the children. He had also several live creatures and birds of great beauty. He showed us a tortoise from Siam with six legs. The hinder ones it only used when trying to get up a very steep bank or steps, propping itself up with them, while it struggled on with the four front ones. The Siamese cat was a remarkable little creature, coloured like a fox, and might possibly have been a mixture of the two animals originally. It had sky-blue eyes, and was very shy. Mrs. S. had one which followed her about and slept in her room.

The Maharajah of Johore, a near neighbour and great friend of her husband's, came to dine and play at billiards with him in a black velvet coat with diamond buttons, worn over the usual Malay petticoat or Sarong. He wore a rich turban on his head, and spoke good English. After a fortnight I went to stay at Government House with Sir William and Lady Jervoice [*sic*]. It was a huge building with fine halls and reception-rooms, but very little bedroom accommodation. It stood on the highest hill of the district, and overlooked all the town of Singapore, its bay and islands, and miles of the richest country covered with woods and cocoa-nuts. Close under my window was a great india-rubber tree with large shiny leaves and fantastic hanging roots. In the front of the garden was a gorgeous tree

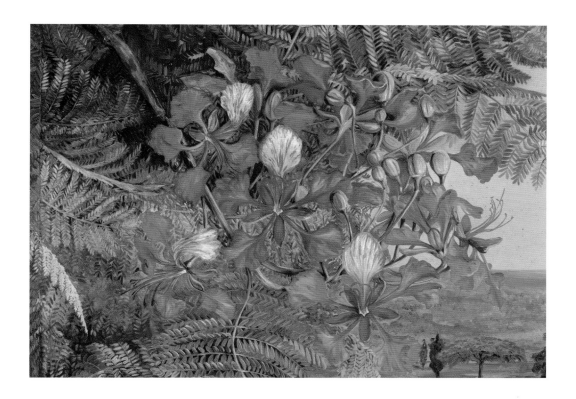

[above] *Foliage and Flowers of a Madagascar Tree at Singapore.* North's final, correctly orientated, painting of a flowering specimen of 'Poinciana regia', a synonym for *Delonix regia*.

of *Poinciana regia* blazing with scarlet blooms. I immediately begged a branch and hung it up to paint, but made a most absurd mistake. I placed it the wrong way up. It was stupid, but I was consoled afterwards when I found that that clever Dutch lady, Madame van Nooten, had actually published a painting of the poinciana growing in the same topsy-turvy way! Nothing approaches this tree for gorgeousness; the peculiar tender green of the acacia-like leaves enhances the brilliancy of its vermilion tints. The amherstia was also in great beauty in the same royal garden, with scarlet pods and delicate rosy-lilac young leaves. The beaumontia creeper was there too, with its white waxy bells and beautifully embossed leaves. It was curious to see how little the English people cared for these glories around them. Lawn-tennis and croquet were reigning supreme in Singapore, and little else was thought of after business was over. Lady Jervoice [*sic*] and her daughters were exceedingly kind to me, and played Mozart deliciously of an evening, while Sir William was a most genial host.

Chapter 8

Sarawak and the Brookes (Malaysian Borneo)

FEBRUARY–MAY 1876 (RETURN VISIT MAY–JULY 1880)

Sarawak, the largest of Malaysia's 13 states, stretches across the north-west of Borneo, the world's third largest island. In the early nineteenth century, Sarawak (then referring to a far smaller area) was a dependency of Brunei. In 1841, the Sultan granted governorship of Sarawak to James Brooke, a veteran of the East India Company's Bengal Army, as a reward for suppressing a rebellion of Malay chiefs in areas around the Sarawak River. In a written transfer, the Sultan named Brooke as sole owner of Sarawak's revenues. Brooke's aim of exploiting Sarawak's resources for trade was realised in 1856 with the establishment of the Borneo Company. In exchange for payments to the Sarawak Treasury, the Borneo Company was granted the right to mine, process and export all metals and minerals within the territory.

In visiting Sarawak, North was following other naturalists, notably Alfred Russel Wallace, who spent over a year there in the 1850s at the invitation of Brooke. It was his nephew and successor, Charles Brooke, who hosted North at the Astana in 1876 and again in 1880. In *Recollections* North writes flatteringly about Charles Brooke's paternalistic rule in Sarawak, claiming his word to be 'always just and well chosen' (Ex. 25) and elsewhere opining that Sarawak's population – Indigenous peoples (principally Iban and Bidayuh), Malays, and Chinese migrants – all 'submitted cheerfully to the

mild despotism of one honest Englishman'. She enjoyed Sarawak immensely, particularly during excursions away from the Astana. She stayed at Brooke's cottage in the Matang mountains to the west of Kuching (today the site of Kubah National Park) catered and cared for by a cook, a soldier, and a servant from the Raja's staff. At least five paintings in the gallery relate to this location. Walter G. Brodie ('Mr B.'), manager of the Borneo Company's mining operations in Sarawak, oversaw her subsequent expeditions, arranging for bungalows (complete with food, furniture and servants) to be ready for her at two mining sites: the working Tegora quicksilver mine, and the used-up antimony mine in Jambusan.

Brodie and one of Brooke's soldiers, supported by at least four unnamed Indigenous assistants, escorted North to Tegora (spelt 'Tegoro' in *Recollections* Vol I), travelling by boat, tram and on foot, with a pony and a chair at North's disposal for the climb through the mountainous, forested terrain. Less than a decade earlier, the area had been untouched primary forest. The mine had quickly been established after the discovery of cinnabar in 1867 and by the early 1870s the complex had a workforce of around 2,000 Chinese and Indigenous miners, and included mercury and antimony processing works, an office, manager's bungalow, shop, hospital and police officers. During her stay, North was shown how ore was mined and processed, and reports plunging her arm into a tub of liquid mercury. Her account suggests an antipathy towards mining: she 'felt quite sorry to think that fine old mountain was steadily being blown to pieces with gunpowder', and notes the dangers to health and life (Ex. 26). Her writing from her return visit in 1880 suggests the ore may have become scarce (this was not so – mining continued until 1895), and reports the forest near the bungalow had been cleared, leaving a stand of trees outside the bungalow scorched and bleached (Ex. 27).

In 1876, North stayed at Tegora for three weeks. After Brodie left, she was looked after by Alfred Hart Everett ('Mr E.'), manager of a quicksilver mine. Everett had travelled to Sarawak as a naturalist in

1869, hoping to establish himself as a professional collector of natural history specimens, but from the early 1870s onwards he additionally held a variety of posts for the North Borneo Company and Charles Brooke. North's account states that he was sent to Sarawak by the geologist Sir Charles Lyell (Ex. 28). Modern scholarship indicates he first travelled to Sarawak independently, but sent specimens to Lyell and other prominent scientists with whom he was connected. From 1878 to 1879, he was funded by the Royal Society and the British Association for the Advancement of Science principally to investigate specific caves in Sarawak, searching (largely unsuccessfully) for the remains of early humans. North wrote to Margaret Shaen that Everett was 'a most charming companion' and that he and Brodie had more 'brains than all the rest of the Rajah's subjects put together, himself included'. Everett escorted North to Jambusan and collected specimens for her, including a local pitcher plant unknown to western science and subsequently named by Joseph Hooker as *Nepenthes northiana*. He also arranged for Indigenous workers to clear a path to the entrance of a large cave that he thought North would like to explore (p. 27) but, she wrote to Margaret Shaen, 'I never enjoy stumbling in dark holes and got out as soon as I could politely, after all the trouble he had taken to get me there.' North delayed returning to the Astana until the day before she left Sarawak, preferring instead to spend her last days with the manager of an antimony mine near Busau and his wife, who had come to Sarawak from Hastings.

[page 112] *View down the River at Sarawak, Borneo.* The flight of stairs depicted leads from the river boathouse to the terrace and gardens of the Astana, where North stayed with the Brookes in 1876 and 1880. Construction of this palace, consisting of three interlinked bungalows, was completed in 1870 for the arrival of Charles and Margaret Brooke, following their marriage in England the previous autumn. Today it is the official residence of the Governor of Sarawak.

At least seven of North's paintings in the gallery collection were painted from the Astana's grounds. From a remark in *Recollections*, it appears this may have been the first painting she worked on during her return visit in 1880.

25.
FIRST IMPRESSIONS, 1876

We steamed up the broad river to Kuching, the capital, for some four hours through low country, with nipa, areca, and cocoa-nut palms, as well as mangroves and other swampy plants bordering the water's edge. At the mouth of the river are some high rocks and apparent mountain-tops isolated above the jungle level, covered entirely by forests of large trees. The last mile of the river has higher banks. A large population lives in wooden houses raised on stilts, almost hidden in trees of the most luxuriant and exquisite forms of foliage. The water was alive with boats, and so deep in its mid-channel that a man-of-war could anchor close to the house of the Rajah even at low tide, which rose and fell thirty feet at that part. On the left bank of the river was the long street of Chinese houses with the Malay huts behind, which formed the town of Kuching, many of whose houses are ornamented richly on the outside with curious devices made in porcelain and tiles. On the right bank a flight of steps led up to the terrace and lovely garden in which the palace of the Rajah had been placed (the original hero, Sir James Brooke, had lived in what was now the cowhouse). I sent in my letter, and the Secretary soon came on board and fetched me on shore, where I was most kindly welcomed by the Rani, a very handsome English lady, and put in a most luxurious room, from which I could escape by a back staircase into the lovely garden whenever I felt in the humour or wanted flowers.

The Rajah, who had gone up one of the rivers in his gunboat yacht, did not come back for ten days, and his wife was not sorry to have the rare chance of a countrywoman to talk to. She had lost three fine children on a homeward voyage from drinking a tin of poisoned milk, but one small tyrant of eighteen months remained, who was amusing to watch at his games, and in his despotism over a small Chinese boy in a pigtail, and his pretty little Malay ayah. The Rajah was a shy quiet man, with much determination of character. He was entirely respected by all sorts of people, and his word (when it did come) was law, always just and well chosen. A fine mastiff dog he had been very fond of, bit a Malay one day. The man being a Mahomedan, thought it an unclean animal, so the Rajah had it tried and shot on the public place by soldiers with as much ceremony as if it

[opposite] *Stagshorn Fern and the Young Rajah of Sarawak, Borneo, with Chinese Attendant.* This painting shows the young (Charles) Vyner Brooke, with his Malay ayah and Chinese attendant (both unnamed). Vyner Brooke ruled Sarawak from 1917 until 1946, when he ceded Sarawak to the British government. Sarawak became a Crown Colony until 1963, when it gained self-government, and in the same year became federated into Malaysia.

had been a political conspirator, and never kept any more dogs. He did not wish to hurt his people's prejudices, he said, for the mere selfish pleasure of possessing a pet.

He had one hundred soldiers, a band which played every night when we dined (on the other side of the river), and about twenty young men from Cornwall and Devonshire called "The Officers," who bore different grand titles – H. Highness, Treasurer, Postmaster-General, etc. – and who used to come up every Tuesday to play at croquet before the house. Some of them lived far away at different out-stations on the various rivers, and had terribly lonely lives, seldom seeing any civilised person to speak to, but settling disputes among strange tribes of Dyaks, Chinese, and Malay settlers.

The Rajah coined copper coins, and printed postage-stamps with his portrait on them. The house was most comfortable, full of books, newspapers, and every European luxury. The views from the verandah and lovely gardens, of the broad river, distant isolated mountains, and glorious vegetation, quite dazzled me with their magnificence. What was I to paint first? But my kind hostess made me feel I need not hurry, and that it was truly a comfort and pleasure to her to have me there; so I did not hurry, and soon lost every scrap of Japanese rheumatism, the last ache being in the thumb which held my palette – it is usually the limb that does most work which suffers from that disease.

26.

THE TEGORA QUICKSILVER MINE, 1876

That forest was a perfect world of wonders. The lycopodiums were in great beauty there, particularly those tinted with metallic blue or copper colour; and there were great metallic arums with leaves two feet long, graceful trees over the streams with scarlet bark all hanging in tatters, and such huge black apes! One of these watched and followed us a long while, seeming to be as curious about us as we were about him. When we stopped he stopped, staring with all his might at us from behind some branch or tree-trunk; but I had the best of that game, for I possessed an opera-glass and he didn't, so could not probably realise the whole of our white ugliness. At last we reached a deep stream with a broken bridge, too bad even for the pony to scramble over or under, and he was sent back.

Four Dyaks were waiting with a chair, but I was too anxious to examine the plants to get in, and walked on till near the end of the journey, when, in order not to disappoint them, I got in, and they started at a run and carried me up the steep little hill, and then up the steps of the verandah with a grunt of satisfaction and triumph.

It was an enchanting place that bungalow at Tegoro, entirely surrounded by virgin forest and grand mountains. Just opposite rose a small isolated mountain, full of quicksilver, with a deep ravine between us and it, and huge trees standing upon its edge, festooned with leaves, their branches adorned with wild pines and orchids – for foreground. I was taken to the top of the mountain the next morning, where I saw all the process of collecting and purifying the quicksilver. [...]

I felt quite sorry to think that fine old mountain was steadily being blown to pieces with gunpowder. Every bit of it was said to be impregnated with quicksilver or cinnabar, and one could pick up lumps of pure vermilion as one walked over it. It was a cruel process too, sweeping out the flues; and though eleven

out of the twelve men employed twice a year on it lost their health or died, fresh hands were always to be found for the work, being tempted by the high rate of pay. I plunged my arm into an iron bath of the pure metal up to the elbow, and found it very hard work to get it in. Much more is said to be in other hills around.

I never saw anything finer than the afterglow at Tegoro. The great trees used to stand out like flaming corallines against the crimson hills. It was lovely in the full moon, too, with the clouds wreathing themselves in and out of the same giant trees around us. We had our morning tea at half-past six on the verandah, and a plum-pudding in a tin case from Fortnum and Mason was always brought out for the benefit of our young Cornishman, who was always ready for it.

27.
*TEGORA,
'AT REST', 1880*

Mr. B. again took me up the river in his steam-launch to Busen, and on with the tram and a pony to Tegora, through that wonderful forest, with its dangerous bridges. One broke in two just as my pony scrambled over, the strut under it having been washed away by a late swollen stream. I was on foot, so came to no harm. [...] The old quicksilver mine of Tegora was at rest, as they had missed the lode for some time, and were anxiously probing in all directions, hoping to come to it again. The chairs in the bungalow had also dwindled down to three decrepit specimens; but I used to sit on the steps and watch the sunset, as I did before, gossiping with the two tired men there.

[...] In front of the bungalow at Tegora was a group of tall trees, left standing alone from the original forest, which was gone. They were incredibly white, and without a knot or a branch for full one hundred feet, bleached by the sun, which they had never seen before their companions were taken from them. One had to go far off to see both bottom and top at once of these gigantic poles, which were straight as ships' masts, with rope-like lianes tying them together, as ropes tie the masts of ships. The two under-officers of the mines asked leave to come and see me and my paintings again. They always called me Mr. B.'s sister (he said), and had often asked him when he was going to bring her up-country again. Such strong sensible

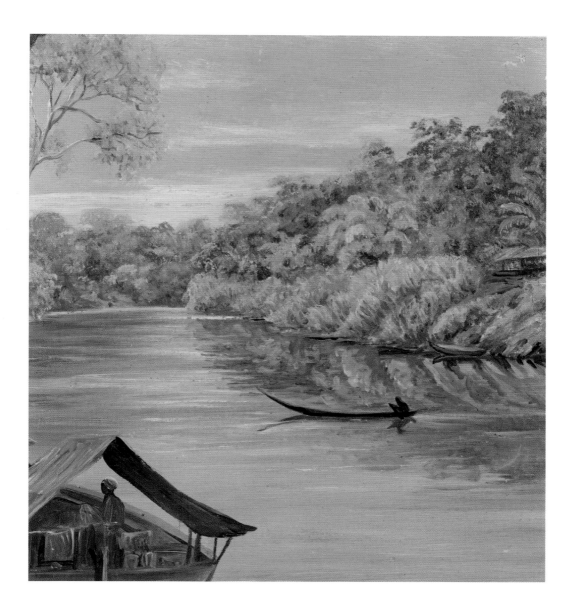

[above] *River from Bussa.* North's trips to Tegora started by taking a small steamship upriver from Kuching to Busau, where there was a pony route with bridges up to the mining complex.

Scotchmen both of them, it was no slight sensation shaking hands with them.

I began my return journey badly, for my pony displaced a plank in one of those horrid bridges, took fright, ran away, and tumbled me off, the Rani's new saddle having no off pommel, and I lost my spectacles in a bank of fern. My friends were too frightened to let me risk the other slippery bridges, and got a canoe with a mat and pillow, and two Dyaks to paddle

North's painting of the pitcher plant subsequently named *Nepenthes northiana*. The specimen was collected for her by the naturalist Alfred Hart Everett, whose botanical and archaeological collections are held by London's Natural History Museum. At least one other gallery painting, depicting a leaf insect, was painted by North using a specimen collected by Everett.

and push; so I gained once more the pleasure of shooting the rapids, lying on my back and looking at the tangled branches overhead, with their wonderful parasites; sometimes shooting swiftly down through deep-green water and white foam, while the men clutched at the rocks and tree-stumps; sometimes being almost carried by them over a few feet of water. Once we stopped to cut through a tree which had fallen across the river only a few hours before; and they hacked away with strange knives – half swords, half hatchets. These men were gentle creatures, with soft voices, and skins as muddy as the banks. I knew not which was more lovely to look at – the tangled banks, or the lacework overhead with natural bridges of lianes and fallen trees. At last we reached the place where Mr. B. was throwing in big stones to make a dry landing-place for me; after which came a pleasant ten miles of forest-ride and no accidents, and I was left to stay three days with the young manager of the antimony mines at Busen, where I spent my mornings up the river in a canoe, sketching strange trees and a bamboo bridge. One large cane alone serves as the foothold, supported on either side by a cobweb of others bound with rattans. These form a lacelike fence upwards from the footway, spreading like the letter V, which gives a feeling of security to the person passing over, even though the bridge swings in the air with his weight or the wind. I saw people constantly passing over the fragile thing with heavy loads on their heads and backs; women too were carrying children, all apparently without nervousness.

28.

ALFRED HART EVERETT, 1876

Mr. B. soon started for some other mines, and I was left to the care of his assistant, Mr. E, who had been sent out originally as a naturalist by Sir Charles Lyell, in search of the "missing link," or men with tails; and after searching the caves in vain, kept himself alive by "collecting" for different people at home. Mr. B. found him out and sent him to Tegoro. He was full of wit and information about the country. I found him a most delightful companion, as good as a book to talk to, and he was delighted to find one who was interested in his hobbies. [...] Mr. E. was a cousin of Millais, and his sketches and illustrations of his

different adventures in pen and ink were most excellent. I tried hard to make him publish them. [...]

One day Mr. E. took me into the great forest by a regular Dyak path, which means a number of round poles laid one in front of the other over the bogs and mud. It requires some practice to keep one's balance and not occasionally to step one side of the pole, in which case one probably sinks over the tops of one's boots in the wet sop, lucky if one goes no deeper! We crossed the river several times on the round trunks of fallen trees, which, when rendered slippery by recent rains, are not altogether a pleasant mode of proceeding, particularly when there is a noisy rushing deep river a few feet below. Now and then there was a bamboo rail; but as they were generally insecurely fastened and rotten, one was as well without them. We passed one or two large gutta-percha trees which had escaped the usual reckless felling, and had the scars of present bleeding; and I was taken inside the trunk of a splendid parasitic tree, a gigantic chimney of lace-work, the victim-tree having entirely rotted away and disappeared – I could look straight up and see the blue sky at the top through its head of spreading green. The lace-like shell was not two inches thick, and it must have been over 100 feet high.

We went back another way along the banks of the stream, under rocks more in than out of the water – such clear cool water with grand ferns and rattans dipping into it from the banks above. Mr. E. found me a Green Stick insect, which curled its long tail over its head like a scorpion and looked most vicious, but was perfectly harmless. It had gorgeous scarlet wings to fly with, but on the ground was invisible as a blade of grass.

At last I had to leave Tegoro. Mr. E. walked down two miles with me; then we got into a canoe and shot the rapids for many more miles, with the great trees arching over the small river we followed, and wonderful parasites, including the scarlet aeschynanthus, hanging from the branches in all the impossible places to stop. We sat on the floor of the canoe, held on tightly, and went at a terrible pace, the men cleverly guiding us with their paddles and sticks. Sometimes we stuck, then they went into the water, pushed, lifted, and started us again. We met other canoes returning, and being dragged up by the men. Some

were going down like us with three stone jars of quicksilver in each, very small things, but as much as two men could lift.

At last we got out and walked again through the wonderful limestone forest and out to the common or clearing round Jambusam, where there was a long-forsaken antimony-mine. Mr. B. had kindly arranged for me to stay there, and had sent food and furniture to meet me.

Mr. E. went up a mountain near and brought me down some grand trailing specimens of the largest of all pitcher-plants, which I festooned round the balcony by its yards of trailing stems. I painted a portrait of the largest, and my picture afterwards induced Mr. Veitch to send a traveller to seek the seeds, from which he raised plants and Sir Joseph Hooker named the species *Nepenthes Northiana*. These pitchers are often over a foot long, and richly covered with crimson blotches.

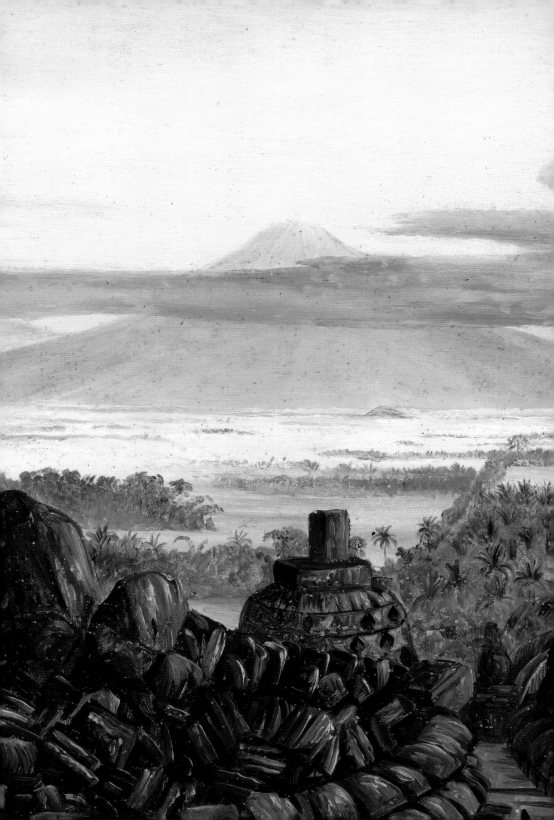

Chapter 9

Volcanic Java

JUNE–SEPTEMBER/OCTOBER 1876

Marianne North landed in Batavia (Jakarta), Java – then capital of the Dutch East Indies and today Indonesia's capital city – and quickly took a train to Buitenzorg (Bogor), where she settled for over a month. Here she learnt Malay and painted, aided by the director of Buitenzorg Botanic Garden, Rudolph Scheffer, who supplied her with whatever specimens she desired. She also took early morning carriage rides with a local resident named Mrs Fraser ('Mrs. F.'). The Frasers had, North tells us, 'promised to make all easy for me both at Buitenzorg and on my future travels, and they abundantly fulfilled their promises'. Further help resulted from North's attendance at a dinner at the Istana (Bogor Palace), official residence of the Dutch Governor General of the East Indies, where North felt typically ill at ease meeting Governor Johan Wilhelm van Lansberge (Ex. 29). Nevertheless, when she left Buitenzorg it was with a letter from him: 'to all officials, native and Dutch, asking them to feed and lodge me, and pass me on wherever I wish to go'.

Travelling – often on horseback, or in carriages on the main post road, and generally escorted by Dutch colonial officials or Javanese chiefs – became a narrative concern in *Recollections* as North criss-crossed the island, guided in part by Wallace's *The Malay Archipelago* which was, she declared, 'a Bible to me in Java, all he says being

thoroughly true'. She also possessed a bilingual dictionary and a head full of tips on where to visit, the results of her fortuitous first meeting with the judge and Sanskrit scholar Arthur C. Burnell onboard the boat to Java from Singapore. Once touring the island, the chain of active volcanoes along its mountainous central spine became a particular interest, leading to volcanoes featuring in over a third (32) of her Java paintings, 17 of which include the volcanoes' names in their titles. In Tosari, she visited the Bromo volcano and Tengger Sand Sea, recording her impressions of this unique desert-like landscape in paint and words (Ex. 30), including an account of the Yadnya Kasada festival, which is still practised annually by the Tenggerese people. This land has been protected since 1919, and is now within the Bromo Tengger Semeru National Park.

The interest in temple architecture first evident from her travels in Japan continued in Java. She painted the Hindu Kidal and Singosari temples near Malang, and the Prambanan temple – the largest Hindu temple complex in Indonesia and today a UNESCO World Heritage Site – and included paintings from these three sites in the gallery. But it was Borobudur ('Boro-Bodo'), one of the world's greatest Buddhist monuments, that seized North's imagination during her ten-day stay (Ex. 31). The 'Mr. Fergusson' who North wishes was with her to explain the Borobudur carvings was the architectural historian James Fergusson, whom she later commissioned to design her Kew gallery (see Chapter 17). Borobudur is today understood to be a compound consisting of three temples, the main temple and two smaller aligned temples to the east, Mendut ('Mendoot', 'Mendoet') and Pawon. North painted all three, selecting for the gallery a painting of the smaller Pawon temple almost crushed by an enormous cotton tree, two similarly composed paintings depicting Borobudur temple stupas against volcanic backgrounds, and one of an ex-situ Buddha. She made at least two paintings of the stepped main Borobudur pyramid but did not choose either for the gallery, nor did she include her painting of the colossal Buddha inside Mendut temple.

Her last excursion was to a private (non-governmental) tea plantation in the hills above Garut ('Garoet'), established by Karel Frederik Hölle ('Herr Hölle') in 1862. Hölle had lived in the East Indies since boyhood and was fluent in Malay, Sundanese and Javanese. He had a long-established friendship with Garut's chief, Raden Muhammad Musa ('the Mufti of Garoet'), and from 1871 onwards acted as an honorary adviser on 'native affairs' for the colonial government. North's tour of his experimental plantation resulted in three gallery paintings – but her effusive and idealistic written account suggests the greatest impression was made by the man himself (Ex. 32).

[page 126] Detail from **The Volcanoes of Merapi and Merbaboe, Java, from the Top of Boro Bodoer.** One of two paintings in the gallery collection showing stupas from the main Borobudur temple against distant volcanoes.

29.

BUITENZORG (BOGOR) BOTANIC GARDEN

Java is one magnificent garden of luxuriance, surpassing Brazil, Jamaica, and Sarawak all combined, with the grandest volcanoes rising out of it. These are covered with the richest forests, and have a peculiar alpine vegetation on their summits. One can ride up to the very tops, and traverse the whole island on good roads by an excellent system of posting arranged by Government. There are good rest-houses at the end of every day's journey, where you are taken in and fed at a fixed tariff of prices. Moreover, travellers are entirely safe in Java, which is no small blessing. Mrs. F. used to drive me about in the very early morning, and show me lovely views and forest scenes, with tidy little native houses hidden among the trees and gardens, made of the neatest matting of rattan or bamboo, with patterns woven in black, white, and red, and slight bamboo frames hung round with bird-cages. [...]

The famous Botanic Garden was only a quarter of an hour's walk from the hotel, and I worked there every day, but soon found it was of no use going there after noon, as it rained regularly every day after one o'clock, coming down in sheets and torrents all in a moment. On one occasion I was creeping home with my load, without the slightest idea of a coming storm, when down it came, and in five minutes the road was a river. I had to wade through some places a foot deep in water, when a kind lady saw me from her window, and sent her servant running after me with an umbrella.

The Governor-General asked me to dinner in his grand palace in the midst of the garden. There were several people there, and some great men with fine orders on their coats; and when a little dry shy-mannered man offered me his arm to take me in to dinner, I held back, expecting to see the Governor-General go first; but he persisted in preceding the others, and I made up my mind that Dutch etiquette sent the biggest people in last, only taking in slowly that my man *was* his Excellency after all. We ought not to be led by appearances, for he was very intelligent, and talked excellent English. But as Madame de Lonsdale (a Spanish lady) only understood French, the conversation was mostly carried on in that language, and I floundered about in my usual "nervous Continental." [...]

[opposite] *A Tailor's Shop in the Botanic Garden, Buitenzorg, Shaded by Sago Palms and Bananas.* North produced 11 paintings in Buitenzorg (Bogor), principally featuring palms but also banyan and rubber trees.

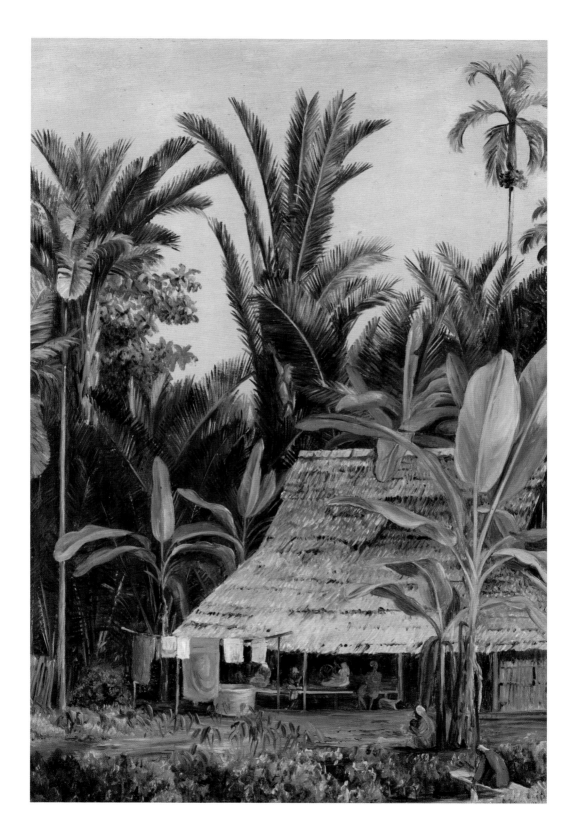

The Botanic Garden was a world of wonders. Such a variety of the different species was there! The plants had been there so long that they grew as if in their native woods – every kind of rattan, palm, pine, or arum. The latter are most curious in their habits and singular power of emitting heat. All the gorgeous water-lilies of the world were collected in a lake in front of the palace. The Director was most kind in letting me have specimens of all the grand things I wanted to paint. The palms alone, in flower and fruit, would have easily employed a lifetime. The blue thunbergia and other creepers ran to the tops of the highest trees, sending down sheets of greenery and lovely flowers.

30.
TOSARI, MOUNT BROMO, AND THE TENGGER SAND SEA

Tosari is 6000 feet above the sea. Its season was over, and it was cold at night, and generally wrapped up in clouds. The scenery is very curious, the steep volcanic hillside ploughed up into great furrows from top to bottom, often 1000 feet deep, and the tops a few yards across. One could talk to people on the opposite hill-slope, though it would take hours of hard scramble or roundabout paths to reach them. Those steep slopes were cultivated in the most marvellous way. I never met such an industrious people, and where other crops are impossible, the gaps are filled by tree-ferns and almost alpine flowers – marigolds, nasturtiums, balsams, guelder-roses, raspberries, great forget-me-nots, violets, sorrel, etc. The country was splendid beyond the casuarina trees, which are tall and transparent like poplars, and invaluable for foregrounds, as they cut the long horizon-line of sea, plain, and sky, and do not hide the landscape. The people (like all other mountaineers) were honest and friendly, and every spur had a village perched on its sharpest point. The politeness of every one was overwhelming. As I was mooning along collecting flowers one day, the chief of the district rode up, with half-a-dozen wild men in attendance on bare-backed ponies. They all dismounted and made bows while I passed on, then remounted and disappeared.

My good landlord himself accompanied me on the great expedition of the place, to see the Bromo volcano and Sand Sea. He said there were wild horses feeding on the Sand Sea which

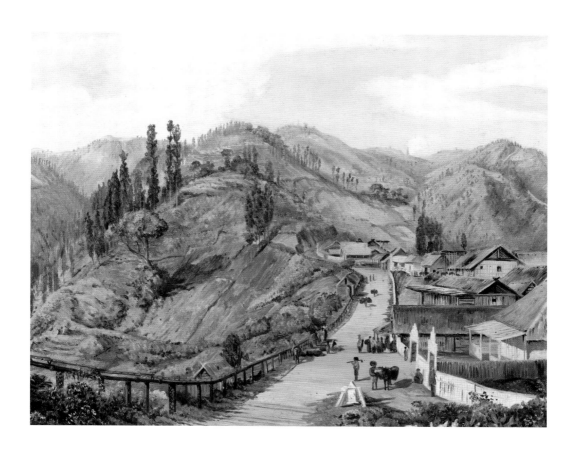

[above] *Village of Tosari,
Java, 6000 feet above
the level of the Sea.*
During her stay in Tosari,
North painted four views
illustrating the region's
rich vegetation and the
Arjuno-Welirang and
Semeru volcanoes. The
smoke surrounding the
hills is from Semeru.

might be troublesome to my little horse, so he put his gun over
his shoulder on the chance of shooting some small birds for
me. We started over the white frost in the early morning, and
the only bird he shot at was a peacock – an enormous one,
which flew across the road with a great yell and fluster, and
I hope was none the worse for my landlord's small-shot. The
Sand Sea was the original crater of the Bromo, which fell in and
sent up that flat plain of sand, like a moat round the present
crater, surrounded on all sides by high rock walls 800 or 1000
feet high, down which we walked or slid with our ponies
following us. Then we crossed the sand for some miles, and
climbing to the edge of the present Bromo crater, looked down
on the sulphur and smoke within. It is considered very holy
by the 8000 Hindus who still exist in that southern end of the
island, and who go on a particular day every year and throw
chickens in, which generally fly out again, and are caught and

[right] *Smoke of Semeru Volcano and Bromo Volcano, East Java.* North's painting of the Tengger Sand Sea and Semeru and Bromo volcanoes, held in Kew's art collection, is a stark contrast to the richly cultivated landscape shown in her other Java paintings.

eaten. In early times human sacrifices were made there, then animals; now these rites are next to nothing. We mounted up on the other side of the Sand Sea cliffs, and got a view of the cone and smoke of the Smeroe volcano over the other mountains, the only really active one, and the highest, it being 13,000 feet above the sea.

31.
BOROBUDUR 'THE BEAUTIFUL'

We came to a huge cotton-tree, which had nearly strangled and swallowed up an exquisite little temple. Two sides of it were hidden entirely by the roots, between which the poor, crushed, but finely-carved stones peeped out. It was the tallest tree in all the country round, and towered up twice as high as the cocoa-nut plantations near it. [...]

About a mile beyond the giant tree and tiny temple we came to the great pyramid or monastery of Boro-Bodo, or Buddoer. At its foot an avenue of tall kanari trees and statues of Buddha lead up to a pattern little mat rest-house, and the farmhouse of its manager. The house contained a central feeding-room and

three small bedrooms. From the front verandah we had a good
view of the magnificent pile of building, a perfect museum,
containing the whole history of Buddha in a series of basso-
relievos, lining seven terraces round the stone-covered hills,
which, if stretched out consecutively, would cover three miles.
There were four hundred sitting statues of the holy man, larger
than life, the upper ones under dagobas or hencoops of stone.
Many of them had been knocked over by earthquakes, which
had cracked the whole, and thrown the walls so much out of
the perpendicular that it was a marvel how it all held together
without cement of any kind. The whole was surmounted by a
dome. From the top terraces was the very finest view I ever saw:
a vast plain, covered with the richest cultivation – rice, indigo,
corn, mandioca, tea, and tobacco, with the one giant cotton-tree
rising above everything else, and groves of cocoanuts dotted all
over it, under which the great population hid their neat little
villages of small thatched baskets. Three magnificent volcanoes
arose out of it, with grand sweeping curves and angles, besides
many other ragged-edged mountains. Every turn gave one fresh

pictures; and if Boro-Bodo were not there I should still think it one of the finest landscapes I ever saw.

The sun used to rise just behind the highest volcano, tipping the others with rose-colour, throwing a long shadow on the miles of cotton-wool mist below, through which the cocoa-nuts cut their way here and there. In half an hour all the clouds rose and hid the great mountain for the rest of the day. It is the second highest in Java, and only a few years ago buried forty villages during an eruption. At sunset the mountains were generally seen again. I never missed climbing the pyramids night or morning, and was always rewarded by some curious and beautiful effect of colour and cloud, and always found

[right] *Statue of Buddha.* This painting shows the colossal statue of the Buddha in Mendut Temple, one of two secondary temples associated with Borobudur.

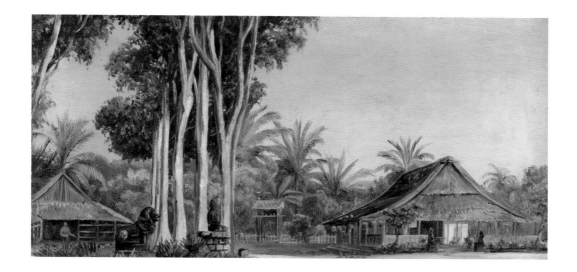

[above] ***The Hotel, Boro Boro, Java.*** North summarised her four months in Java in a letter to Burnell, writing that she 'went over all the most interesting parts from Tosari in the east, with its curious sandsea and volcanos, to the Priangger – I even spent some nights and days on the Dienge and made plenty of drawings at Borobodo the beautiful where I was ten days in the nice little hotel you told me of – your hints were most valuable and so was your dictionary, though it led me into a few odd mistakes from bad guesses at Dutch words.'

new stories in the great stone picture-book on my way up and down. I longed for Mr. Fergusson at my side to explain it all to me. Some of the carvings are very fine. The figures have often much beauty and expression in them, and are divided by exquisitely fanciful scroll-work, arabesques of flowers, birds, and mythological animals. [...]

Four miles from Boro-Bodo was the other curious monument of Mendoot, only accidentally discovered a few years before I went there, under the mound of earth by means of which it was originally built up. It is said to be Hindu, and its carvings are worthy of the old Greeks, so polished and exquisitely designed and finished are they. The statue of Buddha inside, preaching, might have done for a Jupiter or a Memnon. It is of gray granite, quite colossal, as are his two friends on either side of him. The calm beauty of the great preacher haunts me still, and I was fool enough to waste two mornings in trying to paint it, of course failing utterly.

32.
WITH KAREL FREDERIK HÖLLE IN GARUT

I was on my way to the house of Herr Hölle, who lived on the hills behind Garoet, and I had a letter to the native Prince or Regent there to send me on [...]

[After waiting outside Hölle's house] I had almost made up my mind to wait no longer but return to Bandoeng, when Herr

Hölle walked in, a grand man with a strong look that reminded me of Garibaldi, the same curious mixture of simplicity, power, and gentleness. The Governor-General called him "our great civiliser." He wore a fez on his head and sandals with wooden soles like the country people, but was otherwise more decently dressed than many of the Dutch country gentlemen. He talked all the dialects of the country, as well as Sanscrit and Arabic, and his English was excellent. He devoted his life to improving the condition of his people in the province, had written books in their languages, and established schools and other institutions for their enlightenment and comfort. He had had the ferry mended, and drove me, in his little single-seated carriage with two small spirited ponies, through Garoet and up a zigzag narrow road, 2000 feet above it, to his village and pretty little house, a model place in every way, ornamented with carved wood and terra-cotta mouldings, all made by natives under his directions.

No door or window was ever locked day or night. The people passed through the garden from cottage to cottage, and never stole a flower. Herr Hölle said he liked to see them moving about, and to know they were not afraid of him. They often came great distances too to beg him to doctor them or give them advice when in difficulties, and to work in his tea plantations, which covered miles of hillside. The winding paths were bordered with cedars, sheds being built at intervals to shelter the pickers from the rain. No scene could be more picturesque than those hills crowded with gaily-dressed people amongst the tea-bushes, the plain of golden rice and palm-groves below, with grand mountains beyond, two of them always smoking.

[...] I did plenty of painting, but my chief delight was in hearing my host talk, and seeing him among his people. One evening he took me to see the children shaking the trees to collect cockchafers, which they roasted and ate with their rice. They had a bit of burning wood on the ground, the insects flew to it, and were caught by the eager little creatures. So picturesque they looked in the firelight, the whole under the brightest moon I ever saw. The Government constantly sent Herr Hölle to mediate and arrange difficulties with natives all over the island. He knew all their peculiarities, proverbs, and

[below] *Tea-Drying in Mr Hölle's Establishment.*
North painted three paintings at Karel Frederik Hölle's tea plantation. One depicts the tea terraces with the Papandayan volcano in the background, the second shows labourers harvesting the tea, and this one shows the drying process and boxes packed and ready for export.

idioms, and could always manage them. His great friend was the Mufti of Garoet: orthodox old ladies used to say he was a Muhammadan himself. He knew the Koran by heart, could convince the people by their own arguments from it, and met them half-way in most things; he allowed no pork on his table, no dogs in his house.

He had plenty of books and illustrations of the antiquities of Java, and showed me how both Boro-Bodo and Mendoet were raised, by covering up with earth as the builders went on, so as to form a long slanting road to the work, over which they could bring the stones to the very top. Mendoet had never been uncovered till a few years before, which accounted for its great smoothness and preservation.

I was taken to see the whole process of tea-culture – picking, drying, and packing, all so nicely and cleanly done. The boxes had English labels stuck on them, as they went chiefly to Australia. The great buffaloes brought their little carts up the hills and took them away.

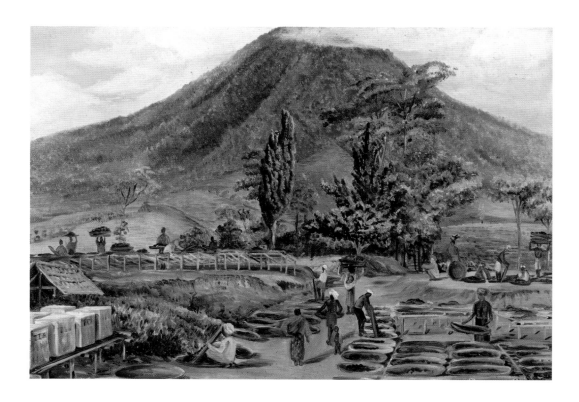

Chapter 10

'Complete Rest' in Ceylon (Sri Lanka)

OCTOBER/NOVEMBER 1876–JANUARY 1877 (RETURN VISIT NOVEMBER 1877)

Marianne North had planned to visit the Moluccas (Maluku Islands, Indonesia) after Java but finding herself feeling 'rather limp' abandoned that idea and instead travelled via Singapore to Ceylon (Sri Lanka). Her first destination was the fortified city of Galle, where she stayed at the New Oriental Hotel for ten days, followed by eight days at nearby Bonavista beach. Unusually, presumably on account of its fame among western travellers, she named the New Oriental Hotel in *Recollections* and recorded her impressions of its guests in a narrative that leaves readers in no doubt that she preferred admiring the coconut palms at the nearby coast. The hotel had opened its doors in 1866, catering to European guests in a complex of buildings dating back to 1684, first used as military headquarters under Dutch colonial rule and then as barracks under British rule. Today it is a luxury heritage hotel named Amangalla, owned by Aman Resorts. After her exertions in Java North craved 'complete rest', and this was found in Kandy, where she was hosted by Mr Laurie, the district judge, who let her stay on at his house for a further six weeks while he visited India.

Naturally, the nearby Royal Botanic Garden at Peradeniya was a prime attraction – as was the garden's director, George Henry Kendrick Thwaites, who ran the gardens from 1849 until 1880. In a letter to Joseph Hooker, Thwaites described North as a

charming artist and reported that she showed him her paintings of Java, Singapore and Sarawak, and was working on drawings at the botanic garden, including one of the Talipot palm. In her own correspondence, North wrote of enjoying many pleasant evening walks with Thwaites, whom she considered 'one of the most perfect gentlemen I have ever known' (Ex. 33). He thrice rewarded her abiding interest in butterflies by showing – and later sharing – his personal collection with her, providing a tour of their habitats in the garden, and arranging for her to view exquisite artworks depicting the butterflies of Ceylon. These were by the Sinhalese artist William de Alwis Seneviratne (unnamed in North's text), a member of the artistically gifted de Alwis family employed at Peradeniya over three generations, starting with William's father Harmanis de Alwis. The original watercolours representing 350 species of Sri Lankan butterflies and moths are now sadly lost but were, by all accounts, stunning.

The innovative portrait photographer Julia Margaret Cameron, probably best remembered today for her portraits of prominent Victorians, was North's host at Kalutara (Ex. 34). Cameron's husband, Charles Hay Cameron, had overseen legal reform in Ceylon during the 1830s – reforms which enabled him, by the mid-to-late 1840s, to become Ceylon's largest single landowner through purchasing land in the island's interior to develop as coffee plantations. The Camerons' property on the Isle of Wight, where Julia Margaret established her photographic career in the 1860s, was named Dimbola after one of their coffee estates. It had long been the dream and intent of Charles Hay to return to Ceylon where, by the 1870s, three of the couple's sons managed the struggling coffee estates while the fourth was in the Ceylon Civil Service. In late 1875, when Julia Margaret was 60 years old and Charles Hay was in his 80s, this wish was fulfilled. They had been in Ceylon for a little over a year when North stayed with them in January 1877. At the time of North's visit, Julia Margaret was working on what North calls 'studies of natives', a series of

photographic portraits of domestic and plantation workers on the Camerons' estates – and she was keen to add North to her collection of models. North's account of modelling for Cameron is relatively well-known, but focuses on only one of the surviving photographs, a highly staged portrait depicting North in an orientalised manner (p. 19). Another of Cameron's portraits depicts North as an ethnographic painter, observing a young Tamil man (unnamed but presumably one of the Camerons' workers) who stands posed before her easel with a pot hoisted onto his shoulder (p. 150).

North had intended to travel on from Ceylon to southern India in January 1877 but, evidently feeling the strain of travelling through successive countries without a rest at home, she changed track and returned to England. She returned to Ceylon in mid-November 1877, a short, unplanned visit prompted by her discovery on arrival at Suez that the ship to Bombay (Mumbai) was overbooked. This gave her the opportunity to revisit Thwaites and the Camerons before crossing to Tuticorin (Thoothukudi, Tamil Nadu) a fortnight later.

[page 140] *Talipot Palm near the Botanic Garden Peradeniya, Ceylon.*
In *Recollections* North described seeing a talipot palm in full flower nearby where 'six men with loaded clubs . . . grinding down the stones in the roadway,' close to the entrance to the botanic garden. These men are acknowledged as 'road-makers' in the gallery catalogue caption.

[overleaf] *In the Old Palace, Kandy.* When the British conquered the sovereign Kingdom of Kandy in 1815, they took over the royal palace, appropriated the sacred Buddha Tooth Relic which signified the right to rule, and deported the king and royal family to India. The palace was repurposed for the colonial administration, becoming the residence of successive Government Agents. In *Recollections* North writes that 'The Governor-Agent and Mrs. P. lived in the old palace, and the rooms were full of quaint figures, half raised on the wall, picked out with white on a blue ground.' The text does not mention the two women featured in the painting. Ceylon was under British rule until 1948 when, after decades of agitation, the island gained independence as a Dominion. In 1972 it became the Republic of Sri Lanka.

33.
G. H. K. THWAITES, WILLIAM DE ALWIS SENEVIRATNE, AND THE BUTTERFLIES OF CEYLON

The Governor had told me Mr. Thwaites was going to Colombo to stay with him the next day, so I ordered a carriage at six, and drove over to the Botanic Gardens to catch him before he went. I found the dear old gentleman delighted to see me; and, in spite of the drizzling rain, we had a charming walk round the gardens for two hours. He had planted half the trees himself, and had seldom been out of it for forty years, steadily refusing to cut vistas, or make riband-borders and other inventions of the modern gardener. The trees were massed together most picturesquely, with creepers growing over them in a natural and enchanting tangle. The bamboos were the finest I ever saw, particularly those of Abyssinia, a tall green variety 60 or 100 feet high. The river wound all round the garden, making it one of the choicest spots on earth. Mr. Thwaites showed me also his exquisite collection of butterflies, and promised to give me

[opposite] *A View in the Royal Botanic Garden, Peradeniya.* During his 30-year tenure as director of the Royal Botanic Garden, Peradeniya, George Henry Kendrick Thwaites lived in the cottage shown on the left. In 1880 he retired to a bungalow named Fairieland in the hills above Kandy.

some of his spare ones. He kept that promise most generously; he never said anything he didn't mean, and detested everything false. He was one of the most perfect gentlemen I have ever known, and I longed to be able to stay a while to rest and paint near him and his beautiful garden. [...]

He had a clever Cingalese head-man, and employed another native to make paintings for him of all the moths and butterflies, with their caterpillars and larvae, and the leaves they fed on, as well as of the fungi and flora of Ceylon. These paintings were done in water-colours, so exquisitely that one could see almost every hair in the insect's wings; they were all painted from the real thing, without any help from glasses. I spent many a delightful hour looking over them and the beautiful collection of insects Mr. Thwaites had made, hearing all their habits and histories. He also took me to the different trees in the garden where they lived and fed, and showed me their nests.

34.
JULIA MARGARET AND CHARLES HAY CAMERON

[overleaf] *Some of Mrs Cameron's Models, with Cocoanut and Teak Trees, Kalutara.* The gallery contains three paintings from Kalutara, a fourth is in Kew's art collection. The unnamed young man carrying a water urn was most likely one of Julia Margaret's estate workers and photographic models. In her written description of the Camerons' property, North refers to the 'tame rabbits' and 'beautiful tame stag' also featured in this painting.

[I] went on to stay with Mrs. Cameron at Kalutara. I had long known her glorious photographs, but had never met her. She had sent me many warm invitations to come when she heard I was in Ceylon. Her husband had filled a high office under Macaulay in India, but since then for ten years he had never moved from his room. At last she made up her mind to go and live near her sons in Ceylon. Every one said it would be impossible; but when told of what she was going to do, he said that the one wish he had was to die in Ceylon! He got up and walked, and had been better ever since. He was eighty-four, perfectly upright, with long white hair over his shoulders. He read all day long, taking walks round and round the verandah at Kalutara with a long staff in his hand, perfectly happy, and ready to enjoy any joke or enter into any talk which went on around him. He would quote poetry and even read aloud to me while I was painting. His wife had a most fascinating and caressing manner, and was full of clever talk and originality. She took to me at once, and said it was delightful to meet any one who found pearls in every ugly oyster.

Her son Hardinge, with whom she lived, was most excellent, and had made himself liked and respected by all his neighbours.

MARIANNE NORTH'S TRAVEL WRITING

[...] Their house stood on a small hill, jutting out into the great river which ran into the sea a quarter of a mile below the house. It was surrounded by cocoa-nuts, casuarinas, mangoes, and breadfruit trees; tame rabbits, squirrels, and Mina-birds ran in and out without the slightest fear, while a beautiful tame stag guarded the entrance; monkeys with gray whiskers, and all sorts of fowls, were outside.

The walls of the rooms were covered with magnificent photographs; others were tumbling about the tables, chairs,

[right] **North's account of the taking of this portrait draws attention to the artificiality of its staging** – referring not only to the costume and styling that Cameron chose but also to the background vegetation being 'nailed flat against a window shutter'.

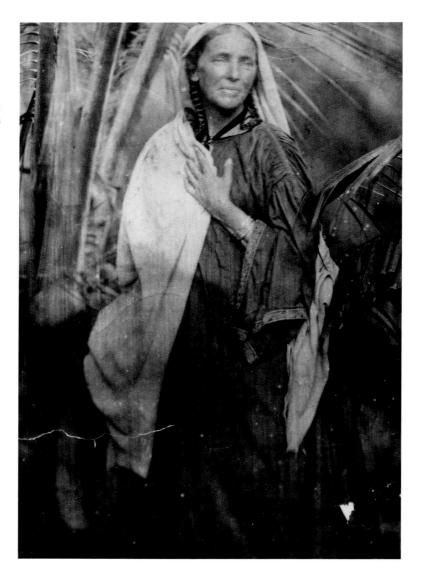

[above] **North to Burnell, 20 March [1877].** In this letter, written from London, North apologises to Burnell for any trouble caused by her abandoning her plan to travel straight from Ceylon to southern India in January 1877. She is evidently very happy to be home after 'twenty months wandering amongst strangers' – and yet, she writes: 'when summer comes and country houses dressed up parties are put as counter temptations to wandering away quietly with my easel and old portmanteau to unseen wonders the other side of the world, I think both you and I can guess which will carry the day.'

and floors, with quantities of damp books, all untidy and picturesque; the lady herself with a lace veil on her head and flowing draperies. Her oddities were most refreshing, after the "don't care" people I usually meet in tropical countries. She made up her mind at once she would photograph me, and for three days she kept herself in a fever of excitement about it, but the results have not been approved of at home since. She dressed me up in flowing draperies of cashmere wool, let down my hair, and made me stand with spiky cocoa-nut branches running into my head, the noonday sun's rays dodging my eyes between the leaves as the slight breeze moved them, and told me to look perfectly natural (with a thermometer standing at 96°)! Then she tried me with a background of breadfruit leaves and fruit, nailed flat against a window shutter, and told *them* to look natural, but both failed; and though she wasted twelve plates, and an enormous amount of trouble, it was all in vain, she could only get a perfectly uninteresting and commonplace person on her glasses, which refused to flatter.

Travels in India

India from South to North

If North had carried through her original plan to cross from Ceylon to India in January 1877, she would have arrived during the month Queen Victoria was proclaimed Empress at a costly, ostentatious coronation ceremony (known as a durbar) presided over by Viceroy Lord Lytton. At the time this event took place in Delhi, the south and south-west of the subcontinent were in the grip of a devastating, badly managed famine, the Great Famine of 1876–78, which spread to central and north-western provinces during 1878. An estimated 58 million people suffered during its two-year duration, with contemporaneous estimates of the number of lives lost ranging from 5.6 million to 9.4 million.

This tragic situation shaped North's travels through India, particularly the three months she spent touring the south. She arrived at Tuticorin (Thoothukudi) in December 1877 and travelled by train to Madurai, where the monsoon rains had finally fallen, sparking further suffering in the forms of flooding and malaria. Her early impressions, recorded in *Recollections*, include the horrific contrast of crops ripening in fields as people starved, and describes people's desperate efforts to cross the flooded Vaigai River in Madurai to reach a famine relief camp, an account incongruously accompanied with a description of squirrels (Ex. 35). Her host in

Madurai, a judge named Mr. Thompson, guided her tour around the Meenakshi Amman temple, which left her 'dumbfounded by [its] strangeness'. Unable to travel onwards, she did not reach her host in Tanjore (Thanjavur), Arthur C. Burnell, until Christmas Eve. North and Burnell had stayed in contact following their initial meeting in Java in 1876, and during their time together she began painting sacred plants from specimens he provided – a joint project that continued throughout her time in India, as she sought to locate flowering specimens of the species he told her about (Ex. 36). She also painted Tanjore's Brihadisvara temple, now one of three World Heritage Site temples in Tamil Nadu, and, as a result of Burnell's work cataloguing Sanskrit manuscripts in the royal collection in Tanjore, was invited to visit the Princess of Tanjore (Ex. 37).

The Princess's 'expedition to Delhi' and 'medal and ring given by the Queen-Empress' refer to the coronation durbar almost a year earlier, which was an event intended to strengthen British rule – badly shaken during the Indian Rebellion and its aftermath – by incorporating the Indian aristocracy into a system of imperial heraldry. North refers to the uprising (as 'the mutiny') several times in *Recollections* (for instance in Ex. 40 and 43), generally focusing on incidents of British people being 'kept safe', perhaps indicative of the personal anxieties

[opening spread] *Mount Everest or Deodunga, from Sundukpho, North India.* The gallery catalogue painting caption draws on data from the Great Trigonometrical Survey of India (GTS), which estimated the mountain's height to be 29,002 feet. When naming mountains, it was the general practice of the GTS to use local names. In the case of Everest, the Surveyor-General Sir Andrew Scott stated that no definitive local name could be ascertained. His suggestion to name the mountain after the previous surveyor-general was objected to, even by George Everest himself. Brian Houghton Hodgson, a former Resident to Nepal, favoured the name Deodungha (meaning Holy Mountain), which was used in Darjeeling – but in 1865 the name Everest was confirmed by the Royal Geographical Society.

[page 154] *Festival of Muharram, Udaipur, Rajasthan.* Muharram, the first month of the Islamic calendar, is a period of remembrance and reflection. Public processions such as this one observed by North in Udaipur, occur on *Ashura*, the tenth day of Muharram, which commemorates the martyrdom of Hussain ibn Ali, grandson of the Prophet Muhammad.

about her safety which can be glimpsed in her account of Delhi. Shortly after leaving Burnell, one of his associates sent North an attendant named Alex, who had served him 'partly as servant, partly as secretary in Bombay and Mauritius', but this was destined to be an unhappy and very short-lived arrangement, lasting only one journey from Beypore to Cochin before North declared she believed him to be insane, and replaced him with a different (unnamed) mediator.

In February, she boarded a steamer to Bombay (Mumbai), enduring a ball at Government House with four hundred guests, and meeting the regional governor Sir Richard Temple – the man responsible for carrying out Lytton's famine relief policy. Having been reprimanded for over-expenditure in his handling of the Bihar famine a few years earlier, the qualification criteria he drew up and the relief rations allocated during the existing crisis were meagre in the extreme. North depicted Temple as a demanding and ceaselessly energetic man, who swept her around Government House in the evening, and its surroundings in the early morning. He was full of advice on where she should travel and assisted her excursions around the region, although their tastes in architecture proved to differ. 'These great officials do provoke me,' she exclaimed to Burnell. 'Fancy Sir Richard Temple advising me to see Karli and leave all the thirty caves of Ellora alone!' The Kailasa temple at the Ellora Caves in Aurangabad was, North wrote, 'the grandest cathedral in the world', and she despaired at not having sufficient time to produce drawings that justified its complexity (Ex. 38). During this time, she was travelling in the company of an intermediary named John, whose services had been arranged by a Mrs. Rivett Carnac in Bombay. North said little about him (and even less positive) during the roughly four months they were in each other's company – until they reached Dehradun in early June, where she reported their parting of ways, declaring him a drunkard and vowing: 'to be tied to no more idle, lying servants, but to pay local people whenever I was well, who would take far better care of me than if I had a go-between'.

Other factors had hindered her travels. In Agra in late March, she had developed a debilitating fever. Craving greenery and rest, she abandoned her plan to travel to Delhi and instead retreated to the hills, staying first at Nainital, and later spending most of June and July in Simla (Shimla), the summer capital of the Raj. Here she socialised with, among others, the Lyttons – forming a discernibly higher estimation of Lady Lytton than of her husband (Ex. 39). In private letters she was caustic, writing to Margaret Shaen that he 'sets the worst example in every way and is a regular spoilt child … His wife is altogetheracious, as Mr Lear would say – and wonderfully beautiful.' To Burnell she confided, 'I think him a most contemptible mortal, and his court of A.D.C's [aides-de-camp] suit him exactly.' More to her tastes was her host in Binsar near Almora during August, the long-standing Commissioner of Kumaon, General Henry Ramsay, whom North termed 'a benevolent despot'. He organised her excursions during her Kumaon travels, along with the unnamed cook, bearers and guards who facilitated them (Ex. 40).

In her scathing assessment of Lytton, North was far from alone: his four years as viceroy (1876–80) were controversial, particularly for his appalling mismanagement of the famine and his aggressive invasion of Afghanistan in November 1878, which precipitated the Second Anglo-Afghan War. The approaching planned invasion was on North's mind during October 1878 when staying at a bungalow on Sandakphu ('Sundukju') peak near the India–Nepal border on an expedition to paint Mount Everest (Ex. 41 and p. 152). After Bengal she travelled to Benares (Varanasi) and Mathura, and finally reached Delhi, where she stayed during November, painting at the Qutb Minar complex, Siri Fort ruins, and Nizamuddin Dargah (Ex. 42). Her last months in India were spent touring Rajputana, where Udaipur was a particular delight (Ex. 43). Upon leaving Udaipur she proclaimed it to be a 'wonderful city, so full of magnificence, and yet not three hundred years old!' In late February 1879, she boarded a steamer from Bombay, with an additional 300 paintings in her collection.

35.
FAMINE AND FLOODS IN MADURA (MADURAI)

The first part of my Indian journey was over white sand covered with Palmyra- and Fan-palms, and cacti; then came cotton, quantities of millet, Indian corn, gram, and other grains. The richest crops were just ripening, and ought to be the best cure for famine. But I also saw many human wrecks, all skin and bone, quite enough to teach one what starving looked like. The stations were crammed with coolies, beautifully picturesque figures, loaded with bangles: some of these were as big as curling-hoops. Mr. Thompson met me at the Madura station, and took me home to his comfortable bungalow. [...]

Starvation, floods, and fever were all round. The railway was washed away in nine places, and I could not have left it even if I had wished. The gardens were all flooded, the great river rising, tanks breaking on all sides. The Pandanus pines alone seemed to enjoy it, being buried in water up to the tops of their odd stilted roots. Every one was taking opium, so I followed the fashion, prevention being better than cure. The punkahs were kept going day and night, to blow away the mosquitoes; and if the punkah-pullers went to sleep, Anglo-Indians had squirts by their bedsides, to squirt water at them through the Venetian shutters. The natives had grown so much into the habit of expecting this, that they used to hold umbrellas over their heads (made of matting). They got two rupees a month for half a night's work. I saw some terrible remains of starvation about the streets. The relief-camp was on the other side of the river. It was so flooded that people could not cross without difficulty, and were constantly washed away and drowned, and I have seen them climb up the stone posts put to mark the ferry, and cling on to them for hours, till an elephant was sent to bring them on shore.

The squirrels in the roof were a great amusement to me. I watched one of those tiny creatures playing close to me with its child. At last the young one got on its mother's back, was carried right up to the roof, and along the rafters to the corner where the nest was, when a whole tribe of little creatures with ridiculous tails came out to meet it, with much chattering. Then the old one came down to watch me again. They were very tame, and not longer than one's middle finger, with tails rather longer than themselves, and the most intelligent ears.

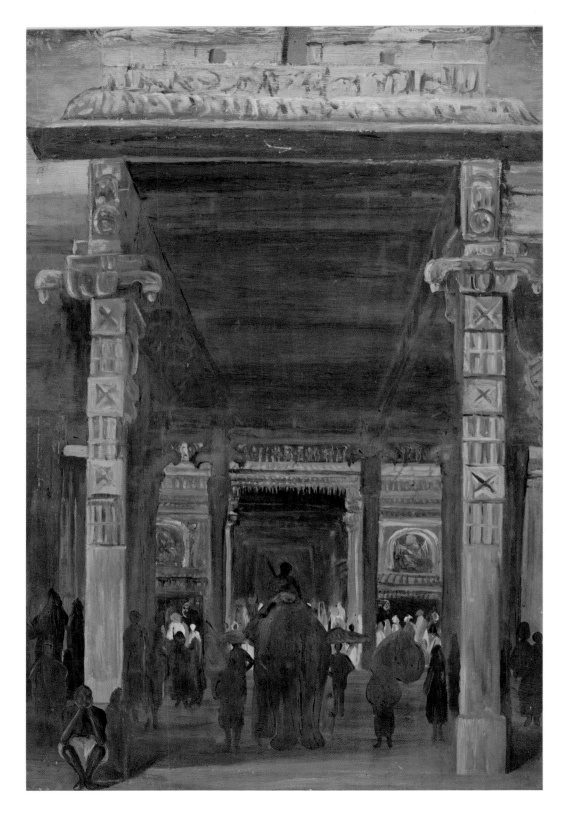

The rain came on again worse than ever. It was impossible to get away and dangerous to stay. The river was overflowing, and we were only a couple of yards above it, tanks bursting on all sides. No road out of Madura was practicable for more than a mile; all were lost in the floods.

36.

IN SEARCH OF SACRED PLANTS

Personal letters to A. C. Burnell, multiple dates in 1878

24 January. I am so glad you like the idea of our book of sacred plants. It will be a great pleasure to me to do my part and I am sure you will make the subject interesting [...]

I have made out most of the plants from Roxborough's *Flora Indica* here, and find the greater number flower in March and April and live about Calcutta and Bengal. The *Mimusops elengi* you mention in your note I had in my hand at Trivandrum but without fruit or flower – it looked like a rather uninteresting laurel, and I merely took the outline of the leaf to await a better opportunity. Dr. Houston also got me the *Ficus glomerata*, Nimbo [neem], *Bassia latifolia*, and *Erythrina* but all in the same way – I have merely learnt to know the look of their leaves. I hope to get the lotus here but the people are intensely stupid. But I have done a great many on your list and painted the Pandan's glorious red fruit and sandal wood. I cannot remember if you said those ought to belong to the set.

26 February. My object in going to Lanowli was to see the cave of Carlee ... Just under it was a most glorious Asoka with huge branches of lilac young leaves and orange flowers. And I found one most beautiful flower growing out of a honeycomb, with the stalks bedded in the wax close up to the flower, the honeycomb full of honey. I have painted it so, and you may write a romance about it if you will. No doubt the bees like that tree, the flowers are full of materials for them to store.

2 June. I was much provoked on return to Saharanpur to find two of my sacred plants had flowered. I got a miserable specimen of the *Nauclea* and the *Bassia latifolia* was quite over, I must do it with its fruit instead of flower. Mr. Duthie was so positive <u>none</u> of the plants I wanted would be out for a month, he told me so even after I reached his garden, and now says he depended on the "Molly" [Mali, a skilled gardener] – fancy

[opposite] *Gate Leading into the Temple, Madura.* North's painting of a scene at the spectacular and significant Meenakshi Amman Temple, a 14-acre temple complex at the heart of Madurai, Tamil Nadu. In *Recollections* she describes how two temple elephants with painted heads were accompanied through the temple by attendants each morning, one to visit the main Meenakshi shrine, the other the Shiva shrine.

[right] *The Asoka.*
Recollections and the gallery catalogue state that the honeycomb and flower specimen were given to North by the priest of a temple at the Karla (or Karli) Caves. 'The priest of the temple found me one fine flower growing through a honeycomb full of honey, which had been built around its stem,' she writes in *Recollections*. 'Now this was a very curious thing. Did the buds push their way through the honey and wax, or was the thing built quickly round them? I never satisfied myself which was the first perfected.'

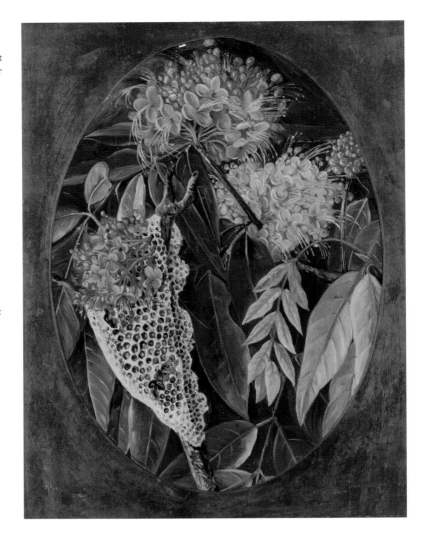

anyone in his senses depending on a "Molly"! When he is older he will be wiser, I hope.

6 June. I found your letter when I got here two days ago. I should like much to send the sacred plants to the Congress Exhibition if the collection were complete. But I still want the *Bassia latifolia, Mimusops elengi, Acacia catechu* and Soma, and the *Mesua ferrea*. The last I have in England and can copy if I get no fresh models, it belongs to Ceylon and the south. It was too provoking of Mr. Duthie to let me miss the *Bassia* flower, but I have written to ask him to send me a piece with the fruit in a tin box, if I do not get down, as well as the *Mimusops*.

22 July. I write just a line to say this old weathercock is going straight to Darjeeling tomorrow! Resting a day at Saharanpur and two or three at Calcutta where Mr. L. Thompson has telegraphed to some friends to put it up for a few days and where I hope to catch the Acacia Soma and Catechu and perhaps the iron wood tree in flower [...] if you want me to paint anything else there a letter to the care of the latter at the Gardens, or Post Office Calcutta, will find me.

14 September. At the Calcutta Gardens, Mr. Riedmann, in the absence of Dr. King, hunted with real good will for my plants. Neither was in flower. A learned Baboo in the garden thirty years says the Somi *Prosopis spicigera* is the acacia you mean, not the Suma. Bra[h]mins had come from far parts of India to get a bit of this tree, which he hopes may be in flower when I return next month. This Baboo is a most strict Hindu. He says he never passes the Ball [Bael] tree without bowing and picks a leaf every morning to keep next to his heart all day and then no evil can happen to him, as Siva loves it and all near it. He was so genuine in his belief of this it was delightful to see, and we became great friends. He said I must paint the "three [illegible]", *Aegle marmelos* (Ball), *Terminalia citrina*, *Santalum album* – (not the plant I thought it was), and *Emblica officinalis*. Also, the Hibiscus, Chinese Gooseberry (Blimbi) and Til, a kind of hemp which is grown much for its oil here. When I return to Calcutta in, October, I hope to stay in the gardens a few days and do these things.

37.
IN TANJORE (THANJAVUR)

I reached Tanjore by the earliest train, asked a policeman I saw to show me the way to the Doctor's [Burnell's], and walked under his porch about nine o'clock, to his great surprise, as he was sitting among his books deep in work, having expected me by a later train. Living with him was like living with a live dictionary, and was a delightful change. He had another clever man spending his Christmas holidays with him, Dr. N., who had written a book about Indian snakes, and the two talked deliciously together. I had a delightful upper room full of windows, looking over some miles of country. My table was loaded with different valuable botanical books (including MSS [manuscripts]). An old ayah sat on the floor in a corner to wait

[above] *African Baobab Tree in the Princess's Garden at Tanjore.* At least three paintings from Thanjavur feature in the gallery collection: a study of a cashew nut tree, this study of a baobab tree in the royal garden, and the Brihadisvara Temple.

on me and watch me, much to my discomfort, but as the doctor said it was absolutely necessary for her to do so, I submitted. He had all sorts of sacred Hindu plants ready for me to paint (he having undertaken to write their history at the same time, and to publish it some day with my illustrations). He made me feel quite at home, and in no hurry. He and his friend showed me the splendid temple, lingering over all its rare bits of carving and inscriptions till I felt at home there too. I know no building in its way nobler than that temple of Tanjore. The colour of its sandstone is particularly beautiful; its whole history is inscribed round the basement in characters as sharply cut as if they were done yesterday. I did one large painting of the outside, driving every afternoon to the point of view I had chosen, where the Princess of Tanjore had ordered a small tent to be put up for me, and a guard of honour to attend me! It was comical, but most luxurious. After the men had saluted me, they retired to a distance, and did not worry me. Dr. Burnell used to bring his papers and work there also when he had time; he worked day and night, never resting.

One afternoon we went by invitation to the Palace, in our best clothes. We drove in to the court through the gates, and were saluted by six elephants, all throwing up their trunks and roaring at us, much to the disgust of our big English horses, who had an especial dislike to them and to their ways. A flourish of drums and trumpets also greeted us, and his Excellency, the husband of the Princess, came down to meet us. He gave a hand to each, and led us under three scarlet umbrellas into a large hall, and up to the centre of it, over gorgeous carpets, till we reached a screen of silk interwoven with gold thread, chairs placed in a semicircle in front of it. Here I was delivered over to Miss Wolff, her Highness's English teacher, and led behind the mysterious curtain, where I found the Princess seated. After giving me her hand, she stooped down, lifted the curtain a little, and put out her hand for Dr. Burnell to take, who said such pretty things to her, that she kept her attention fixed nearly all the time on his talk with her husband on the other side of the curtain, thereby saving me the trouble of amusing her. She was a very pretty woman of perhaps thirty, with clear olive skin. Her head and limbs, nose and all, were loaded with ornaments, her toes all covered with rings and enormous anklets. Her drapery was of silver and gold embroidery, and she had a very sweet smile and voice. Behind her was a square frame like a shower-bath, covered with gold kincob, under which she walked when in public; but, except on that one expedition to Delhi, she had never left home. She showed me the medal and ring given by the Queen-Empress.

38.

TO THE
ELLORA CAVES

Personal letter to A. C. Burnell, 21 March [1878]

I posted my last letter at Nassick – such a curious place! The shores of the river [are] lined with pretty old Hindu buildings and steps and causeways, and a perfect fair going on amongst them, too much so for any possibility of comfortable sketching. You know it [Godavari] is a most sacred river, and every twelve years the actual Ganges finds its way through half a continent and refills the source in the heart of the mountains, which is very convenient for those pious people who cannot get so far as Benares and want to die in an orthodox way. I am sorry I did

[above] ***In the Kylas, Ellora.*** One of three paintings in Kew's collections depicting the Kailasa Temple, an elaborately worked rock-cut Hindu temple. The Ellora Caves complex (a World Heritage Site) features 34 monasteries and temples with sanctuaries devoted to Buddhism, Hinduism and Jainism. North wrote to Margaret Shaen that Ellora was somewhere she 'had always had a romance about'. She was not disappointed, writing that they were 'most noble and awe inspiring'. Her only laments were the ants and 'artistic despair' that she could not do such wonders justice.

not go to the source, but I had written beforehand (according to orders) to beg the loan of the Roza tomb from the officers of Aurangabad and did not like to keep their military red-tapeism waiting. How all these fixing of days spoil pleasure in travelling! I like to be entirely free to stay as the spirit moves me. So after a night in the Nandgaon station room I drove to Aurangabad, [the] "Dawk", a most benevolent Parsee, managing everything most excellently – all but the dust, which was most decided in its movements. Eight hours took me to Aurangabad where I saw the pretty tombs of Aurangzeb's daughter imitated from the Taj and, Fergusson says, belonging to a debased stage. Such a wild city of ruins! I got mobbed in the streets when I tried to shop and "John" got frightened and was useless but I got what I wanted – some gold lace to trim the red jacket I am going to make of your silk scarf, it is just what I wanted with the same red mixed in it, and the process of weighing it against rupees was very funny with an end dragging out to make it heavier.

The next day I climbed Daulatabad (for my sins) and then the tombs at Roza (also debased) but very pretty with the white painted chatties hung between all the arches for the doves to build in – all beautiful [illegible] and materials of white and the people there reading their Koran also in white dresses, with no colour but fig and nimbo [neem] trees and deep blue over all. But it is sad to see such fine cities completely ruined and reduced to dust heaps. Those Hyderabad people seemed to have passed their lives knocking one another to pieces. The mess bungalow was just outside the wall of Roza on the top of the cliffs which contain the Ellora Caves, a most airy spot with far views over the dusty plain – one great room with high domed roof and eight sides and high arched recesses – perfect quarters with no end of rubbishy shilling novels whose very names were unknown to me. But the caves were a good steep mile off and I felt the utter impossibility of doing anything good there under a month, at least. All the drawing is so complicated, but how grand! The grandest Cathedral I ever saw resting on the back of I know not how many hundred elephants, almost life size – and all hollowed out of solid hillside with a space between it and the rock which is full of galleries for the accommodation of artists – and ants! The ants there are the first I have met who have a taste for oil paints! And they positively made life unbearable and reconciled me to going away the next day, with only three miserable sketches, which I finished at Jubblepore. That is a nice place for rest, the "Nation Hotel" was perfection and the air fresh and wholesome always.

[above] *North's sketch of the mess bungalow where she stayed for two nights:* in fact, a Muslim tomb commandeered by the army. Khuldabad (as Rauza or Roza is named today) has religious significance to Muslims as the resting place of the Mughal Emperor Aurangzeb and other royal figures, and Sufi saints dating back to the fourteenth century.

SIMLA AND
THE LYTTONS

I went out in the jampany (an arm-chair with bearers) up to the top of the hill before breakfast, and saw three separate sets of snow-mountains, with craggy hills in front, having large pines and oaks perched on them; nearer still, native houses and bazaars, all most picturesque, with wonderful pine-tops and deodaras [Himalayan cedars] to fill up awkward places. I wondered what people had meant when they told me Simla was not beautiful. I found endless subjects to paint close to the Governor's house, and used to slip out before the live bundles in the hall had done sleeping, and shaken themselves up into a sitting posture for the day (which was all the toilet they ever performed). Simla was lovely in the early morning, but I met few people out then except natives. The English made the cooler climate an excuse for returning to their late home-hours. Lord Lytton set them a bad example, keeping up very late at night, and of course not appearing early in the morning. The visiting hours were from twelve till two, the hottest hours of the whole day. I used as usual to work indoors during the heat, and generally the Governor called me out for a stroll with him in the evening. He knew more about the plants and trees than any one I met in India.

One afternoon he proposed going in to the Simla Monday Popular Concert close by, and before I knew where I was, I found myself sitting in a great arm-chair next the gorgeous and lovely Lady Lytton in front of everybody, in my old looped-up serge gown and shabby old hat; the Governor being on the other side! I consoled myself by thinking it was quite distinguished to be shabby in Simla; and the Queen of Simla made everybody believe she was entirely devoted to them and interested in their particular hobbies while she talked to them. I was bad enough, but not quite so bad as the Governor's faithful bull-dog Flora, who always wanted to keep her master in sight, and came and sat down opposite to her ladyship, staring into her face, with great teeth grinning ferociously. The very sight of her frightened ladies into fits sometimes. The concert was chiefly an amateur one, and because one of the ladies was nervous, Lady Lytton made the Governor encore her song to encourage her. It was impossible not to love that

[below] *The Bazaars, Simla.* Kew's collections hold at least nine paintings representing North's time in Shimla. In the gallery there are two studies of deodar cedars and two of wild flowers, while the art collections hold three mountain views painted from Shimla, a study of a water fountain in the town, and this depiction of its bazaar (marketplace).

beautiful lady. I took my paintings one day, and had luncheon with them, in the middle of which entertainment the Viceroy lit his cigarette (like Salvatore Politi). He was interested in my work, and spent an hour or more looking at it. One night I went to a tremendous dinner there. About fifty sat down in the great dining-room, and a band played all the while. The table was quite covered with green ferns and ivy laid flat upon it, with masses of different coloured flowers also laid on, in set patterns. The yellow bracts of the enthamia, with bougainvillea, hibiscus, etc., formed separate masses of colour. The ladies' dresses were magnificent, Lady L. herself so hung with artificial flowers that she made quite a crushing noise whenever she sat down. Lord and Lady L. came in arm in arm, just as dinner was announced. I seemed to know nearly every one there in some way or other. After dinner an A.D.C. [aide-de-camp] carried a small chair for Lady L., who went about talking to every one in turn. The Viceroy also did his best to be civil to people. Our journey home was very amusing – about three miles of road along the ridge in the bright moonlight, the ladies all in jampanys, the men on horseback. I had a continual

gossip all the way with different people, and did not wonder at Anglo-Indians raving about the delights of Simla and its society, for there of course one met the very best people in India, in the very easiest and pleasantest way.

40.

BINSUR AND THE RAMSAYS

[below] *From Lady Ramsay's Garden, Binsur, Kumaon.* The Ramsays' home in Binsar was built on land purchased by Henry Ramsay in 1856. Today it stands within Binsar Wildlife Sanctuary, and the property is run as a heritage hotel under the name Tree of Life Grand Oak Manor.

Personal letter to Margaret Shaen, 13 August 1878

Three days more took me up and down the hills and through forests of oaks and rhododendrons to Almorah, the capital of this province. One long street of bazaars of a mile in length covers the ridge or hogsback of a steep hill which is quite covered with terraces of tea, [illegible], corn, millet and potatoes – a few trees only on the top – and the pink Lagerstroemia in full blaze of colour in the gardens.

I found a lot of letters waiting for me and one from Lady Ramsay asking me to come and see her at Binsar – you probably have heard of the General her husband who is called the King of Kumaon. He was made commissioner of that poor province more than 30 years ago and loved the country so much he begged that the appointment might be made permanent. He has

[below] *North's sketch of herself being carried in a 'dandy', a term for a simple litter carried by two or four men.* Doolies, jampanys, dandies and palanquins are all various classes and designs of open or covered chairs or hammocks, suspended on poles. North's writing contains many references to her travelling by these means in India.

built houses, made gardens and ruled as a benevolent despot (the only call for half civilised races) and when the mutiny broke out he pulled up the roads and offered a judicious bribe to the Gourkahs [Gurkhas] and kept all quiet – and safe. He is a grand old fellow and reminds me of old Dan O'Connell in looks and manners. His house at Binsar is nearly 8000 feet above the sea and the snow views are the grandest I ever saw anywhere – five distinct giants, not a lone one as in the other Himalaya views I have yet seen, and the oaks (white lined leaves) are monstrous and their trunks twisted in the most picturesque way with moss and ferns nearly covering the branches. The rhododendrons are nearly as big with pink coloured bark when damp (a chronic state at Binsar). You can fancy I worked hard!

Lady Ramsay and her daughters were very nice, and it was a joy to see the grand old King digging in his shirt sleeves. His greatest pride was his gooseberries and Ribston Pippins, which he declared would win prizes even in England. And I

never saw such big lumps of butter, made by a native sitting in the passage with a spoon in a soup tureen of cream. He was always at it, one heard the pat pat pat always going close to the sitting room door. If it did not go pat pat Lady R. enquired what had happened. She supplies all her friends in Almorah fourteen miles below. Such [illegible] too and heliotrope, and honeysuckle and verbena, all sweet flowers there. There are not many flowers now but I have seen six different ground orchids since I came to Kumaon, and the wood anemones are almost as high as those you call Japanese in England.

The Genl [General] made up his mind, as it was too uncertain weather for me to go near the glaciers and see the biggest known deodaras, to send me in search of a grove of the next oldest he knew and I am now on my way. He lent me a most capital factotum [servant] of his own who runs like a deer and cooks, and ordered me coolies and another chaprasi to look after them from Almorah. I am now writing this from my several day's march from there. I have been in the clouds more or less all day but do not repent having come, the breaks are so lovely and this outdoor life is intensely enjoyable, the bungalows always clean. I am going to have a fire tonight – my old chaprasi enjoys puffing at it. He is such a good old man I never wish for a better servant – though we have few words in common we always understand one another. Tomorrow I hope to go to Dibee Dhoora Dee where the trees are and some small temples, and hope for sunshine to sketch. Then three days back to Almorah where I am to stay with Mr and Mrs Pearson a while – Sir Henry Ramsay's greatest friends and very agreeable people. She paints flowers in water colours very nicely and knows a good deal of the things of the country as she goes camping about with him more than half her time.

41.
A VIEW TO MOUNT EVEREST

Personal letter to A. C. Burnell, 7 October 1878
Sundukju, 7th October
14000 feet above the sea
Dear Dr. Burnell,
Your note followed me here and I am so sorry you have been so suffering. I believe starvation is a grand cure for some people

[below] *Mount Everest or Deodunga, from Sundukpho, North India.* When naming mountains, it was the general practice of the GTS to use local names. In the case of Everest, the Surveyor-General Sir Andrew Scott stated that no definitive local name could be ascertained. His suggestion to name the mountain after the previous surveyor-general was objected to, even by George Everest himself. Brian Houghton Hodgson, a former Resident to Nepal, favoured the name Deodungha (meaning Holy Mountain), which was used in Darjeeling – but in 1865 the name Everest was confirmed by the Royal Geographical Society.

and complaints but not for all. I am sure it agrees with me. So you are going to England before me? Won't you be cold, that's all! For I am going to start the end of February, probably. I get a taste of the kind of climate here, for I was sitting in the midst of white frost this morning, painting the highest mountain in the known world. It is not so beautiful as Kangchenjunga and if it had not such a high reputation I should have preferred doing my old friend again – it did look so magnificent from here and is so beautifully balanced between its two wings.

I wonder how the life I am now leading would suit you – this bungalow has absolutely no furniture except one chair and I have to roll myself up in my quilt before the fire on the floor, so close that I can put on fresh logs without getting up, for if once I let the fire out I should be frozen! That's comfort! I shall not be entirely sorry to get back to a warmer climate again. But it was worth some trouble to see the glorious views and vegetation I have seen lately, the great tree rhododendrons with huge leaves lined with brown and white plush and flowers which would send me wild if they were in bloom. Hydrangeas also grow into timber trees here, and there is a blue tree poppy four of five feet high, and such monkshood and tiny alpine flowers. One Balsam wishes to be taken for an orchid, it is entirely like through my

[below] *North's sketch of the mirage she saw while at the summit of Sandakphu.* In *Recollections* she describes this as 'a most curious reflection of myself and the sun's disc in the mist, opposite the setting sun, with a gold halo and rainbow tints round it. It would have made a good suggestion for a Madonna or saint's picture.'

magnifier. What for? It puzzles me. I will send you Johnnie's [John Addington Symonds] poems by the post which takes this. I can't read them, perhaps you may be able. They seem such twaddle, and the language so tortured. Did you see the Viceroy mentioned me in his speech at the opening of the Simla expedition as "the accomplished sister of an accomplished brother-in-law"! Rather a poverty of adjectives.

I shall be so glad to get to a warm place again. It is positively too cold to paint but I have just seen myself "the spectre of [illegible]" from the top. Half an hour before sunset my shadow appeared on the opposite mist surrounded by a halo of gold, and a rainbow coming out of the top of a Rhododendron tree. What a good miracle it might have made for one of your Jesuit friends. I wrote the colours down and their proportions and mean to paint it. This morning too there was a grand sunrise. Mount Everest gets the sun's rays after the lesser but nearer

giant, and was still a cold greenish white when the cloud over it was such a vivid salmon that the cotton wool clouds in which the lower world was packed reflected the upper brightness – a lazy way of becoming conspicuous.

42.
THE RUINED CITY OF SIRI AND THE NIZAMUDDIN DARGAH, DELHI

After three nights the D.s [the Davies] rode away, their camp disappeared, and I remained in sole possession of the dead city and enjoyed its quiet. But the mornings got almost too cold for me to hold my brush, and I wandered about the ruins instead of attempting to sit and work, till the sun warmed the day. I found endless beauty in the old ruined city of Siri behind the Kutab. Some of the mosques were most elegant, with marbles and coloured tiles let into their walls and ceilings. In one building were exquisite medallions in fine plaster-work, which I longed to steal; nothing could be more beautiful than their designs, and they were only crumbling away there. Every dome had a big bird sitting on its point, generally a black vulture with a white head, and so motionless that they looked as if part of the stone-work; but the whitened bones which strewed the ground explained why they haunted that place. Nearer me, the camp-horses had left an abundant harvest for the squirrels to gather in. They came in crowds to the place, and were most tame and pretty to watch. I nearly caught one little fellow, head downwards on a branch of a tree, nibbling at one of its pods as it hung. The cold also brought the mina-birds and doves down on the ground, with their feathers all ruffled up, making believe they had fur coats on. It was sometimes rather lonely and awesome among those tombs of the old city, with the wild dogs, vultures, and bones. One morning I did not like the looks of the people. First a child came to beg, then a woman, then a fierce man who ordered me to give them backshish. I always pretended not to understand, and never had any money to give, but I did not like the scowls I saw, or the looks of other men who mounted up the towers, and seemed to be looking out to see if I had any friends or was watched. I thought discretion the best part of valour, so went back to the shade of the Kutab, and within reach of its guardians, and began a sketch of the big arch and iron pillar from under the Hindu colonnade. The old trees must have been

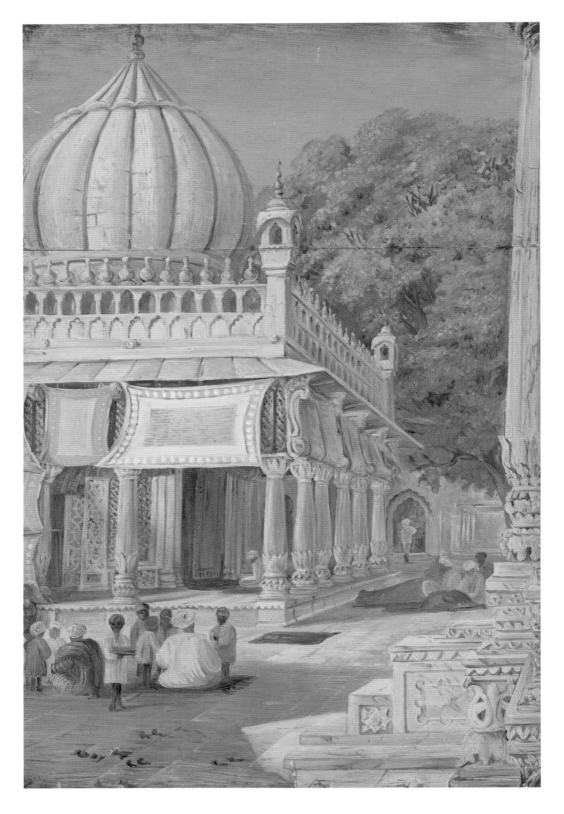

as old as the Kutab itself, possibly much older. The iron pillar is supposed to be the pivot on which the earth turns, and to go down to its very centre; and though some English engineers dug down underneath it some two yards, the Hindus did not cease to believe the story, and said the English thought they dug underneath it, but the gods muddled their brains.

On the 24th I drove away from the Kutab and across to Nizamudin – a most lovely little tomb and mosque of white marble with richly coloured praying-carpets hung up as blinds, and a grand old tamarind-tree over it. A fine old Moslem was keeping a school of little boys in the court, all the children gaily dressed, and standing on bright carpets spread on the marble pavements of the court as foregrounds. What a subject it was, if I could but have done it as I wished to do it! Another picture close by attracted me – a deep tank with tumble-down old buildings round it, and another old tree on the top of the steps, the faithful doing their prayers and ablutions on its edge. It was difficult to tear myself away, but at last I did, drove on to Delhi, and put up at a hotel made out of a collection of old tombs strung together, my bed being under a beautiful dome.

43.
CITY OF LAKES

At the last stage an elephant was sent out to meet him by the greatest noble of Udaipur, whose brother he had been to doctor; but Dr. S. preferred the easy carriage to the slow lounging pace of the more dignified elephant, and we passed through the great gate which fills up a chasm in the hills seven miles from Udaipur (and is the only entrance on that side) just as the last remnant of daylight faded from the sky. The rest of the drive was made by the light of the stars. Even in that light I could distinguish the city glittering like a group of pearls, with the marble palace above it, and the lake behind, surrounded by bare mountains. Then we turned up a side-road to the Residency – a picturesque mass of Oriental buildings, fitted with English comforts, which I had all to myself, as the Doctor went to his own quarters, in a tent, half a mile off.

The next morning he came early and took me in the grand carriage, which was put at my disposal all the time I stayed, by the Rana, and we drove through the old gates into the city

[right] *Lake of Islands, Oodipore, Guzerat.* North made at least 13 paintings while in Udaipur. This painting shows the Lake Palace (now run as a hotel), located on the island of Jag Niwas in Lake Pichola, Udaipur.

and through the busy bazaars to the grand Jaganāth Temple in its centre – one of the richest bits of Hindu work I had seen in India, great elephants of stone guarding the top of the steep flight of steps which lead to it. Then we walked down a steep street to the water-gate, and the full glory of the lovely lake burst upon us, with its distant islands of palm-trees and marble palaces, and its nearer orangery surrounded by white marble arches and pavilions with exquisite tracery. Still nearer, palaces, gardens, and gates, all reflected in the still blue waters, and over all the pale salmon-coloured hills, with their lilac shadows, so faint, yet so pure in colour. The people who were washing and filling their water-jars in the foreground, were covered with the richest colours, every shade of red preponderating. We found the Rana's boat waiting for us, rowed round all the islands, and walked in their lovely gardens and courts. In one of these sixty English women and children had been sheltered, clothed, and fed during the mutiny by the good Rao of Baidah. He went with his drawn sword to the Rana, and said he would kill him if he did not help them; then took an escort and rode off ninety miles to Nimach, and brought them safely back with him. It was a

small paradise, but no doubt they thought it a prison. This good old man had a great liking for Dr. S. He came and paid me two visits, looked at my paintings (and held none of them upside down). He was a most noble old man, full of intelligence, and he told me many things I did not know about the different plants whose portraits I showed him. His dress was exquisite, all black and gold, with diamonds and pearls all round his neck, and a snowy turban with a bit of turquoise coloured silk twisted into it, his long black whiskers and moustache tied back over the tops of his ears. He used to send me a great basket of vegetables and flowers every day, as well as barley-sugar cakes and nuts.

On the island where the sixty women were lodged grew cocoa-nuts, palmyra-palms, mangoes, bananas, pomegranates, oranges, and lemons, with plenty of lovely flowers, all kept in the best order, and stone elephants half under the water. At the landing-place the lake was very full, and we rowed up into odd corners and inner lakes, as wild as any in the Highlands of Austria, only inhabited by wild boars and peacocks.

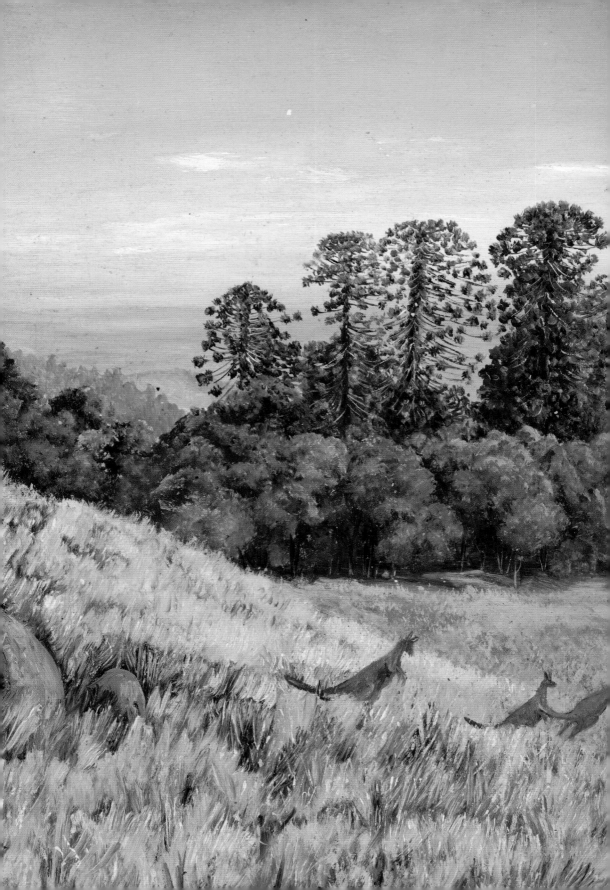

PART IV. 1880–1885

Representing the
World's Vegetation

Chapter 12

Australian Adventures

AUGUST 1880–FEBRUARY 1881

Marianne North travelled to Australia from Singapore after her second visit to Sarawak. Her travels took her through Queensland, New South Wales and Victoria, from where she sailed to Western Australia before heading eastwards again (via Victoria) to Tasmania. These Australian states were separate British Crown Colonies at the time, self-governing except for Western Australia. By the end of the nineteenth century, Australia (along with New Zealand) was largely politically independent, and it went on to be officially granted 'Dominion' status in 1907, with subsequent constitutional evolution further loosening bonds with Britain during the twentieth century.

North's first destination was Brisbane, where she arrived on 8 August 1880. She spent a week painting in the city's botanic garden while staying at Government House as the guest of Lady Bell and Sir Joshua Peter Bell, the acting Colonial Administrator. The Bells arranged her four-day expedition to the Bunya Mountains with their cousin Samuel Moffat ('Mr. M.') and his family (Ex. 44). Afterwards she travelled to Harlaxton, home of Francis Thomas Gregory, a noted explorer of Western Australia who remembered meeting Darwin in 1836 during the second voyage of HMS *Beagle*. From early September she toured New South Wales, initially travelling with Cobb and Co coaches in the company of a 'Miss B.'. In Sydney she received a guided

tour of the botanic garden before travelling to Camden Park, where she stayed as the guest of Sir William Macarthur, one of Australia's most influential horticulturists. His father, John Macarthur, had been a prominent British colonist in New South Wales, and a pioneer of the Merino wool industry. She considered Camden Park 'certainly the most lovely garden in Australia' and during her stay painted specimens of the 'monster' Chilean wine palm (*Jubaea chilensis*) planted by William Macarthur 50 years earlier. The Macarthurs lent North a buggy and a driver for a week's tour of the coastal region where, between visits to the Osborne family's many properties, she noted the deliberate burning of forests to clear land for farming (Ex. 45).

She reached Victoria by late October, and stayed in Melbourne before taking a coach to Fernshaw to paint in the eucalyptus forests (Ex. 46). The person mentioned in North's account as 'the Baron' was Ferdinand von Mueller, one of Australia's foremost nineteenth-century botanists and the first director of the Royal Botanic Gardens, Victoria. Back in Melbourne, North boarded a steamer to Western Australia, landing in Albany. Her first host there was 'Mrs. R.', the botanical artist Ellis Rowan (1848–1922), who like North was in Albany to paint the flora (Ex. 47). Rowan later wrote that she became

[opening spread] *View in the Bunya-Bunya Forest, Queensland, and Kangaroos.* Five gallery paintings relate to North's expedition to the Bunya Mountains, including a study of the bunya pine (*Araucaria bidwillii*). This painting, a view from a hilltop near to North's camp in the Bunya Mountains, shows the tall pines in the distance, with a foreground depicting the first kangaroos she saw in Australia.

[page 182] *Australian Bears and Australian Pears.* The gallery catalogue caption for this painting states that the koala depicted was made from 'a young pet in Victoria.' The koala was the pet of Ellis Rowan's son, which North painted while visiting their family home in Melbourne. She wrote in *Recollections* that, 'he had huge ears and astonished ears, and was not so big as a cat. He was the best of sitters, as his activity came on only at night, when we carefully fastened him into his box. How he got out no one knows, but the next morning he was found sitting demurely on the doorstep, wishing to go into the house, with his funny claw-like paws crossed, looking the picture of sleepy innocence.'

North's 'devoted admirer' – and for her part, North subsequently promoted Rowan's art, drawing it to the attention of Kew, personally purchasing many of her paintings, and orchestrating the display of one hundred of her artworks at a colonial exhibition in London. North stayed with another accomplished flower hunter in Perth, Lady Margaret Forrest, and her husband Sir John Forrest, explorer, surveyor-general and future premier of Western Australia. Margaret Forrest provided North with specimens and accompanied her to Newcastle (Toodyay) in December to see and paint a flowering *Eucalyptus macrocarpa*.

In late January 1881 she travelled to Tasmania. Thomas Stephens, a keen geologist and geographer employed as the Inspector of Schools for Tasmania, had booked her rooms in a boarding house in Hobart but, after she called at Government House to pick up letters, Lady Lefroy and Governor John Henry Lefroy invited her to stay at Government House, and North soon moved there. In her first days she enjoyed walks around kunanyi / Mount Wellington (Ex. 48), guided by the curator of Hobart Botanical Gardens Francis Abbott ('the Head of the Gardens') and, on another occasion, by Judge William Lambert Dobson ('Judge D.'). Before a spell of poor weather restricted excursions, the Lefroys took North to Port Arthur, a colonial penal settlement where convicts were transported from the 1830s to the 1850s, where they visited the empty prisons. Today, Port Arthur is one of the eleven penal sites that jointly form the World Heritage Australian Convict Sites.

As her time in Tasmania continued, North struggled with fatigue and faltering spirits, unable to enjoy the trips or to sketch as she felt was expected of her by her hosts. Nevertheless, she travelled south to Geeveston (named Franklin in *Recollections*) and then back up to Ferntree near Hobart, before leaving Tasmania for New Zealand on 18 February 1881.

THE BUNYA
MOUNTAINS

We had our mid-day rest, all among the grass-trees, near a hollow, where a little bad water was found for the "Billy" – a huge saucepan, which we boiled and then half filled with tea. Into this our cups were dipped, after the primitive custom of the country. After that we went on again till we reached the steep ascent where we were to leave the carriage. I was mounted on the best horse, and started ahead with Sam the Chinaman, who had been disagreeing with his horse all the way, and was in an awful temper now. It was his usual state: no one minded "Sam," who made the best bread in all Australia.

I soon passed him, and much enjoyed my entire solitude through the grand forest alone, especially when I reached the magnificent old araucarias. Their trunks were perfectly round, with purple rings all the way up, showing where the branches had been once, straight as arrows up to the leafy tops, which were round like the top of an egg or dome, and often 200 feet above the ground. Only the ends of the branches had bunches of leaves on them, and only a third of the stem had branches left on it. But these grand green domes covered one hundred miles of hill-tops, and towered over all the other

[right] ***Our Camp on the Bunya Mountains, Queensland.*** North camped with the Moffat family during a four-day excursion to the Bunya Mountains. The gallery catalogue caption acknowledges the tree's cultural significance to Aboriginal Australians and discusses the bunya gatherings, traditionally held triennially during the major harvesting season. White settlement, the subsequent displacement of many Aboriginal people and the felling of trees for timber ended this important community custom around 1900. In recent years, the Kabi Kabi elder Aunty Beverly Hand has reimagined the traditional gatherings and revived them in a contemporary form; the most recent Bunya Dreaming gathering was held in 2019.

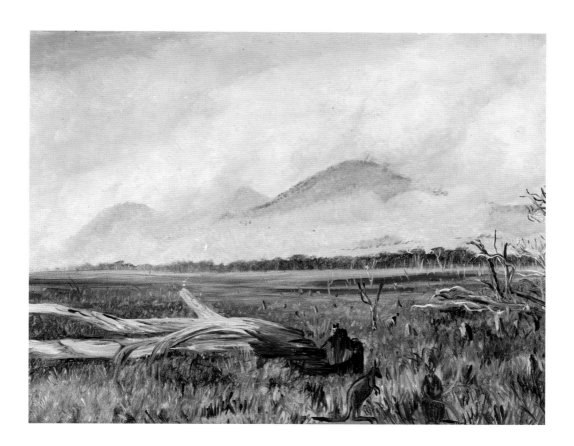

trees of those forests. Nowhere else were the old bunya trees to be seen at all; and at the season when the cones ripened, the native population collected from all parts and lived on the nuts, which were as large as chestnuts. Every tree was said to belong to some particular family, and they produced so great an abundance of fruit that it was also said, the owners let them out to other tribes on condition that they did not touch the lizards, snakes, and 'possums – a queer form of game-preserving, which reduced the hirer to such a state of longing for animal food that babies disappeared, and then there was a row, and no white person ever ventured on those hills while the bunya harvest was going on. Under these giants there was a fine undergrowth of every shade of green, brown, and yellow, roped together by fantastically twisted lianes, and great creeping roots, like the snake-tree of Jamaica, dracaenas, ferns, and the sandal-wood raspberry. After half an hour of this scrub I came out to the

clearing, where our tents were being put up, having arrived only a little before us, owing to the difficulties of the road.

The rest of the things arrived in the course of the night, when the horses, not finding it comfortable, trotted off home, thirty miles without a house, and scarcely anything like a road, but no one troubled himself about them. We found many of the trees hung with whip-birds' nests – long hanging pockets of the greenest moss, the entrance often decorated with the feathers of the blue and red parrot, one of the commonest birds there. The whip-bird has a pretty bronze crest, and makes a call like the whistling of a whip. We climbed up to the top of the highest point, and got a grand view over the yellow burnt-up plains, with now and then patches which looked like lakes, and miles of forest-covered tops.

45.
I WISHED
I WERE AN
OSBORNE

They lent me a buggy with a fat horse and driver for a week, and I went through pretty scenery till I reached the top of the Illawarra Mountains, and went down the wonderful bit of road to Balli. [...] But it was always raining in this unexpected bit of the tropics, and I had no easy task to finish a picture there. Three times I packed up my things in disgust, and at last brought home my paper wetter with rain than with oil-paint. People were all related to one another, and all hospitable, and I drove from house to house, only regretting that the horse and buggy were not my own, when I could have stayed much longer with enjoyment. Another day I stopped to paint a gigantic fig-tree standing alone, its huge buttresses covered with tangled creepers and parasites. The village was called Fig-tree village after it, and all the population was on horseback, going to the races at Wollongong. At Mr. H. O.'s I saw a grand specimen of the "red cedar." It had leaves like the ailanthus, but its wood smelt like cedar pencils, and was red as mahogany, which gave it its name. The tea-trees there were covered with tiny white bottle-brush flowers, and were rosy with their young shoots and leaves. Another sort was called the paper-bark tree, *Melaleuca leucadendron*. One could pull lumps of soft paper from it, tear it apart, and write on it without difficulty in a blotty sort of way. [...]

[right] *Illawarra,*
New South Wales.
This painting shows a
paperbark tree (*Melaleuca*
sp.) and a flowering pink
tip (*Callistemon salignus*)
that North painted in
the garden at one of
the Osborne family's
properties in the Illawarra
region.

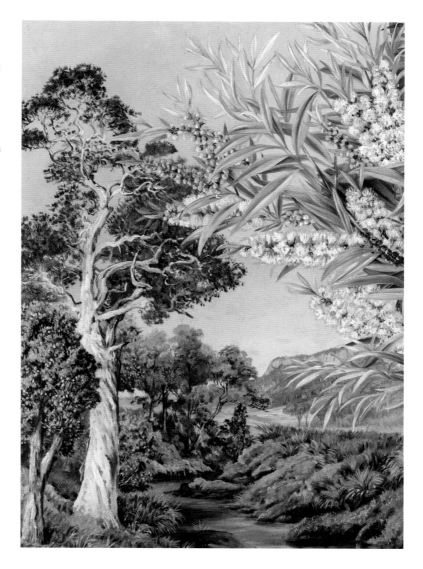

The garden at Doondale was a sight to see: pink and white
Azalea indica fit for London shows, bougainvillea with three
yellow blooms at once in their purple bracts, flame-trees
(*Sterculia*), gorgeous Cape lilies, and all our home-flowers in
perfection. I was offered the loan of this lovely house for a
month, when they were all going to another house on the cooler
side of the hills. It had a valley of ferns a mile off, and one could
see miles of cabbage-palms below like gigantic Turk's-head
brooms, such as housemaids use to sweep away spiders with.

The road along the coast to Kiama (pronounced "Kye-aye-mar") was dreary enough, through miles of tall dead trees all ringed or burnt to death purposely by civilised man, who will repent some day when the country is all dried up, and grass refuses to grow any more.

At the lake of Illawarra we again found ourselves in the tropics, all tangled with unknown plants and greenery, abundant stag's-horns, banksias, hakea, and odd things. I put up at the house of a pretty little widow, who apologised for having a party to say good-bye to some friend. They danced till morning, soon after which she was up to see me off. Before this I had wandered on the lovely sea-sands, seeing and hearing the great waves as they dashed in and out of the blowholes. Rocks and giant fig-trees grew close to its edge, and I found basalt pillars as sharply cut as any on the Giant's Causeway itself. The road up the Kangaroo river and over the sassafras mountain is pretty. I tried to make out the sassafras leaves by their scent, but nearly all the leaves were much scented on that road, and it was not till some time afterwards that I made out the tree. After turning the top of the hill we came suddenly on the zamia or cycad – a most striking plant, with great cones standing straight up from the stem. When ripe the segments turn bright scarlet, and the whole cone falls to pieces, then they split open, and show seeds as large as acorns, from which a kind of arrowroot can be extracted, after washing out all the poison from it. The natives roast and eat the nut in the centre of the scarlet segments. There were no zamias outside that valley, which seemed to have no outlet. Like that of the Yosemite, it was discovered by a mere accident. It belonged, like the greater part of Illawarra, to the family of Osborne, who were building a large house there. It was certainly the most enticing part of Australia, and I wished I were an Osborne.

46.
GUM TREE GIANTS

After leaving Healesville I got on the box-seat, and saw the lovely forest as we mounted the steep ascent. The driver said he did not believe any of the trees were 320 feet, and that they could make the Baron believe anything they liked; but it was a noble forest. The trees ran up like gigantic hop-poles, with

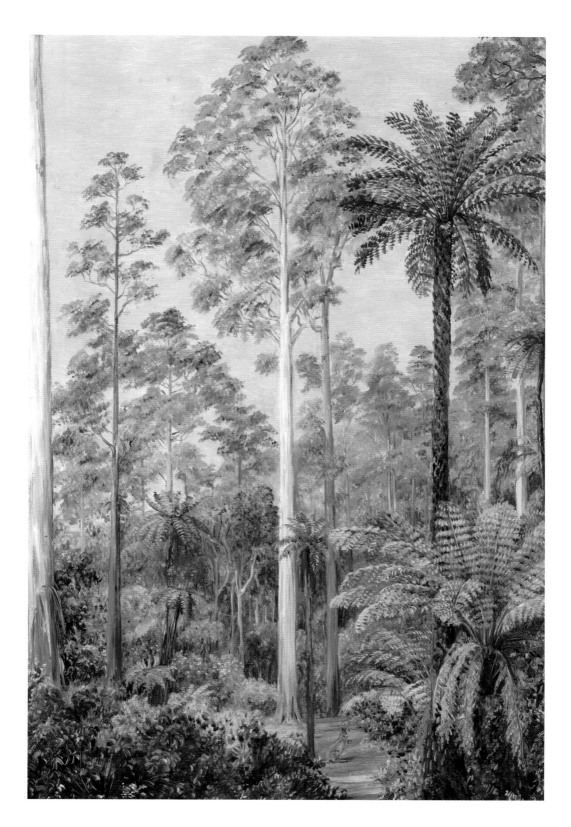

thousands of tree-ferns under them, also straight, and thirty feet high, swelling much at the base of their stems, a nice undergrowth of young gums and other shrubs under them again. The little inn at Fernshaw was perfect quarters, with a lovely little garden of sweet flowers, surrounded by the forest, and with two nice girls and their brothers to take care of me, their only guest. One of the girls took me out for a walk at once, crossing the stream by a long straight fallen tree for a bridge; then we walked under the fern-trees to another fallen tree, of which I could not see the end, but which was being sawn up bit by bit to use in building some new rooms at the inn. We found our way under the lace-work roof of fern-fronds to a small stream, which was also arched over by them. Their stems were green with moss and parasites, wire-grass, ferns, and creepers; over them was a lovely tecoma, with white flowers tipped with deep red purple, hanging among its glossy green leaves. There was a delicate moss on the ground with flowers like Maltese crosses, and tiny white and purple violets without scent.

The musk-tree was just coming into masses of white bloom, its leaves magnificent, polished like those of the great American magnolia, with white linings. It is difficult to realise the great height of those gum-trees, they are all so much drawn up. It was two and a half miles up hill to get to the tallest group, and was very cold, with some rain. I was glad to warm my half-frozen fingers by a fire in one of the blackened tree-stumps now and then. Not a creature passed me all day, and there was no noise, except the songs of birds and the jeerings of the laughing jackass. The leaves of those amygdalina gums were much larger and darker in colour than the other sorts I had met with; its young shoots were copper-coloured, and the stems were just peeling off their old bark, showing all sorts of delicate gray and red brown tints. The tree-ferns (chiefly dicksonias) were unfolding their golden crowns of huge crooks. Every step brought me to fresh pictures, but it was impossible to give any idea of the prodigious height, in the limited space of my sheets of paper. The Baron had said, "One thing I must entreat of you, Mees; when you will go to the forest, make a boy go before you and beat about with a stick, and please, you will always keep your eyes fixed on the ground, for the serpents are

very multitudinous and venomous." But the girls told me the only place a snake is ever seen is on the high-road; there it is dangerous. Snakes here only like dry places.

On the 5th of November the loyal Protestants of Fernshaw made a circle of great fires all round the house. Their effect among those tall trees was a wonderful sight, but the trees were so full of moisture that there was no danger of fire spreading, they said. A woodman told me that he had often felled trees over 400 feet high. "When they was down you could easily stump them off, and there could be no mistake about that," he said. The highest the Baron measured was 365 feet, and I painted that very tree, a white gum. There are over three hundred of these giant trees.

47.
ELLIS ROWAN, AND A NATURAL FLOWER GARDEN

Mrs. R., the flower-painter I had heard so much of, sent her friend, the young manager of the bank, to meet me on board, and to bring me to the little cottage she was lodging in, where she had kept a room for me, and at once introduced me to quantities of the most lovely flowers – flowers such as I had never seen or even dreamed of before. The magistrate, Mr. H., came soon after, and wished me to go on to stay at his house, but I was too well off to move. He told me the only way of going to Perth was either by the horrid little coasting steamer once a fortnight, or by the mail-coach, which also went once a fortnight, travelling day and night, with passengers and boxes all higgledy-piggledy, any quantity in a sort of drag or open cart. It generally broke down and killed one or two people. If I hired a private carriage, it would cost me £25 for it alone, without the horses. I said "Thank you," and wrote to the Governor by the mail just starting, who telegraphed in reply that he would send me a carriage at seven shillings a day hire, and I might have the free use of police-horses and a driver as long as I stayed in Western Australia, to take me wherever I wished. Long live Sir H. R.!

So I stayed on at Albany till the carriage came, and found abundance to do. The garden of our little house led right on to the hillside at the back, and the abundance of different species in a small space was quite marvellous. In one place I sat down, and without moving could pick twenty-five different flowers

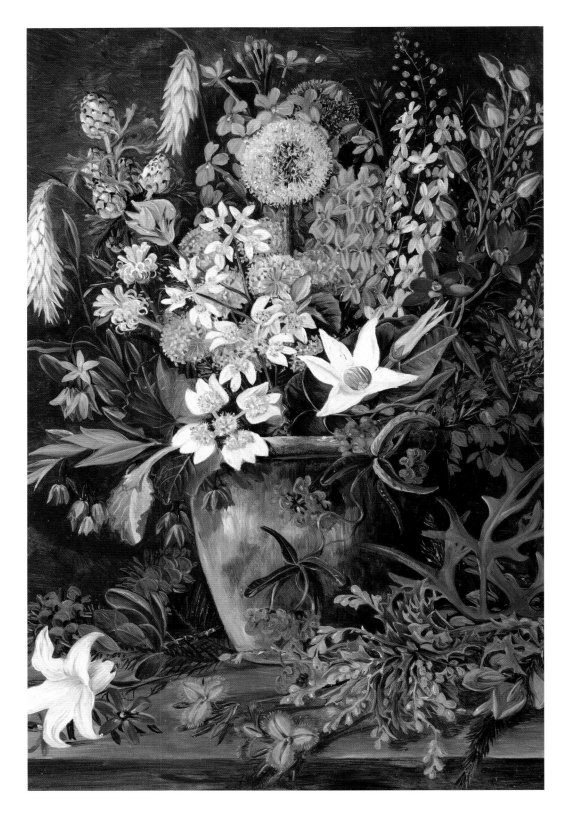

MARIANNE NORTH'S TRAVEL WRITING

[opposite] **Wild Flowers of Albany, West Australia.** The gallery catalogue gives details of 12 species depicted in this cornucopia of Western Australian flowers.

within reach of my hand. The banksias were quite marvellous, their huge bushy flowers a foot in length, and so full of honey that the natives were said to get tipsy sucking them. The whole country was a natural flower-garden, and one could wander for miles and miles among the bushes and never meet a soul. The difficulty was to choose the flowers. One was tempted to bring home so many, and as they were mostly very small and delicate, it was not possible to paint half of them. Mrs. R. did it most exquisitely in a peculiar way of her own on gray paper. She was a very pretty fairy-like little woman, always well-dressed, and afraid to go out of the house because people stared at her. I admired her for her genius and prettiness; she was like a charming spoiled child. There was one interesting person beside in Albany, Miss T., who had a weak spine and could hardly walk a step, but she could ride all day long, and knew where all the rarest plants were to be found; she kept Mrs. R. supplied with them.

48.
KUNANYI / MOUNT WELLINGTON

Before I went to stay at Government House, the Head of the Gardens came and drove me up the Huon road to the shoulder of Mount Wellington; thence we walked to St. Crispin's Well, where there is a tablet to the memory of Mr. Crispin, a shoemaker, who grew rich and started the great waterworks of the city. Strangers and custom have gradually canonised him, and surely he had deserved the honour more than most saints! Four miles of walking took us to the lovely spot where the clear water bubbles out amongst the fern-trees and all kinds of greenery. After a rest we plunged right into the thick of it, climbing under and over the stems and trunks of fallen trees, slippery with moss, in search for good specimens of the celery-topped pine, of which we found some sixty feet high. It was not in the least like a pine, excepting in its drooping lower branches and its straight stem: the leaves were all manner of strange shapes. We also saw fine specimens of sassafras (which yields an oil rivalling the real American sassafras in value), and the dark myrtle or beech of Tasmania. Quantities of the pretty pandanus-looking plant they call grass-trees or richea, really a sort of heath. The whole bunch looks like a cob of Indian corn,

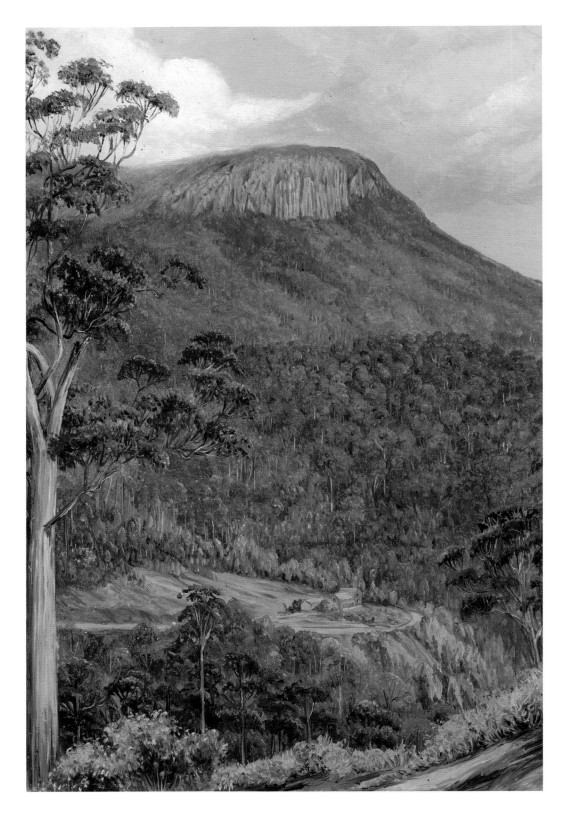

[opposite] **View of the 'Organ Pipes', Mount Wellington.** Tasmania's capital city Hobart sits at the foot of this mountain. Kunanyi is the mountain's name in palawa kani, a reconstructed, composite language developed from the remnants of the multiple original languages spoken by Tasmanian Aboriginal communities. In 2013, Tasmania's adoption of its Aboriginal and Dual Naming Policy for geographic features and places was announced from the mountain's foothills.

each corn like a grain of white boiled rice, which, again, when shed or pulled off, sets free the real flowers – a bunch of tiny yellow stamens, with the outer bracts scarlet. There is also an exquisite laurel, with large waxy white flowers. There were many gum-trees, some of them very big, but mostly peppermint or "stringy-bark." The famous blue gum (*Eucalyptus globulus*) was rare even there: strange that this should be almost the only species known or grown in Europe.

Another day I scrambled up a staircase of fallen trees and tree-fern trunks, by the bed of a half-dry stream, for 1500 feet, till we reached the first ridge of the mountain, where an old convict and his wife lived summer and winter by boiling tea-kettles for visitors. After that I was led by Judge D. and his son to the foot of the basalt cliffs under the top, and was shown many pretty berries and flowers peculiar to the mountain. The Judge loved the place so much that he and his brother had bought the greater part of the mountain, to prevent its forest being destroyed and the flowers exterminated. It was a grand position up there – a perfect moraine of fallen stones, squared and cornered by volcanic action below, and above were gigantic walls and pillars, sharp-cornered and dry, without even the relief of plants among them; but all around were endless varieties of small shrubs, now loaded with beautiful berries, the flowers being over. Few capitals in the world have such a wild mountain-side near them.

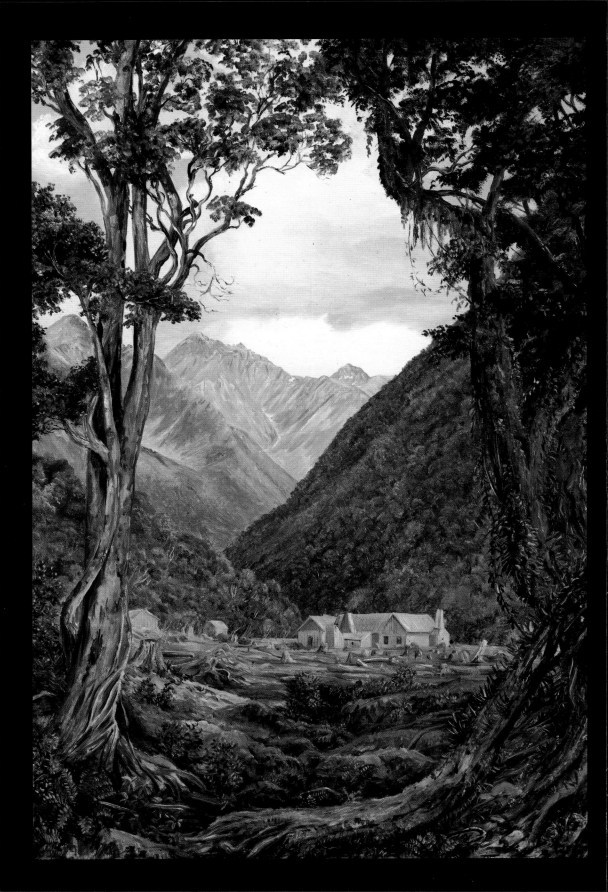

A Month in New Zealand

By the time North arrived in New Zealand from Tasmania she
was exhausted. Her first destination was Lake Wakatipu near
Queenstown, where she stayed until 1 March (Ex. 49). She travelled
from there to Christchurch to meet her cousin, the sheep farmer
and notable naturalist John Enys (1837–1912), who had emigrated to
New Zealand in 1861. British emigration to New Zealand began in
the 1840s after the Treaty of Waitangi was signed but did not gather
pace until the 1870s, after the New Zealand wars – a series of short
land battles between some Māori groups and government (British
and colonial) troops and allies during the 1840s and 1860s which
had lasting impacts, including substantial confiscation of Māori
land by the Crown.

North stayed with Enys in his timber cottage at Castle Hill
('Castle Rock'), his central Canterbury farm (Ex. 50). Here she was
supplied with flower specimens to paint, including the endemic
species named *tutāhuna* in Māori (*Raoulia eximia*), commonly
known as vegetable sheep due to the appearance of its tiny woolly
leaves (p. 250). Enys took her on a trip through the Otira Gorge
where, despite her poor health, she produced two paintings.
From Castle Hill she returned to Christchurch and travelled up to
Wellington, feeling ill and miserable.

Governor Arthur Hamilton Gordon – a man ill-suited to and unhappy in his post, who gained the nickname 'abdicator' due to his frequent threats to resign – became North's saviour when she moved into Government House in Wellington and heard him 'abuse the island and all belonging to it with as much heartiness as I did'. He secured her a cabin on the *Zealandia* from Auckland, and after a dash there from Wellington, North was on her way back to California by the end of March. She had mixed feelings about fleeing with her hopes to paint the northern kauri forests unfulfilled. But, as in Japan, rheumatism brought on by the cold forced her exit. While travelling to a warmer climate brought some relief, she did not fully regain her ability to walk for two months.

[page 198] ***Entrance to the Otira Gorge.*** North explored the Otira Gorge on horseback, guided by her cousin John Enys, who had last visited just ten days earlier. The building shown may be the inn where they stayed for two nights, viewed from nearby fern-covered woodland.

49.
LAKE WAKATIPU

The scenery was all bare and savage. Not a place to land on for miles after Queenstown, and no plants or trees to be got for foreground within three miles of walk, except a few lots of flax. My bones already began to ache with rheumatism, so I contented myself with finishing a sketch of the lake from my window on the ground-floor, with only the road between me and it. Every now and then it would lash itself up into a rage without the least warning, the great waves making as much noise as the sea, and sending breakers up against the little pier. The lake is said to be unfathomable, with fabulous undercurrents, so that things thrown in do not sink, but float about half-way down, and in calm weather can be seen in a state of perpetual motion. People come to Queenstown for consumption. The air was exquisitely pure and fresh; the inn well kept; my hostess, a model of energy and good method, had a gang of Chinamen to cook and do housemaid's work, with some nice girls as waiters, and was most anxious to make her guests feel at home.

I joined an excursion party in a steamer to the end of the lake on the 26th of February. It was a small boat, but quite full. A large club of Foresters in green, with a band of music, had come from Dunedin the night before, and were greatly enjoying themselves without getting drunk. There were some other odds and ends of travellers like myself. One young man came and introduced himself as the son of some people I had stayed with in Queensland. On every side I made and found friends. The clouds cleared off, and the weather was glorious, the whole scenery really magnificent, as we went near enough to the shore to see the curious plants in the little crannies. I saw young panax trees with leaves two feet long and yellow midribs. The cabbage-trees grew into grand branching masses like the dragon-tree. It was funny going through all this magnificent scenery with such a crowd of second-class English people. They got so excited over the beautiful lake and the terrible band of music on board that they began dancing solemnly, and the band itself got some one to play on an accordion, and began dancing too: only the men by themselves, no women joined in. They told me that dancing was quite a passion with our countrymen

[overleaf] *View of Lake Wakatipu.* The foreground plants are New Zealand flax, named *harakeke* in Māori (*Phormium tenax*). Flax became a crucial resource for the Māori after their arrival in New Zealand from around AD 1250. The plant remains strongly associated with Māori culture, and has become a symbolic emblem for New Zealand. The gallery catalogue caption lists many Māori uses for flax, including the making of garments, nets, sails and baskets from the leaf fibres, use of the leaf pith as tinder, and the gum as a pain-relieving medicine. The flower nectar produced a sweet honey-like drink.

in New Zealand. We were all landed on a lovely wooded island to dine, and I got a splendid view of Mount Earnshaw, a real snow-mountain 9000 feet or more above the sea, with a grand foreground of New Zealand plants. That island has been preserved, like some few other spots in that part of the world, for the sake of picnics! I wished there had been more of those places required; for saw-mills and fires as usual followed fast the introduction of white people into the land.

50.
JOHN ENYS

The sight of Judge I. and his wife warmed me; they were so thoroughly genial and alive. But though he was the Resident Judge, I had a long hunt before I found any one who knew where they lived! They knew everybody and everything, and drove me to the club to inquire for my cousin, John Enys, who came up just at that moment, swinging a pot of apricot jam in his hand, which he was going to take back as a treat for me, to celebrate my visit to his station. He took us to the museum, and showed us all the New Zealand stuffed birds, and its one native beast, a pig, also a rat which was generally supposed to have been imported. But the birds did their best to look like beasts, having next to no wings, the great moa skeletons looking like giraffes. John Enys had made a hobby of the museum from its first start, and spent all his holiday-time collecting for it. He brought a friend who had collected nearly all the nests and eggs of the country, and the two were most pleasant companions there. He took me four hours of rail westward the next morning, talking and joking with every one along the road, and seemed a general favourite. He had hired a horse and buggy, which met us at the end of the railway, and we drove over the dreary burnt-up hills to his house, which was called Castle Rock, after a pile of strange old rocks near; they looked like the remains of some fortified place. His own quarters were at the edge of a black beech forest, which gave a more cosy look to the spot, but they were a hard, cruel sort of trees, the very tallest not more than forty feet high, with leaves as small as the box, under which no green thing liked to live; their branches feathering to the ground like Cedars of Lebanon.

[above] ***Castle Hill Station, with Beech Forest.*** North's painting of Castle Hill farming station, owned by the brothers John and Charles Enys.

The house consisted of a few single-roomed huts joined together by a verandah. An old man did the cooking in another separate hut, into which we went when the meals were ready. We generally found him pouring portions out of a saucepan into our plates, which were arranged in a circle on the floor for the operation, after which he placed them before us, and went and sat on a stump till we had finished and fed the cats, when he and the shepherds came in and finished what was left. John had a cheerful little parlour full of curiosities all over the walls and tables, besides plenty of books and newspapers, and he was never dull. He corresponded with all the scientific people of those parts, and got into the wildest excitement over a new weed or moth. He sent a man up the hills some 2000 feet, and had some large specimens of the vegetable sheep brought down (Raoulia) – a mass of the tiniest daisy plants with their roots all tangled together, and generally wedged in between two rocks, leaving the surface of the colony like a gray velvet cushion: at a distance the shepherds themselves could not tell it from the sheep they had lost.

Chapter 14

Coastal South Africa

AUGUST 1882–MAY 1883

North arrived in South Africa to travel the British Cape and Natal colonies in late August 1882, having sailed from Dartmouth to Cape Town in what she recorded as, 'rather more than eighteen days – one of the shortest voyages ever made'. British settlers had first arrived in the Cape in 1820; Natal had been annexed by the British from the Dutch-descended Afrikaners ('Boers') in 1843. North's travels in South Africa included a stay at Port St Johns, a small British settlement established in 1878 at the mouth of the Umzimvubu River that was not formally annexed to the Cape Colony until 1884. During her overland journey to Port St Johns, she noted a procession of wagons destined for the recently developed diamond mines in Kimberly: 'the mainspring of all trade in South Africa. Strange that those glittering little stones should govern half a continent!' The discovery of diamonds in 1867 (and gold in 1884) in South Africa's interior accelerated and intensified British efforts to expand and consolidate their territories. In the 1870s, Britain annexed first the diamond fields and then the Afrikaner Transvaal republic. In 1879, a short and brutal war with the powerful African Zulu kingdom ultimately led to the banishment of the Zulu leader, Cetshwayo, and the carving up of Zulu lands into 13 chiefdoms. In 1880, the Transvaal Afrikaners rebelled and defeated the British during the first, short

Anglo-Boer War, and were granted qualified independence.

North's time in South Africa began with three months in today's Western Cape province, followed by four months in the Eastern Cape, and two months in KwaZulu-Natal. Her first destination was Wynberg. Now a suburb of Cape Town, in the 1880s the area was still rural, and so suited North that she turned down the inevitable invitation to stay at Tuynhuys (then Government House, now the office of the president of South Africa) which soon arrived, delivered in person by the governor's daughter. 'I knew when I was well off,' commented North, clearly far happier to stay with the elderly Mrs Brounger, 'the mother of my brother-in-law's cousin's wife', enjoying meals and rambles with her daughter Mrs Gamble and painting the profusion of flowers collected for her (Ex. 51). In September she accepted an invitation to stay at Groote Post farm in Darling, 20 miles from Malmesbury, where she was impressed by her indefatigable hostess Hildagonda Duckitt ('Miss Duckett') (Ex. 52), who went on to become something of a celebrity recipe writer and author of books on cooking and household management. North travelled to Ceres via Tulbagh in October, to take an excursion to the Karoopoort mountain pass – a plan eventually abandoned due to poor weather. She returned to Wynberg but finding 'much illness' in the household quickly left in early December to travel to the Eastern Cape via Beaufort West.

En route to Port Elizabeth (Gqeberha), she stayed in a hotel booked by the expedition party of the Scottish astronomer David Gill, who oversaw official observations of the December 1882 transit of Venus, where she 'slept soundly among astronomical instruments' in a room they gave up

[page 206] *Foliage, Flowers and Fruit of the South African Silver Tree.* North was fascinated with the silver trees she saw while exploring Table Mountain with Mr Gamble, a government official in irrigation. She produced two paintings included in the gallery collection: one showing a view through a wood of silver trees, and this study of the tree's foliage, flowers and fruit. She wrote of her fascination with the tree in a letter to Maggie Shaen, describing how 'its flowers are just now like balls of gold, and the cones full of exquisite, winged seeds which must have delighted Darwin.' She sent two of the cones to the botanist George James Allman, writing to his wife Hannah Louisa, 'I sent the Dr. two cones of the silver tree lately, I wonder if they had any of their beauty still on them when they arrived! I do not know anything more lovely than that whole tree, every bit of it.'

for her. The next day, in Port Elizabeth, she met Russell Hallack ('Mr. H.'), a businessman and naturalist who had emigrated to South Africa in 1843. He advised her to stay at the Cadle Hotel, a popular coaching inn run by Henry and Hannah Cadle. North reports that she felt 'more like a friend than a boarder' while staying there, and included a painting showing the hotel in the gallery collection. Hallack visited her there at the weekend and they explored Van Stadens ('Van Staaden's') Gorge together (Ex. 53). Hallack also supplied North with an introduction to a Mrs Gaplin in Grahamstown (Makhanda), whose seven sons supplied North with many flower specimens. Her main associates in Grahamstown, however, were William Guybon Atherstone ('Dr A.'), his wife Catherine ('Mrs A.'), and the wife of his cousin, Mary Elizabeth Barber (misnamed as 'Mrs Baines'), a noted botanist, entomologist, ornithologist and painter who corresponded with Darwin and maintained a thirty-year correspondence with Joseph Hooker at Kew. North travelled to Port Alfred with Barber, and on her return stayed at the home of the Atherstones (Ex. 54).

North's experiences in Natal (KwaZulu-Natal), where she went after Port St John, offer a glimpse into some instabilities and tensions within white colonial society resulting from differing opinions on the recent imperialist wars. When North first reached Natal she stayed with Katherine Saunders, a plant collector and botanical artist, and her husband James Renault Saunders, founder of the Tongaat Sugar Company and instigator of the campaign to bring indentured Indian labourers to Natal to work the fledgling sugar plantations. But she had in her possession three introductory letters to Natal's elderly Anglican bishop John William Colenso (1814–1883), including one sent via her friend Margaret Shaen: 'there seems but one man in Natal', North commented to Shaen in response. The Colenso family themselves were also writing to her, inviting her to visit. This put North into something of a quandary as the Saunders were, she wrote to Shaen: 'very strongly anti Colenso. I was told not to mention the name, or he [Mr Saunders] would go mad.'

Since arriving in Natal in the 1850s, Colenso's priority had been supporting and advocating for the Zulu people, not white settlers. Rather than establishing himself within the main colonial settlement, he made his home ('Bishopstowe') by his mission station. His family actively supported his work, particularly his eldest two daughters Harriette Emily and Frances Ellen. During the Anglo-Zulu war, the Colensos published pamphlets critical of British colonial authorities; in its aftermath, Colenso advocated for the Zulu people and Cetshwayo, both in Natal and in England, and Frances Ellen published the *History of the Zulu War and its Origin,* which defended her father's criticism of British imperial policy.

Vilified in Natal newspapers and ostracised by Natal society, by the time North visited them in 1883 the Colenso family had become isolated figures (Ex. 55). North's account of this visit is one of the very few passages in *Recollections* to be significantly altered between the two 1890s printings. The version given in extract 55 comes from the original printing, published in 1892. In the 1894 printing, her opinion that Colenso was 'weak and vain and very susceptible to flattery', and that he was 'managed' by his daughters was removed, along with her reaction to the family's political position, which North appears to understand predominantly in racial terms and to view as a betrayal: 'the dear natives were incapable of harm, the whites incapable of good ... they would, I believe, have heard cheerfully that all the whites had been "eaten up" ... [they] had hardly a good word for any white man ... ' In its place, readers of the 1894 printing are told: 'His conversation was delightful, but the strained atmosphere of Zuluism which pervaded the house was painful to me, and difficult to understand. Cetewayo's [Cetshwayo's] portrait was everywhere, and he was talked of as a hero and martyr.'

North's time with the Colensos was the last of her South Africa experiences recorded in *Recollections*. She left in late May 1883, abandoning plans to travel on to either Zanzibar or Mauritius and instead returning to England.

TWO BATHS FULL OF WONDERS

Mrs. Brounger, a most beautiful old lady with silver hair, gave me two rooms in her nice large old Dutch house. Her daughter, Mrs. Gamble, lived close by with her pretty children. Our meals were taken in either house alternately, both husbands being away at Government work.

Mrs. Gamble and I had many delightful drives with an old pony, which had a most remarkable talent for standing still. We used to drive him off the road into the thick bush and leave him there for hours, while we rambled about after flowers. The extraordinary novelty and variety of the different species struck me almost as much as it did at Albany in Western Australia, and there was a certain family likeness between them. But the proteas were the great wonder, and quite startled me at first. I had not formed an idea of their size and abundance: deep cups formed of waxy pointed bracts, some white, some red or pink, or tipped with colour, and fringed some with brown or black plush, others with black or white ostrich feathers. These gorgeous flower-bracts were bigger than the largest tulips, and filled with thickly packed flowers. One large variety seemed to carry its stamens outside. While painting it, I saw them begin to dance, and out came a big green beetle. I cut the flower open, and found an ants' nest. The energetic little creatures had pushed the stamens out to make room for their colony. I found all the other flowers of that kind possessed by ants, and in every nest a beetle. The young shoots generally sprang from below the flower-stalk of the protea, so that when the cone which succeeded it became ripe, it was protected and half hidden by three leafy branchlets.

Many of the species have their male flowers and cones on separate trees; like the silver tree, which only grows on the spurs of Table Mountain, where there are many groves of it, shining like real silver in the setting sunlight. It grows about twenty feet high, shaped like a fir-tree, with its flowers like balls of gold filigree at the ends of the branches. Every bit of it is lovely, but the most fascinating part is the cone, when it opens and the seeds come out with their four feathered wings, to which the seed hangs by a fine thread half an inch long. Another species of protea resembles the waratah (*Grevillea*) of Australia. One

of them is the "krippel boom," a thick bush with a rich yellow flower at the end of each leafy branch, on which the long-tailed honeysuckers delight to perch and take their suppers, plunging in their curved beaks, and tearing the flowers all to pieces in the process. The hills were covered with low bushes, heaths, sundews, geraniums, gladioluses, lobelias, salvias, babianas, and other bulbs, daisies growing into trees, purple broom, polygalas, tritomas, and crimson velvet hyobanche.

Many friends collected for me, and two baths stood in my painting-room full of wonders. The difficulty was to make up my mind what to do first. It was impossible to paint fast enough, but we can all work hard at what we like best. Miss Robinson, the Governor's daughter, called the first day after I arrived, in her riding-habit, at ten o'clock, and told me she had been dancing at one o'clock, up and off to the meet at three, had had a glorious run, and her fingers nearly pulled off her hands by her horse. She wanted me to move into Government House,

but I knew when I was well off, and declined the honour. My quieter home suited my particular work best. Indeed, I only went three times into Cape Town during the whole of my stay in South Africa. The Botanic Gardens are fine, but people there were so very economical (owing probably to the many expenses of the late useless war) that they hardly allowed enough money to keep the plants watered, and Professor M'Owen, its agreeable director, was in despair about it.

52.
HILDAGONDA DUCKITT: A REGULAR QUEEN BESS

She was a regular Queen Bess or Boadicea for ruling men, and had no small work to do on that farm. Every morning she gave out over 100 rations of bread, meat, spirit, etc. Every morning a sheep was killed, and every week a bullock. When she heard that smallpox had broken out in the mission-station three miles off, she established a strict quarantine, and asked a neighbouring doctor what he would vaccinate her people for. He said he could not do it for less than ten shillings each, so she had herself and her niece operated on, then ordered all her people to be collected in the barn, and herself vaccinated every man, woman, and child. I tell the tale as she told it, and the result: no one had the smallpox at Groote Post. [...]

The ladies staying at the farm were very Dutch-looking, but Miss D. had quite an English manner, with a gentle voice, notwithstanding her manly strength of character. Everything we ate was made on the farm, as well as a strong wine resembling Madeira. There was a grand vegetable and fruit garden hedged in by a tangle of aloes and geraniums, heliotrope and plumbago. There were two date-palms, pomegranates, loquats, cypresses, blue gums and wattles covered with their golden blossoms, a perfect wood of poplars loaded with the curious hanging nests of sociable finches, and masses of white arums below. Beyond that wood there was not a single tree for miles. [...]

The whole district was sprinkled with Ducketts or Cloetés, all cousins, and a most happy set of people. One day we had an hour's notice of sixteen coming to luncheon. All hands were called in to whip cream and make cakes, and everything was in apple-pie order when the hungry party arrived. They came in two waggons, each drawn by eight horses. One of the ladies

[above] *Ostrich Farming at Groot Post.* North, who was fascinated by the ostriches at Groote Post, included this painting in the gallery alongside another showing the hatching of two chicks. This painting shows the early nineteenth-century farmhouse, with grazing ostriches and a seated man. We are not told his identity, but from North's account it seems likely he was the unnamed Irishman who cared for the ostriches. Groote Post farm was established in the early 1800s and continues today as vineyards and a winery.

wore a purple velvet dress; she and some of the others having the fair solid flesh and yellow hair Rubens loved to paint. They were all very serene and happy, but not entertaining.

The rooms were always full of pretty flowers. There was a hanging basket suspended from the middle of the ceiling in the sitting-room, filled with arums, ferns, and hanging creepers. Brackets also hung on the walls for the same purpose. Every morning the girls brought in fresh wild-flowers, often from considerable distances, going out on horseback to seek them before breakfast. Miss Duckett always found time to arrange them, in spite of the quantity she had to do. Her storeroom was a sight to see. They made their own candles out of the mutton fat, quantities of butter also, but had no market to sell it in. She salted it down, then when butter was scarce and dear in Cape Town, she washed the salt out again and sent it all in as fresh butter, getting a good price. The ostrich feathers, too, were worth sometimes as much as £8 for one good bird, and under

£2 apiece for the others all round. She made raisins, as well as wine, and the most delicious grape-jam, with a little quince in it to give it a flavour.

53.
A DAY OF DAYS AT VAN STADENS GORGE

On Saturday Mr. H telegraphed to know if I were still there, and came over and spent his Sunday in taking me to the head of Van Staaden's Gorge. They gave me a perfect pony from Basutoland, a strong roan, which treated me as if I were no weight at all, and both walked and cantered to perfection. My companion led the way on an animal he knew well, which stood stock-still whenever he got off to hunt flowers, till he was ready to get up again. It needed no tying up or leading. I suspect the horse knew Mr. H.'s ways even better than Mr. H. knew its own. He was more off than on his horse, going into ecstasies over a dozen tiny flowers on our way over the heathy flats. We saw acres of the *Lanaria plumosa*, white and woolly, with a touch of violet on its six slender petals, and green lily leaves. Then we crossed a deep and very steep kluft through the rather deep stream, and up the almost perpendicular bank, hanging to our horses' manes, through bushes covered with white woolly balls, and the bright scarlet antholyza, known at the Cape as Aunt Elizas. We soon reached the hills, and the aqueduct leading one way to the gorge and the other to Port Elizabeth, whose streets are bordered by delicious running water, and every garden has its fountain. Few towns are better supplied, thanks to Mr. G. The gorge was very narrow, and bordered by reddish cliffs, through which ran the clearest of rivers, with deep pools amid masses of ferns, pelargoniums, watsonias, blue hyacinths, yellow and white daisy-trees, everlastings, polygalas, and tall heaths. Under them we found precious parasites (harveya), white, pink, and scarlet, while above, in rocky cracks, hung euphorbias and zamias, or Kafir bread-trees. At the head of the gorge we came to a waterfall and a reservoir.

Just where the water bubbled out purest and freshest were quantities of a small pink and white disa and lovely droseras. We returned over the windy downs on the other side of the hills amidst acres of protea bushes of different sorts, and huge everlasting-plants standing a yard or two above the ground, with white velvety leaves round a thick stalk, surmounted by a

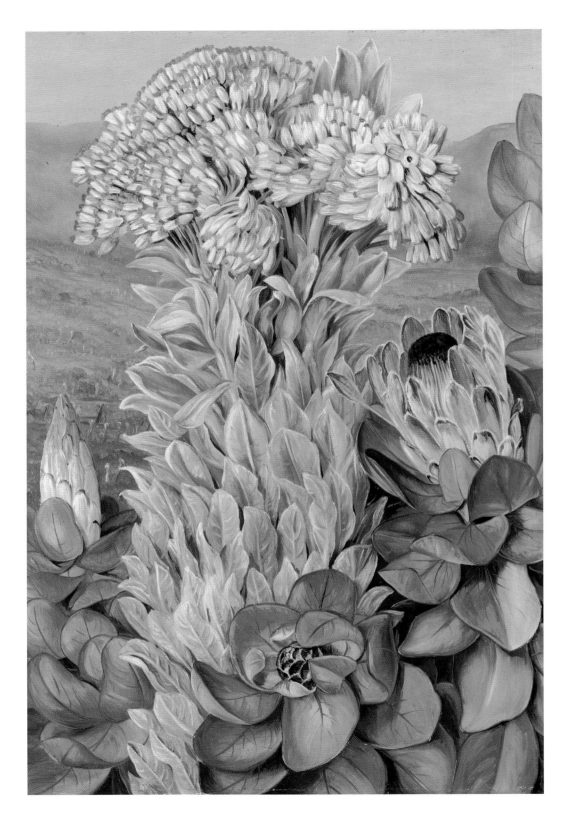

MARIANNE NORTH'S TRAVEL WRITING

cauliflower head of white petals and yellow stamens. These looked like tombstones at a distance. A gentleman who had been also to the gorge cut one of the great things down, and carried it home over his shoulder for me to paint, for which I was grateful, for it was no small weight. One of the proteas had a deep dahlia-carmine centre and pink bracts edged with white ostrich feathers, the leaves exquisitely tinted with lilac, like the bloom on plums. After leaving those downs, we came to a marshy hollow, and saw the *Sparaxis pendula* for the first time. Its almost invisible stalks stood four or five feet high, waving in the wind. These were weighed down by strings of lovely pink bells, with yellow calyx, and buds; they followed the winding marsh, and looked like a pink snake in the distance, making me scream with joy when I first saw them. "I was sure you would do that," said my guide contentedly. As we rounded the mountain he showed me a blue-green patch on the top of it, looking like a swede-turnip field in Norfolk, and said it was a mass of agapanthus! It was a day of days!

54.
WILLIAM GUYBON ATHERSTONE AND MARY ELIZABETH BARBER

I stayed in a quiet room at the railway-hotel, where I could work well with a good light, and seldom went out except for drives with Mrs. A., a wonderful old lady of over eighty. She had two spirited Basuto horses, bright chestnut with white specks, which always stood on their hind-legs before they started, and began kicking if they stood still for more than three minutes. Once off, they were quiet as lambs. Her husband, Dr. A., was the one man of the place, and full of information. He also collected for me, sometimes riding thirty miles before breakfast to get a flower; he was the most active man I ever met. His garden, which he planted forty years before, was well worth coming across the world to see, and full of strange plants, mostly native. The *Strelitzia augusta* was in full flower, as were many varieties of aloes. The biggest of all aloes had been called after his relative, Mrs. Baines [Mary Elizabeth Barber]. I had heard her name ever since I entered South Africa as the great authority on all sorts of natural history, and was delighted when she walked into my room one day and said she had come from the country on purpose to see me.

She showed me some of her own paintings, stippled on white paper, with a line of neutral tint round the edges to raise them (done much in the way old Anne North did her flowers in the year I was born). She had painted many of the stapelias, and brought me two to do – brown and yellow stars with a most evil smell. They attract flies, which try to get at the nectar, and thereby fertilise the flowers, then are rewarded by being themselves caught by their legs, and probably have their lives sucked out of them. [...]

Dr. A had asked me to stay in his house on my return, but all his rooms were so darkened with vegetation that I despaired of finding one I could see to paint in. At last I was taken across a sort of drawbridge to an attic or wide verandah, dark with a solid mass of creepers, bougainvillea, banksia-roses, etc. It was full of old boxes of rubbish, and some crazy steps led into another attic with a small room at either end, one of them given up entirely to a colony of bees, which had built in a corner and resisted intruders; the other belonged to a son, who was on the

opposite side of the colony. There I settled myself, digging out a hole in the bougainvilleas, which let in a blaze of rosy light through their flowery wreaths. It took me some time to make the opening sufficiently large to get natural-coloured light enough to paint by. One side of the room was separated from the verandah by broken green-house-sashes, one of them off its hinges. The roof itself was all of a slant, books, hats, pipes, and various treasures of men in delightful disorder, but it was deliciously quiet and out of the way. I bolted myself in at night, and shared the whole storey with the bees and an occasional rat, bird, or lizard, and through my hole in the bougainvillea I looked on wonderful groups of aloes of many species, and other rare things collected by the Doctor in his long African life.

55.
THE COLENSOS AT BISHOPSTOWE, NATAL

An archdeacon met me at the Maritzburg station the next day, and put me into the bishop's carriage, which took me to a house where I found his youngest daughter at luncheon. She had a hectic flush and a hard cough, and said it was the first visit she had paid since her return from England. An old gentleman who came in, she told me, was one of their worst enemies. He seemed perfectly civil, but the whole family had isolated themselves by their Zuluism. We did not pass a tree after leaving Maritzburg, crossing a dreary waste of long yellow grass or ripe corn till we came in sight of Bishopstowe, with its many-gabled house and gum-trees, like an oasis in the desert. It stood on the top of a small hill, and every tree there was planted by Dr. Colenso. Under the verandah covered with creepers he stood to receive me, giving me his arm with as much courtesy as if I had been a princess. It seemed quite a dream of old days to meet such a thorough gentleman again, and difficult to understand how one so genial and gentle could have made himself so hated by the majority of the country. His conversation was delightful, but he gave me the impression of being both weak and vain, and very susceptible to flattery. His two elder daughters seem to manage him. They were perfectly devoted to him, and to Zuluism! which governed everything. The dear natives were incapable of harm, the whites incapable of good. They would, I believe, have heard cheerfully that all

[above] *View of a Table Mountain from Bishop Colenso's House, Natal.* This painting shows some of John William Colenso's garden plantings. North writes that the Colensos had many pets, including a retriever dog, a lemur, cats, rabbits, and the crane we see stalking through the garden in this painting.

the whites had been "eaten up" and Cetewayo proclaimed king of Natal. His portrait was all over the house, and they mentioned him in a hushed voice, as a kind of holy martyr, and had hardly a good word for any white man, except Colonel Durnford, whose life poor Frances wrote. I found her sadly in want of sympathy, and almost reduced to despair and hatred of Zuluism, though she was the authoress of the book about them, and hated the Government more. I did my best to disentangle her artistic difficulties, and give her courage to go on painting from nature. The companionship of sweet flowers would have done her more good than sickly sentimental phantoms of high

art, such as she was attempting, under the influence and spirit of Burne Jones's school in England.

The only natural thing in the house was the poor old mother, very delicate and feminine. She seemed delighted to get a new listener from the outer world, and to tell me stories of her youth. She did not worry herself about Zuluism, and it was a relief for me also to escape the family mania. I was taken to see the printing-press, which was continually contradicting every fact stated by the Government or officials, who in their turn contradicted every fact published by it. Messengers were continually arriving with fresh lies (I believe) from "the king" over which the bishop and his daughters passed all their time. It would have driven me mad to stay long in such a strained atmosphere.

Island Hopping in the Seychelles

North hoped to travel from Natal (KwaZulu-Natal) to Zanzibar and then Mauritius, but finding no workable route she returned to England for the summer of 1883. In September, she sailed from Marseille in France to the Seychelle archipelago's main island, Mahé, arriving in mid-October to find the islands under quarantine orders from all neighbouring nations, owing to a smallpox outbreak. The resulting food shortages, widespread panic and dwindling public funds disrupted Seychelle life from the summer of 1883 into 1884. At the time of North's visit, the Seychelles and Mauritius were governed as one British colony (until 1903); for the Seychelles, independence came in 1976.

The colonial chief commissioner, Arthur C. S. Barkly, had expected North's arrival for some months. When she finally arrived, he and his wife Fanny A. Barkly were, as Fanny recorded in her memoir, 'somewhat surprised to find she did not appear at all alarmed at our malady or quarantine, but settled down comfortably in Government House'. Barkly arranged North's first day-excursions, including organising chairs and bearers (that North had no wish for), and guides: Mr Estridge ('Mr. E.') who worked for the treasury, and Monsieur Buton, conservator of Crown lands (Ex. 56).

Her main objective in the Seychelles was to paint its famed coco de mer palm. The coco de mer's fame rests on it bearing the world's

largest and heaviest seed – an individual nut can weigh up to 25 kilograms – and for having a shape highly suggestive of the female form. It is endemic to just two Seychelles Islands, Praslin and Curieuse. North travelled to Praslin with 13-year-old Johnnie Brodie ('Johnnie B.'), the son of one of Fanny Barkly's friends, where they were hosted by the government medical officer Dr Hoad and his wife ('the H.'s', Ex. 57). Hoad wasted no time in taking her to the Vallée de Mai (North's 'valley of the coco de mer'). At least two of the four gallery paintings depicting the palm in its natural habitat resulted from that day's sketches. The four-man boat crew, headed by a skilled Malagasy sailor named Emile, took the party to the valley on the far side of the island, and later rowed North (with the Hoads) to Curieuse and other nearby islands, including Aride and Digue. In Curieuse, North climbed an enormous pile of boulders and rested her painting-board on a giant palm leaf to sketch a good view of one tree's leaves and its twenty-five nuts (Ex. 58). North praises Emile and his crew as 'capital sailors', and, elsewhere, tells us they were 'very merry, talking, laughing and singing all the way' – before offsetting this image with a story, told to her by Dr Hoad, that casts aspersions on them. Unusually, North painted and selected for the gallery a study of Emile's home which includes a figure we can reasonably assume to be Emile, although his presence in the painting is not referred to in the caption published in the gallery catalogue.

After some weeks with the Hoads, North returned to Government House in Victoria, Mahé, but soon moved to Mrs Estridge's home on the town's northern outskirts, right on the coast with views to eight nearby islands. By the new year, with hardship and hunger in Mahé escalating, she wished to leave – but the travel restrictions prevented her from travelling onward to Mauritius. Instead, she took to the hills, staying for three weeks with Mr and Mrs Wharry (Mr. and Mrs. W.'), who ran Venn's Town – a missionary school with surrounding vanilla and patchouli plantations established by the Christian Missionary Society in 1876 (Ex. 59). Intended to educate

the children of 'Liberated Africans' (men and women who were taken to the Seychelles from slave ships that had been intercepted in the Indian Ocean), in practice most pupils during the school's 13-year history were the children of African plantation labourers, as the last Liberated Africans had arrived in 1875. Contrary to North's observations, children were taught carpentry, craft and gardening skills, alongside Bible studies and psalm singing. North's paintings of the capucin tree, subsequently scientifically named by Joseph Hooker as *Northea* (now *Northia*) *seychellana*, were made during her stay at Venn's Town.

Towards the end of her quarantine on Long Island before leaving the Seychelles, North experienced a breakdown, attributed by doctors to 'insufficient food and overwork in such a climate'. She recovered gradually during 1884, but episodes of distress would recur in the years to come.

[page 222] ***Waterfall in the Gorge of the Coco de Mer, Praslin.*** Today the Vallée de Mai Nature Reserve is a UNESCO World Heritage Site within Praslin National Park.

Walking was said to be impossible, so my two first expeditions were made with four bearers and a chair. They charged fifteen shillings for the day; but as I found that I walked on my own feet most of the time, and the men were greatly in my way, I never had them again. With two exceptions, the roads were all like the beds of streams, and were literally stream-beds, except in extra fine weather. The first expedition was made with Mr. E. (in search of a cocoa-nut with six heads), over the shoulder of the island and along its south shore, up and down from one sandy bay to another. These are separated by rocks all worn and furrowed by water, and piled up in heaps on their coral foundations. Great twisted cashew trees were wedged in amongst them, spreading their long arms over the sand. Their fruits were a far brighter scarlet than those I had seen in India. All the common Indian trees seemed to grow more luxuriantly in Seychelles than they did at home. The breadfruit trees were loaded with fruit, and so were the cocoa-nuts, oil-making being the principal occupation of the islands. The tree we went to seek was a very ugly deformity, but a good excuse for a delightful walk. We returned round the east coast, passing a grove of the blue fan-palms of Mauritius on the way, and making a short cut across a bay, through the shallow water, and over the wet sand among shells, corals, and blue crabs, a world of wonders; but all the inhabitants seemed on the verge of starvation, and living on credit.

The other chair expedition was made with the overseer of forests, who took me up the one good road which led to the heights, where the few country-houses of Mahé were placed, before which the natural forests were already beginning to disappear. There, for the first time, I saw the noble wild palms and the pandanus trees, the "vacca marron" being the most remarkable of these, topped as it is with a green dome of screw-pine branches, beneath which numbers of straight aerial roots descend, many of them reaching to the ground, and forming a tower of scaffolding among which the original trunk is often lost. The whole looks like a skeleton lighthouse with a green roof. Another pandanus grows only in wet places, and is of great height, with a single trunk rising from stilted

[opposite] *The Six-Headed Cocoanut Palm of Mahé.* Finding this tree was the aim of North's first excursion in Mahé and she dutifully painted it for the gallery, despite considering it to be 'a very ugly deformity'.

roots, then splitting into three branches, which again each split into three, bearing enormous heads of drooping dracaena-like leaves. The fruits and flowers of all these varieties were much alike. I was so busy trying to paint these wonderful things that I gave offence to some friends of my guide, who wanted me to breakfast with them; so I had to climb up their hill to make peace afterwards.

57.
COCO DE MER VALLEY

Johnnie B., a nice boy of thirteen, had been sent over to take care of me; and we had a real good time in Praslin with the H.s in their nice new house. It was not a hundred yards from the sea, but was shaded by tall mango and other trees; only through their branches could one get a peep of its blue water, which at noonday was as deep in colour as a sapphire. Half an hour's row across took one to the island of Curieuse, the only other island where the "coco de mer" grows wild.

To see and paint that was the great object of my visit; so the next morning after my arrival Mr. H. took me round the east side of Praslin in his boat. Four capital sailors rowed us. The head man, Emile, was a native of Madagascar, with a fine forehead and straight nose; the others were Seychelles Africans, all merry and strong, and on the best of terms with the energetic young Englishman. We passed close along the shore among beautiful boulders of salmon-coloured granite, grooved and split into fantastic shapes by heat or ice. Many of the little islands had waving casuarinas on their tops, while bright green large-leaved "jakamaka" bordered the sands of Praslin, varied by patches of cocoa-nut and breadfruit. Above were the deep purple-red, stony-topped hills, with forests between, the famous coco de mer palms shining like golden stars among them. The waves were so high as we reached the south-east angle of Praslin that we had a few anxious moments in our little boat, and decided that it was not safe to go the usual way over the breakers at low tide; we must go out to sea, and round some of the other islands. So out we went, up and down through a great Pacific swell. At last we put up a sail and ran into the valley of the coco de mer: a valley as big as old Hastings, quite filled with the huge straight stems and golden shiny stars of

[overleaf] **Emile's Palm House, Praslin.** North's paintings in Praslin included a painting of the Hoads' home and this painting of the home of Emile, head sailor of the four-man crew who took North on her excursions to Vallée de Mai and to nearby islands. Although there is no known written evidence, it seems likely that the man sitting near the Hawkshead tortoise is Emile.

the giant palm: it seemed almost too good to believe that I had really reached it.

There was a thick undergrowth, and we had not started till late, so that I could only make one hasty sketch of a tree in full fruit: twenty-five full-sized nuts, and quantities of imperfect ones, like gigantic mahogany acorns. The outer shell was green and heart-shaped; only the inner shell was double, and full of white jelly, enough to fill the largest soup-tureen. The male tree grows taller than the fruit-bearing one, sometimes reaching 100 feet; its inflorescence is often a yard long. The huge fan-leaves of both trees are stiff and shiny, and of a very golden green, different from all other palms (except the cocoanut) in colour. I saw many wild palms in the underwood, with lilac stems armed with circles of orange thorns, having edges of the same colour to their young leaves. One was cut down, and the young stem chopped in four bits to carry away on a man's head, the heart making a good salad when sliced like a cucumber. We had sent the boat round and walked up the valley, in which were perhaps a thousand of the giant-palms; but we could not stop, and I never was able to get there again.

58.
NERVES WERE NEVER IN MY WAY

Personal letter to George James Allman, 4 November 1883
I know Mrs. Allman will forgive my sending you the above sketch of my stay in Seychelles instead of sending it to her. I feel that you will better enter into the delight of the situation. How I got up and how I got down is still a mystery to me – but I know that if a cramp had seized me, you would have seen little more of your friend, for the boulder went sheer down some 30 feet or more on all sides! and the footstool of stones was built up to my feet after I was on the point and was very shaky, but the leaf which I used as a desk was perfectly strong and equal to its work and the chance was a grand one – only spoilt (as usual) by the small size of my paper. [...] There were twenty-five big nuts on the tree I drew and hundreds of imperfect ones like strings of gigantic mahogany acorns with green and yellow ends, and they were covered with brilliant green lizards. More than one walked over me as I worked – but nerves would have been as fatal as cramp, and mine were never in my way. [...]

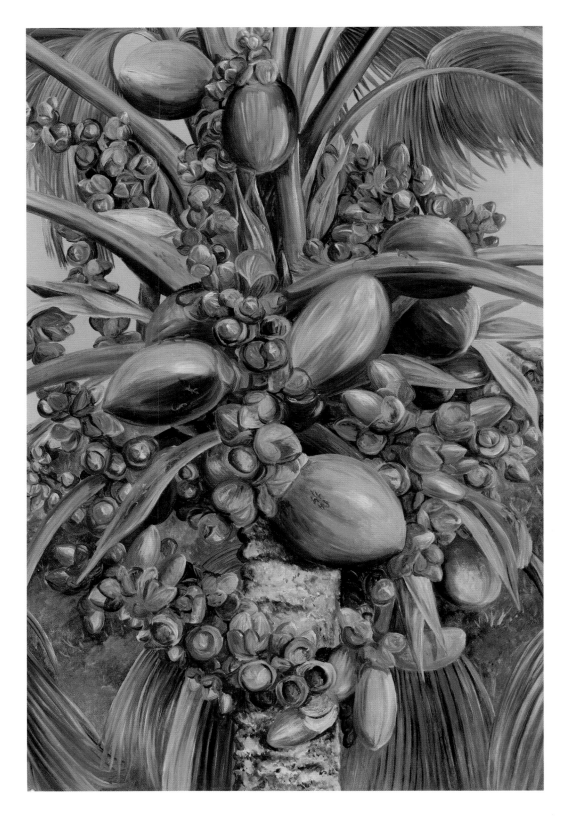

MARIANNE NORTH'S TRAVEL WRITING

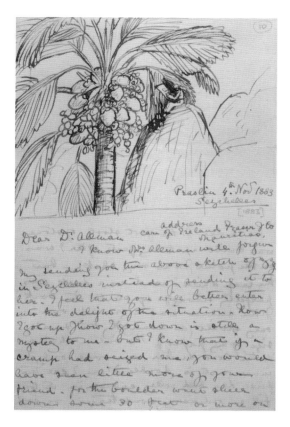

Our diet is most fascinating to me. No bread! Or meat! But roast breadfruit and cassava wafers, instead of the former, and capital fish, shell-fish soup, curry of octopus and crab, eggs, and now and then a chicken or booby or some other fishy bird from Aride. I am going there next week to hunt for J. Wight's gardenia – tell him if you see him [that] I have painted his phalaenopsis vanilla but cannot find the pink in it. Those I have found have more vermillion than pink in the centre. It is most lovely and twines yards of its green, snake-like stalk over rocks and trees till it gets a good safe view of the sea from the top of some tree and then drops down and curls upwards again with its lovely waxy buds and pure white flowers. But I have not seen more than one flower out at a time yet and that is a disappointment.

The corals were a great delight, and the shells. We laid down bait one day with sticks, in a bay of the island of Curieuse, and watched the pretty creatures going under the sand and leaving a certain moving path behind them up to the dainty bits. And [we] caught many fine cowrie, olives, harps and other beautiful specimens with their fleshy jackets fringed with gaily coloured chenille and horns, like snails at home. And the crabs [illegible] these lovely shells when empty with no more respect than they do wilks [whelks] at home. I delight in paddling without shoes and stockings, but the pinna shells and corals cut like knives and spoil the fun rather.

I am staying with Dr. and Mrs. Hoad, just the right sort of people and the only educated specimens on this island. In one year, they have made a most pattern little home with capital garden and poultry enclosure, bath of running water etc. They are very young, and he is full of energy and enjoyment of all these interesting things but finds the absolute solitude of the

[above] *North's sketch depicting herself perched on rocks in Curieuse,* climbed in order to secure a good view of the ripe nuts on a coco de mer palm.

[opposite] *Female Coco de Mer bearing Fruit covered with small Green Lizards.* The painting that resulted from North's sketching antics. Curieuse was designated a Marine National Park in 1979, providing a haven for endemic flora and fauna and, through a conservation programme, nurturing young giant tortoises.

place somewhat wearisome. [...] He is really too good for such a life, and his little Scotch wife too keeps everything in wonderful order, and they seem on good terms with everybody. Mahé is a land of squabbles and "how not to do it" is the great maxim there. [...]

This is the most perfect situation I was ever in. I never really was within reach of a perfect shore before, all clean and pure with marvellous opal tints over the shallow coral shelf and the richest green trees resting on pure white sand as its edge. [...] Perfect peace reigns here and I shall be sorry to return to the exciting life of – Mahé!

59.
VENN'S TOWN

I afterwards stayed three weeks with Mr. and Mrs. W. He had begun life as a blacksmith in Somersetshire, but fancied he had a "call," and came out to be cured of the idea. After five years of perfect loneliness in Mahé, they had now two fair little children of their own and sixty black ones to look after. The schools were originally intended for the children of slaves, but now that none existed others were taken: I could not make out by what rule. They all seemed very happy there, and did not puzzle their brains with too much learning. Report said they were famous thieves when they went down into the lower world, but that lower world had also a great reputation for untruth. I found them quite good-natured and honest when among them. Psalm-singing seemed their chief study; morning, noon, and night it went on, and I rejoiced in being blest with only one ear that could hear. The situation of Venn's Town is one of the most magnificent in the world, and the silence of the forest around was only broken by the children's happy voices.

From that flat-topped, isolated hill, one saw a long stretch of wild mountain coast, and many islands, some 2000 feet below, across which long-tailed boatswain-birds were always flying; behind it, the highest peak of Mahé frowned down on us, often inky-black under the storm-clouds. They were gathering round it when I came up on the 7th of January, and for a whole fortnight the rains came down day and night, showing me wonderful cloud-effects, dark as slate, with the dead white capucin trees sticking through like pins in

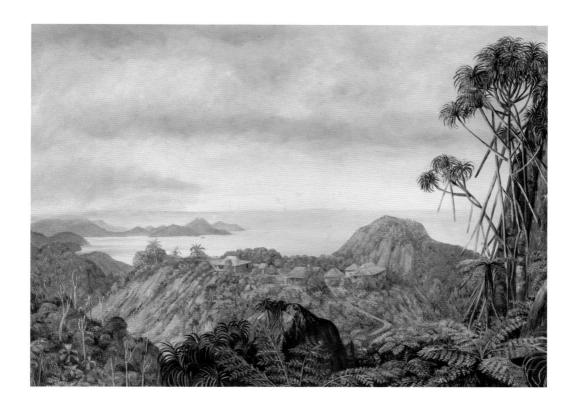

[above] ***View of the South Coast of Mahé and Schools of Venn's Town.*** This mission school in Venn's Town educated the children of Liberated Africans brought to the Seychelles, who played a formative role in developing Seychellois Creole identity and culture. Today the historically important ruins of Venn's Town are a national monument, and have been nominated to become a UNESCO World Heritage Site.

a pincushion. There were few living specimens of any age, but those were noble ones, the young leaves a foot in length, looking like green satin lined with brown velvet, and growing in terminal bunches at the ends of the woody branches. They seemed to me much like the gutta-percha trees of Borneo, but I could make out nothing certain of the flowers, and was told "it had no flower," or a "red flower," or a "white one," each statement most positive, from those who lived actually under the trees! The nuts every one knew, and collected them as curiosities. Flowers were sent afterwards to England, and Sir J. Hooker declared it a new genus, and named it *Northea seychellana*, after me.

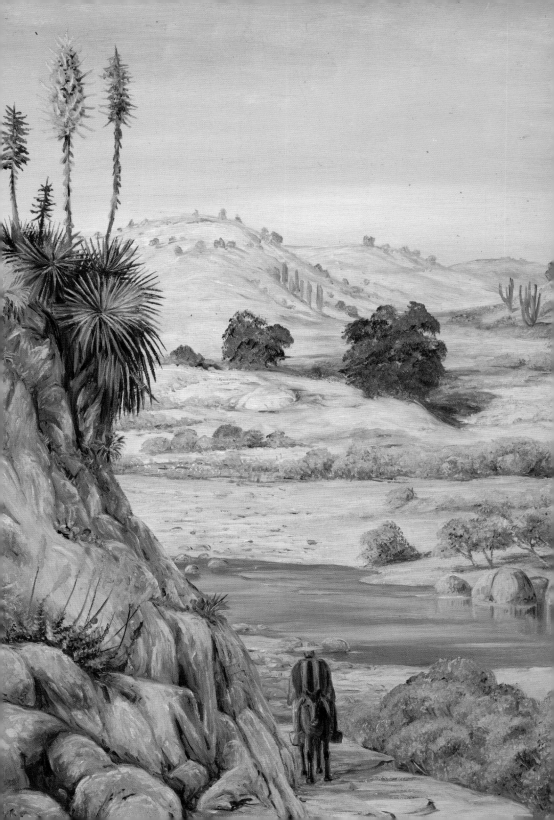

Chapter 16

Chasing Plants in Chile

OCTOBER 1884–JANUARY 1885

North left England for Chile with one specific aim in mind: to paint the famous Chilean monkey puzzle tree (*Araucaria araucana*) in its homeland. Following a voyage disrupted first by quarantines and then by rescuing passengers stranded after a shipwreck in the Straits, the ship on which she sailed reached Lota in central Chile. Her destination was the port city of Valparaíso further north, but she landed in Lota and, thanks to one of her letters of introduction, spent an afternoon touring the gardens (today a botanical park) belonging to one 'Madame C., the owner of the coal mines, and one of the richest women in the world'. This was Isidora Cousino, who by birth, marriage, and her own investments, had become a foremost member of Chile's economic and social elite. It was in these gardens that North first saw the native puya – and set her heart on painting the blue form of this Chilean species.

The day after reaching Valparaíso, North travelled by rail to Santiago, where Francis Pakenham, the British resident and consul-general, and his wife Caroline Matilda, made rooms available to her for the duration of her time in Chile. Her enquiries as to where she might find growing specimens of the blue puya were fruitless, and she resorted to painting a poor specimen. Afterwards, on a two-week painting excursion to Apoquindo (ten miles east of Santiago),

she arranged for a guide to escort her into the Andean foothills. Her rapturous account of encountering masses of blue puya growing on the slopes leaves readers in no doubt that the steep ride and stiff climb was worth the exertion (Ex. 60). To fulfil her original quest to paint the monkey puzzle tree, in early December she travelled by rail to Angol in southern Chile, a two-day journey. The authorities there appointed a guard of three soldiers to accompany North and her guide, one of the forest's (unnamed) Irish owners. After passing 'stream after stream of clear running water, and more lovely flowers than I had seen in all the three months I had passed in other parts of Chile', they reached the *Araucaria* trees – and beyond, breathtaking views (Ex. 61).

Shortly before heading south, North wrote to Margaret Shaen from Santiago, including mention of an 'enthusiastic old Don' who viewed her paintings and promoted them in the newspapers (Ex. 62). *Recollections* names him Benjamin Vicuña Mackenna, the Chilean writer, journalist, historian and former politician, and adds that she stayed at his country house for eight days. The letter also recalls her time in Quilpué ('nearer the sea'), with an English family, who took her on excursions in a bullock-wagon draped with a Union Jack: 'very gay, but trying to the eyes under a Chilian sun', North comments in *Recollections*. The family's business interests were in Tocopilla in northern Chile, where they were involved in the mining of nitrate (saltpetre), Chile's principal export and an industry largely controlled by British companies. A retired nitrate tycoon living in Las Salinas ('Mr. J.'), was North's final host in Chile. Having made, lost, and remade a fortune in mining, North hoped he could now 'give himself up entirely to his love of natural history without more necessity for money-making'. Leaving Chile in early 1885, North was unwell onboard the ship: 'what wise men call my "nerves" were following me always', she writes in *Recollections*. She landed in Lima (in Peru) to consult a doctor, who prescribed bromide and rest – which, she felt, 'had as much effect as toast and water'.

A NEW WORLD
OF WONDERS

Of course the first thing I tried to get was the great blue puya. I was told they were all out of flower; indeed, some people declared they did not exist, because they had not seen them. At last an energetic English lady bribed a man to bring me one from the mountain. It was a very bad specimen, but I screamed with delight at it, and worked hard to get it done before it was quite faded, for it was past its prime. Then I drove out to Apoquindo, over a flat ten miles of uninteresting, cultivated country, with high mud banks or walls on each side of the road, which prevented one's seeing anything; but English weeds seemed to abound, and to grow with far greater luxuriance than they did at home. [...]

My great object now was to find the blue puya, so I got a guide and a horse and started up to the mountains. We tied up the horses when it became too steep, and proceeded on foot right into the clouds; they were so thick that at one time I could not see a yard before me, but I would not give up, and was rewarded at last by the mists clearing, and behold, just over my head, a great group of the noble flowers, standing out like ghosts at first, then gradually coming out with their full beauty of colour and form in every stage of growth; while beyond them glittered a snow-peak far away, and I reached a new world of wonders, with blue sky overhead, and a mass of clouds like sheets of cotton-wool below me, hiding the valley I had left. Some of the groups had twenty-five flower-stalks rising from the mass of curling silvery leaves; about sixty branchlets were arranged spirally round the central stem, each a foot long, and covered with buds wrapped in flesh-coloured bracts; these open in successive circles, beginning at the base. The three flower-petals are at first of the purest turquoise blue, then they become darker, a mixture of arsenic green and prussian blue, the third day a grayer green, after which they curl themselves up into three carmine shavings, and a fresh circle of flowers takes their place outside, so that the longer the plant has been in bloom, the larger its head becomes; and as the ends of the spikes or branchlets bloom the last, it gradually loses its perfection of form, and looks ragged and disreputable. Its orange stamens shine out like gold upon the blue green of its petals.

[page 236] *View near Quilpué, Chili.*

[overleaf] ***The Blue Puya and Cactus at Home in the Cordilleras, near Apoquindo.*** North's painting of the blue puya, showing various stages of growth and decay.

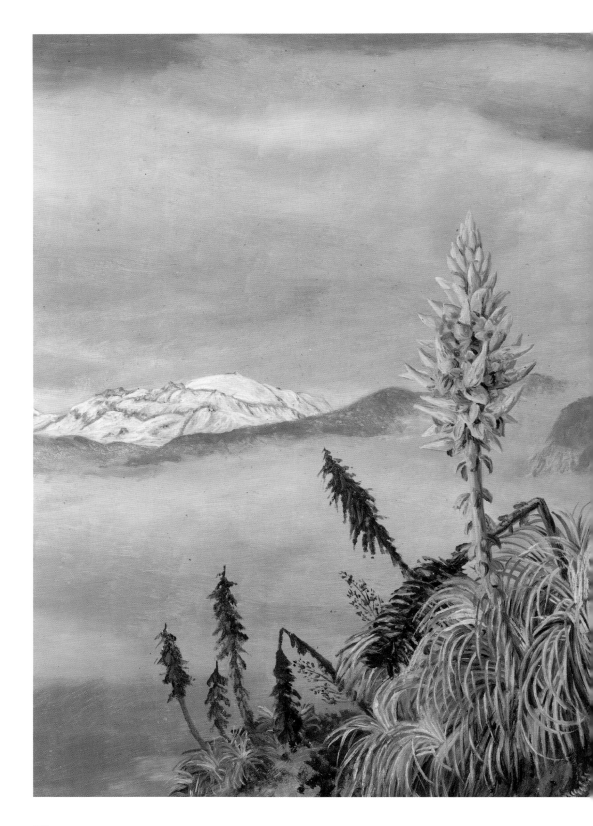

MARIANNE NORTH'S TRAVEL WRITING

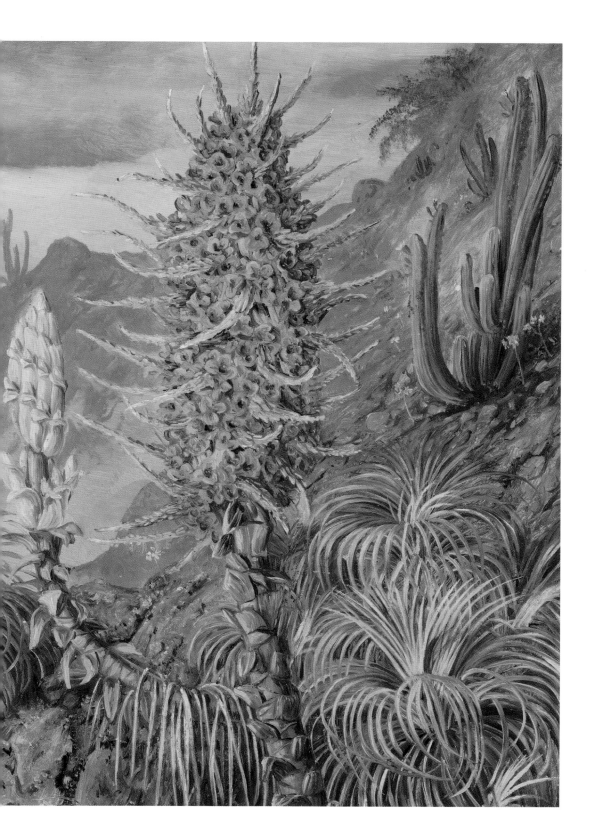

A very large and beautiful moth, having all the colours of the puya on its wings (in one light they looked bronze, in another peacock blue), lays its eggs in the pith of the great flower-stalks when decayed, and the caterpillar lives on them, eating out a cavern or nest for himself and his future chrysalis there. The gum of the plant is valuable as a medicine, and much resembles gum-arabic. A third variety of puya is much smaller, with dark-blue flowers and pink stalks. Near these tall plants the quisquis or cactus generally grew: often fifteen or sixteen feet high, crowned with long white trumpet-flowers and buds, and ornamented with a parasite whose white and scarlet berries were eaten. It was strange, but I found that the flowers on the two plants never faced the same way. The flowers of the cactus faced south. They were as large as German beer-glasses, and their foot-stalks full of sweet juice, most refreshing to suck on the dry hillside, and less stupefying than the usual contents of such glasses.

61.
IN THE ARAUCARIA FOREST

The first araucarias we reached were in a boggy valley, but they also grew to the very tops of the rocky hills, and seemed to drive all other trees away, covering many miles of hill and valley; but few specimens were to be found outside that forest. The ground underneath was gay with purple and pink everlasting peas, and some blue and white ones I had never seen in gardens, gorgeous orange orchids, and many tiny flowers, whose names I did not know, which died as soon as they were picked, and could not be kept to paint. I saw none of the trees over one hundred feet in height or twenty in circumference, and, strange to say, they seemed all to be very old or very young. I saw none of the noble specimens of middle-age we have in English parks, with their lower branches resting on the ground. They did not become quite flat at the top, like those of Brazil, but were slightly domed like those in Queensland, and their shiny leaves glittered in the sunshine, while their trunks and branches were hung with white lichen, and the latter weighed down with cones as big as one's head. The smaller cones of the male-trees were shaking off clouds of golden pollen, and were full of small grubs; these attracted

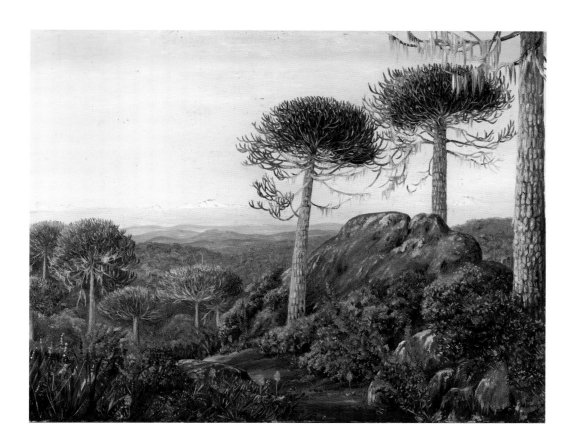

[above] ***Seven Snowy Peaks seen from the Araucaria Forest.*** North's painting of the araucaria trees in their natural habitat, with a view across to snow-tipped peaks. The gallery also includes a study of the tree, featuring two guanacos (closely related to llamas), while Kew's art collection holds an unfinished painting of two male araucaria cones.

flights of bronzy green parrakeets, which were busy over them. Those birds are said to be so clever that they can find a soft place in the great shell of the cone when ripe, into which they get the point of their sharp beak, and fidget with it until the whole cone cracks and the nuts fall to the ground. It is a food they delight in. Men eat the nuts too, when properly cooked, like chestnuts. The most remarkable thing about the tree is its bark, which is a perfect child's puzzle of slabs of different sizes, with five or six distinct sides to each, all fitted together with the neatness of a honeycomb. I tried in vain to find some system on which it was arranged.

We had the good fortune to see a group of guanacos feeding quietly under the old trees. They looked strange enough to be in character with them, having the body of a sheep and the head of a camel; and they let us come quite near. On the other side of the mountains they are used as a beast of burden, though so

weak that ten of them could not carry the load of an average donkey. After wandering about the lower lands, we climbed through the bogs and granite boulders to the top of one of the hills, and came suddenly to a most wonderful view, with seven snowy cones of the Cordillera piercing their way through the long line of mist which hid the nearer connecting mountains from sight, and glittering against the greenish-blue sky. Each one looked perfectly separate and gigantic, though the highest was only 10,000 feet above the sea. Under the mist were hills of beech forest, and nearer still the araucaria domes, while the foreground consisted of noble old specimens of the same tree grouped round a huge gray boulder covered with moss and enriched with sprays of embothrium of the brightest scarlet. No subject could have been finer, if I could only have painted it, but that "if" has been plaguing me for years, and every year seems to take me further from a satisfactory result.

<hr>

62.

HOMESICK IN SANTIAGO

Personal letter to Margaret Shaen, 27 November 1884
Mr. and Mrs. Pakenham give me the most restful home here, and have as yet always come to post my English letters every fortnight. I have finished sixteen paintings, two of them on three and four of my large sheets. The blue and green Puyas were too magnificent to make less than life size – they were no easy work and even in such a space look cramped. I long for energy to repaint them on good canvas when I return but am wearing out and feel that my work will soon cease. They want to have an exhibition here of them. One enthusiastic old Don has made such a fuss in the papers about them and me that there is a craze to see them. Art is not very advanced in Chili. At this moment an exhibition is going on of native work, and these are some rooms of paintings, and one indecent room into which all undraped figures are banished, combined with maps! It is rather hard upon geographical people that they cannot see their charts without being accused of a taste for the costume of Adam and Eve! [...]

I have lately been staying nearer the sea with a very nice motherly body with no end of children, and a husband up the coast at the famous nitrate works amongst the dry works and

[above] ***Armed Bird's Nest in Acacia Bush.*** North's interest in ornithology was indulged by Rudolph Amando Philippi, director of Santiago's natural history museum and founder of the city's botanic garden. North records in *Recollections* that she 'tore her hands to pieces' attempting (and failing) to get to the nest of this bird, which weaves its nest from the thorny branches of *Vachellia caven.*

desert. All the family move there too in spring, and leave their nice home and gorgeous garden for perfect desolation and dangers, with nothing but unlimited sea bathing to entertain them and the possibility of being washed away on a big wave any day to keep up their spirits. I have heard some wonderful accounts of these big waves lately, how they have come up and taken every vestige of house and garden-houses and stables off and left pure smooth sand in the place. One gentleman had his watch washed away and brought back afterwards by another. But they have had none of these horrors for many years now and even the earthquakes are very slight. [...]

The birds are most tame here and their nests exquisite. I have painted an odd group – two gorgeous wrens with their two nests, on one of which a loose untidy nest has been built on the top by a dowdy little bird. The houseless bird is asking his friend, "who has been meddling with my nest?" and the dowdy one looks up and laughs! Professor Philippi is very good to me and gives me anything I like from his museum to take home and paint. There is a most gorgeous moth whose grub builds a nest in the pith of the puya, and I visited an English lady on the seashore who finds and collects insects, and has promised me duplicates when I go and stay with her later on.

Goodbye dear, give my love to all who care for it. I am very homesick and write few letters.

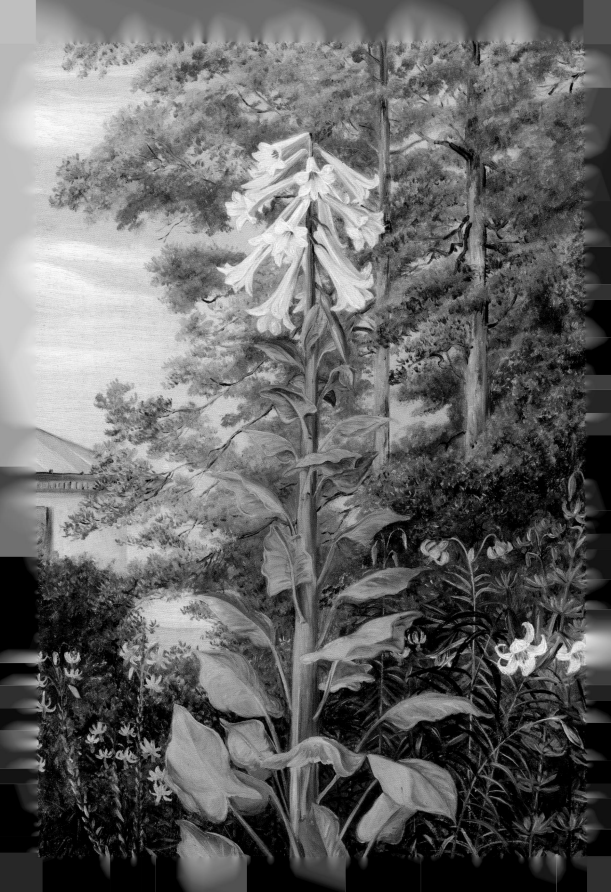

Marianne North at Home: London Life and a Gallery at Kew

1870–1886

North is often portrayed as a perpetual traveller from the early 1870s to the mid-1880s, with any consideration of a home life being relegated to 'before' in Hastings and Rougham, and 'after' in Alderley. London tends not to feature prominently, although her writing includes the significant periods of time spent there before, during and after her travels. Piecing together dates in *Recollections* shows that during the period of her travels from 1871 to 1885, she spent over five years (more than a third of the total) at home in London, or on short trips elsewhere in the British Isles and Europe. The year preceding her first trip to North America and Jamaica was also spent in London, as was more than a year after her return from Chile.

According to her sister, Catherine Symonds, as the years passed North's home became ever more crammed with travel mementos (Ex. 63). The emphasis in Symonds's account of North's hospitality and friendship delicately gestures towards the importance of nurturing and expanding connections with people who could help her establish herself as a travelling – and exhibiting – artist. North exhibited her growing collection of artworks in London from 1877, when her paintings were displayed at the Royal Colonial Institute during its summer 'conversazion' (gathering). After her paintings were appraised by Norman Macleod and Richard Anthony Thompson

of the South Kensington Museum (Ex. 64), the museum hosted her first significant exhibition, framing and glazing 512 paintings for display. The exhibition ran from late 1877 into 1878, while North was in India.

When she returned to London in the spring of 1879, Arthur C. Burnell was visiting England. Her letters to him offer a fascinating glimpse of the interweaving of North's social and professional life at this pivotal point in her artistic career (Ex. 65). The 'P.R.S' in the first letter was the mathematician William Spottiswoode, then president of the Royal Society and one of the most influential men in British science. Another of North's guests, Thomas Henry Huxley, would succeed him in the role in 1883. In the second letter we see the 'friends of many kinds' referred to by Symonds, with the arts represented by the Pre-Raphaelite William Holman Hunt and his (second) wife Edith, the actor Helen Faucit and her biographer husband Theodore Martin, and the Eustace Smiths – North's travelling companions to and across the US in 1875. On the scientific side was the naturalist and anthropologist George Busk, and Herbert Spencer, a philosopher and sociologist who, along with Spottiswoode and Huxley, were close associates of another of North's powerful allies, Kew's director Joseph Dalton Hooker. All were leading figures in scientific circles and advocates of Darwinism. James Fergusson, the architectural historian who North would shortly engage to design her Kew gallery, was also invited to her table.

[page 246] *The Giant and other Lilies in Dr. Allman's Garden at Parkstone, Dorset.* A second gallery painting that was produced in England. This painting, which hangs in the India section of the gallery, shows a cultivated specimen of the giant Himalayan lily *Cardiocrinum giganteum* growing in the Allmans' Dorset garden.

At this time, North was arranging a forthcoming summer exhibition of her paintings from India, Java and Sarawak at a gallery in Conduit Street. For this she relied, as ever, on friends for both practical assistance and publicity. One reviewer, writing for *The Pall Mall Gazette*, commented that 'it would be a happy thing if, by any means, some or all of them could be acquired for permanent national exhibition among the similar objects

now so admirably arranged at Kew'. Less than a week later, North wrote to Joseph Hooker offering both her paintings and a gallery to house them, and Fergusson was engaged as its designer and manager soon after. Along with her growing reputation and experience came a crystallisation of her artistic project. With plans for her Kew gallery maturing, she aimed for its collection to form a 'representation of the vegetation of the world', and spoke about this with Charles Darwin. She writes in *Recollections* that she took his suggestion that her next priority should be Australia as 'a royal command' (Ex. 66) – albeit that her letters show she had already conceived of this trip at least several months earlier – and paid him another visit in the summer of 1881 to show him the resulting paintings.

During the 1880s, her time in London was increasingly taken up with the gallery. Readying it for opening was a year's hard graft: patching, sorting, fitting and framing the artworks, producing the 16 paintings hung in the gallery's upper recesses, organising the woods, painting the panels and door surrounds, and drafting its catalogue (Ex. 67). 'I am at Kew all and every day and so dead tired on my way home,' she wrote to Margaret Shaen, during the final push. The gallery opened in June 1882, displaying 627 paintings produced during her travels from 1871 onwards and a dado of associated wood specimens – but so far as North was concerned, the collection was incomplete. Fergusson was instructed to extend the gallery building, while her travels continued in South Africa, the Seychelles and finally Chile.

Reorganising the gallery took more than a year from 1885 to 1886. Paintings from her last three travels were not simply slotted into the additional space: the whole collection was rearranged and renumbered (and a new catalogue produced), 'so as to keep the countries as much together as possible', she writes in *Recollections*, 'the geographical distribution of the plants being the chief object I had in view in the collection'. Her work resulted in the curation that can be seen today, with its walls filled to the last inch with her vibrant botanical subjects and views.

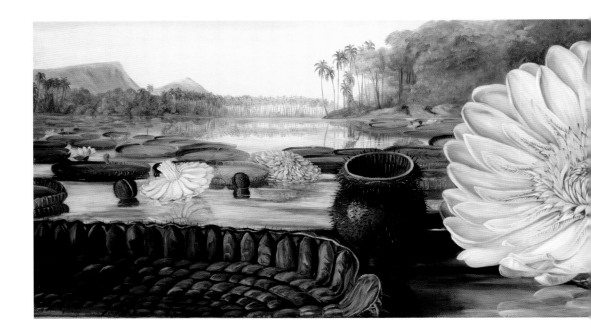

THE FLAT,
VICTORIA
STREET SW1

By Catherine Symonds, in *Some Further Recollections*
of a Happy Life

The flat in Victoria Street remained my sister's permanent home
over a period of sixteen years, from the Summer of 1870 to 1886.

As new interests of many kinds grew up around her, her
cheerfulness returned. London life suited her, with its many
and varied attractions, music especially, and the society of
her ever-increasing company of faithful friends, for she had
the happy faculty of keeping a tight hold on the affections
of all the older ones, while adding to their number year by
year. Friends of many kinds, scientific as well as literary, were
attracted to her by her own untiring industry. Friends came
to her in London from the ends of the earth, who had been
her hospitable entertainers in their distant colonial homes,
and to whom she delighted to give an equally kindly welcome
when they landed in the old country. Children too and young
people she loved, and they were always attracted by her. To
her nephews and nieces "The Flat" was a delightful home,
always wide open for them, and always interesting. To it she
came back at varying intervals from those wonderful journeys,

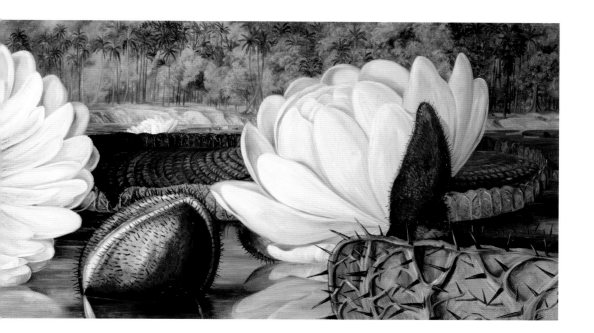

[above] *Victoria Regia.* One of the gallery paintings that North produced in London, most probably during the foggy winter of 1879–80 when she also began *Recollections of a Happy Life.* 'The picture was not painted from nature,' notes the gallery catalogue, 'but from Fitch's splendid illustrations, and done in the fogs of a London winter, assisted by the memory of its magnificence in many tropical gardens.' Walter Hood Fitch was one of the nineteenth century's most talented and prolific botanical illustrators. He published over 10,000 illustrations during the course of his career, including more than 2,700 in *Curtis's Botanical Magazine.*

bringing with her numerous objects rare and strange to cram its not unlimited space. There were glass-cases containing marvellous stuffed birds or tropical butterflies, both sadly liable to ruin from the London climate and London dirt. Pictures, sketches, photographs by Mrs. Cameron, musical instruments of uncertain sound and outlandish form: a big stuffed albatross swinging from the ceiling in the little dining-room; the tiny Australian bear and stately lyrebird, the platypus and a venerable hornbill all crowding into the drawing-room, with shells, crystals, and quaint oriental bronzes – each object not merely bought at a bric-a-brac shop, but carrying its special associations and telling its own history; in the centre of all these stood the stately bust of our mother, which was so strikingly like herself as she grew older.

And how warm and delightful, in the midst of this most un-London-like setting, was the welcome with which she would come forward to greet her guests, whether strangers or near of kin! It was impossible not to wish sometimes, as the years went on, that she might be content to live this pleasant life among her friends, and leave the ends of the earth unvisited – a remnant of them, at least.

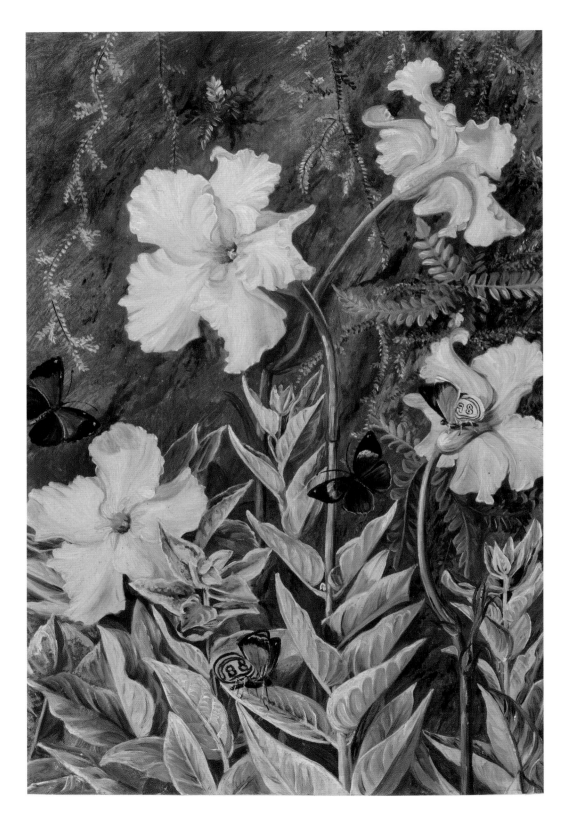

MARIANNE NORTH'S TRAVEL WRITING

But these were idle wishes, and when the wandering mood, "die Reise Lust," came on her, she had to go.

64.
SOUTH KENSINGTON MUSEUM EXHIBITION, 1877

[opposite] *Flannel Flower of Casa Branca and Butterflies, Brazil.* The illustrated newspaper *The Graphic* published a glowing review of North's South Kensington Museum exhibition in January 1878, drawing particular attention to her paintings from Brazil and specifically to this painting depicting flowering *Mandevilla longiflora* and Callicore butterflies, commonly called eighty-eights after the markings on the underside of their wings.

I went straight through from Cannes to London in thirty-six hours, arriving at midnight on the 25th of February 1877. After which I enjoyed six months with my friends in London and in the country, the chief event being a visit the Emperor of Brazil paid to my flat at eleven o'clock on the 20th of June, when he looked at all my curiosities and paintings, and told me about my different friends in his country, forgetting nobody that he thought I was interested in, with his marvellous memory. (He took me, between two visits, to a prison and a museum!) Another event was, that same Kensington Museum sending The [*sic*] M'Leod and Mr. Thompson to look at my different paintings, asking me to lend them for exhibition in one of their galleries. Of course I was only too happy that they thought them worth the trouble of framing and glazing. I was still more flattered when I heard afterwards that in the cab on the way to my flat, Mr. T. had said to the Laird, "We must get out of this civilly somehow. I know what all these amateur things always are!" but in the cab going back, he said, "We must have those things at any price."

I employed the last few weeks of my stay in England in making a catalogue as well as I could of the 500 studies I lent them, putting in as much general information about the plants as I had time to collect, as I found people in general woefully ignorant of natural history, nine out of ten of the people to whom I showed my drawings thinking that cocoa was made from the cocoa-nut.

65.
DINNER DATES

Personal letters to A. C. Burnell, multiple dates in 1879
16 May: Welcome to England! I want you to dine here on Monday 26th at 7.30 to meet the P.R.S and Mrs Spottiswoode as well as the Huxleys & other nice people.

Please say yes.

'Saturday' [June]: Will you let me know some day you will come to dinner after the 26th? I want you to know my "Co"

[above] *The first pages of North's January 1880 letter sending new year greetings to Burnell in India,* in which she thanks him for two vases just received and mentions she has started writing her autobiography. This is the last letter in their correspondence held at Kew. In very poor health, and having suffered partial paralysis, Burnell returned to Europe for good during 1880, and died two years later aged just 42. His joint project with North was never completed; the paintings she created for it form part of the gallery collection.

Mary Ewart – is there anybody you want to meet who I am likely to know. I think one of the chief delights of life is knowing nice people – and wish my friends to have the same enjoyment. [...] I have some nice people to dinner on Monday – a queer mixture! The Holman Hunts, Busks (anthropological), Eustace Smiths (globe trotters), James Fergusson, Herbert Spencer and Theodore Martins, and a very discreet old English lady, a relation, as a balance – of stupidity. I wish you could have come too but you would be no. 13 and might not like it, to say nothing of having no room to sit – if you are wandering in the streets come in afterwards.

Don't be afraid of sending me fresh friends – your sort will not bore me.

Undated [June]: I am going to do a rude thing and ask you to scratch out 30th June and put in 7th July (also Monday) for dining here.

I have just taken a gallery, 9 Conduit Street, for my Indian sketches and shall be in all the agonies of hanging and quite dead by the evening of the 30th and unable to attend to my guests with any degree of politeness. I hope to open the exhibition on the 1st – would you tell all Indian friends if I sent you a pack of printed halfpenny cards – for instance would you direct them to some of your friends? I think that would be a good way – and if you *could* write a line to the Acc<u>a</u>demy! (Lots of 'c's) or any other paper – do you think the Indian Club would put a paper notice in its passage? I am ignorant about advertising – but it must be done to pay the rent! General MacMardo is arranging everything about the hanging for me and will, I believe, come down with hammer and nails and help me himself. I am indeed lucky in my friends!

66.
A 'ROYAL' COMMAND

1880: One day, after arranging all this, I was asked by Mrs. Litchfield to come and meet her father, Charles Darwin, who wanted to see me, but could not climb my stairs. He was, in my eyes, the greatest man living, the most truthful, as well as the most unselfish and modest, always trying to give others rather than himself the credit of his own great thoughts and work. He seemed to have the power of bringing out other people's best points by mere contact with his own superiority. I was much flattered at his wishing to see me, and when he said he thought I ought not to attempt any representation of the vegetation of the world until I had seen and painted the Australian, which was so unlike that of any other country, I determined to take it as a royal command and to go at once. Mrs. Brooke persuaded me to return with her and the Rajah to Sarawak, and make a half-way rest there; so I joined her party on board the Sindh at Marseilles on the 18th of April 1880, and arrived at Singapore on the 15th of May, after an agreeable voyage in that most excellent French steamer in which I had once returned from Ceylon.

Summer 1881: Down is about six miles from Bromley Common, a pretty village, and a most unpretentious old house with grass plot in front, and a gate upon the road. On the other side the rooms opened on a verandah covered with creepers, under

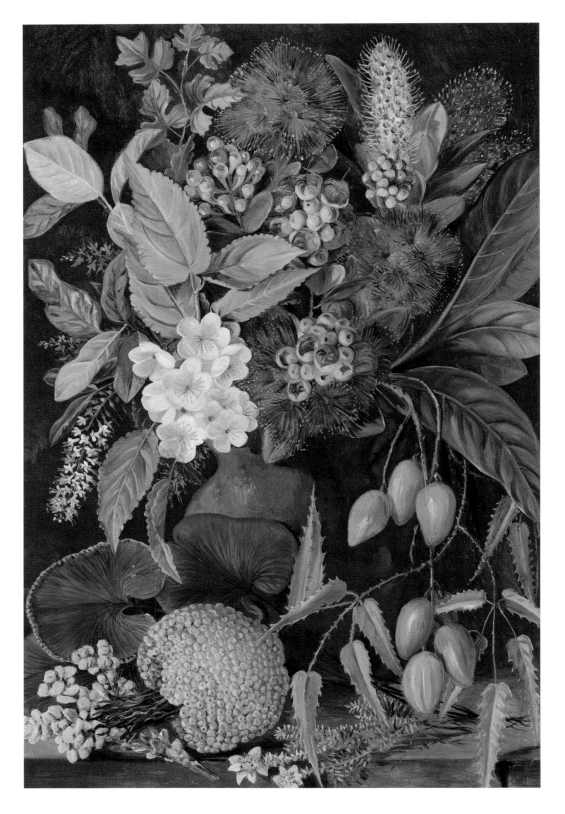

which Mr. Darwin used to walk up and down, wrapped in the great boatman's cloak John Collier has put in his portrait. He seldom went further for exercise, and hardly ever went away from home: all his heart was there and in his work. No man ever had a more perfect home, wife, and children; they loved his work as he did, and shared it with him. He and Mr. Norman had been friends for many years, and it was pretty to see the greater man pet his old neighbour and humour him; for with all his great spirit he was very much of a spoilt child, and proud of his age. Of Charles Darwin's age I never had the smallest idea. He seemed no older than his children, so full of fun and freshness. He sat on the grass under a shady tree, and talked deliciously on every subject to us all for hours together, or turned over and over again the collection of Australian paintings I brought down for him to see, showing in a few words how much more he knew about the subjects than any one else, myself included, though I had seen them and he had not.

[...]

When I left he insisted on packing my sketches and putting them even into the carriage with his own hands. He was seventy-four: old enough to be courteous too. Less than eight months after that he died, working till the last among his family, living always the same peaceful life in that quiet house, away from all the petty jealousies and disputes of lesser scientific men.

[Here follows a short note from Mr. Darwin, written just after this visit, showing his appreciation of my sister's work. The plant referred to is *Raoulia eximia,* a native of the Middle Island of New Zealand [...] – EDITOR.]

2d August 1881.

DOWN, BECKENHAM, KENT.

MY DEAR Miss NORTH, I am much obliged for the "Australian Sheep," which is very curious. If I had seen it from a yard's distance lying on a table, I would have wagered that it was a coral of the genus Porites. I am so glad that I have seen your Australian pictures, and it was extremely kind of you to bring them here. To the present time I am often able to call up with considerable vividness scenes in various countries which I have seen, and it is no small pleasure; but my mind in this respect

must be a mere barren waste compared with your mind. – I
remain, dear Miss North, yours, truly obliged,
 CHARLES DARWIN

67.
MUCH TROUBLE AND MUCH PLEASURE

1881–1882

My first thought after unpacking was of the building at Kew,
and I did not long delay in going there. I found the building
finished (as far as bare walls went) most satisfactorily, its
lighting perfect. Mr. Fergusson kindly arranged about the
decorating and painting of the walls. After that I spent a year
in fitting and framing, patching and sorting my pictures, and
finally got it finished and opened to the public on the 7th
of June 1882. I had much trouble but also much pleasure in
the work. What need now is there to
remember the former? Mr. Fergusson
throughout was my best help and
counsellor, and towards him I shall
always feel the strongest gratitude.

I had intended putting an enlarged
map of the world on the ceiling,
coloured according to the geographical
distribution of plants, in different shades
of green and brown, the sea also shaded
as it is in nature – clearest turquoise in
the tropics, indigo in the middle seas,
and green near the ice. I meant to add
an index of fruits painted by myself, on
the cornice, and twelve typical trees
between the windows, but every one was
against such an unconventional idea,
except my old friend Mr. Fergusson, and
he wanted some good geographer to
make a model, and suggested consulting
Francis Galton or Mr. Wallace. The first
was most kind and helpful as usual, but
covered the map he started on with level
lines and curves from 500 to 10,000
feet, and that was of no use on so small

[opposite] **Australian Spear Lily.** One of the 16 oil-on-canvas paintings that North painted in London for the gallery's upper recesses. Where possible she painted these life size, although this painting is about one-quarter of natural size. At Camden Park in Australia, North had observed a flower spike of this plant for two months, hoping it would come to full flower. *Recollections* notes that the Kew specimen depicted in this painting from spring 1882 took five months to progress from the first flush of colour to full flowering perfection.

[overleaf] **The Marianne North Gallery has benefited from conservation projects** to repair and preserve the paintings and restore many of the gallery's original features, including its floor tiles and 16 oil-on-canvas paintings in the upper gallery.

a scale. Then I made a pilgrimage to see Mr. Wallace, and found him most delightful, and much interested in my plan. He recommended asking Mr. Trelawney Saunders to make my map, which he did – a most exquisite piece of hand-shading, for which I paid £120 – but it was not in the least what I wanted, and did not give the limits of palms or fir-forests, so I resolved to give up my scheme, and to leave the ceiling for the present. I also got woods from all parts of the world to make a dado of. Only half of them came with names on them, and half were lost. It was a great difficulty to arrange them, but time mended all. The catalogue I wrote on cards, and stuck them under the paintings; and after I had put down all I knew, Mr. Hemsley corrected and added more information, which he did so thoroughly and carefully that I asked him to finish the whole, and to put his name to the publication.

Though the work gave me no little trouble and fatigue, it brought me in contact with many interesting people, and sometimes mere strangers said things about it which gave me great pleasure. One day, when the door was accidentally left open, some ladies and a gentleman came in. He was rather cross at not finding Sir Joseph, whom he was seeking. He turned rather rudely to me, after getting gradually interested in the paintings – "It isn't true what they say about all these being painted by one woman, is it?" I said simply that I had done them all; on which he seized me by both hands and said, "You! then it is lucky for you that you did not live two hundred years ago, or you would have been burnt for a witch."

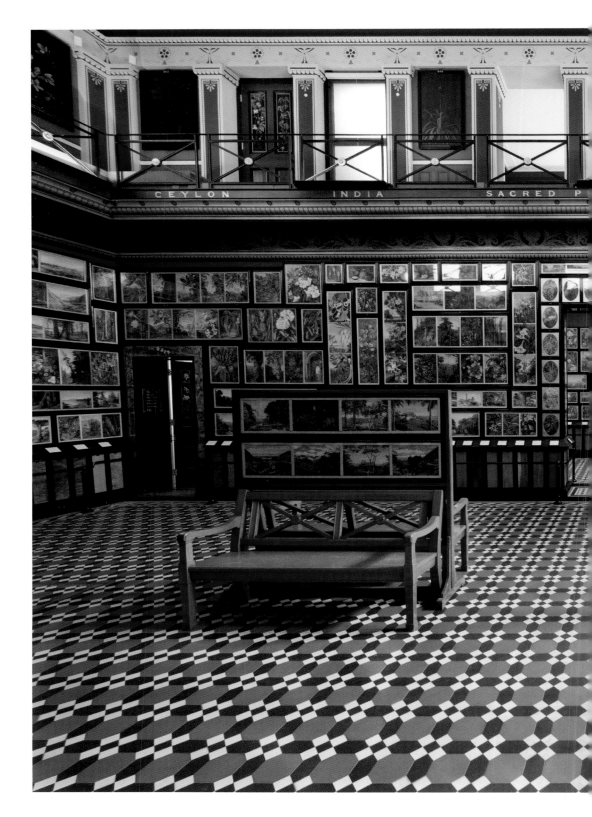

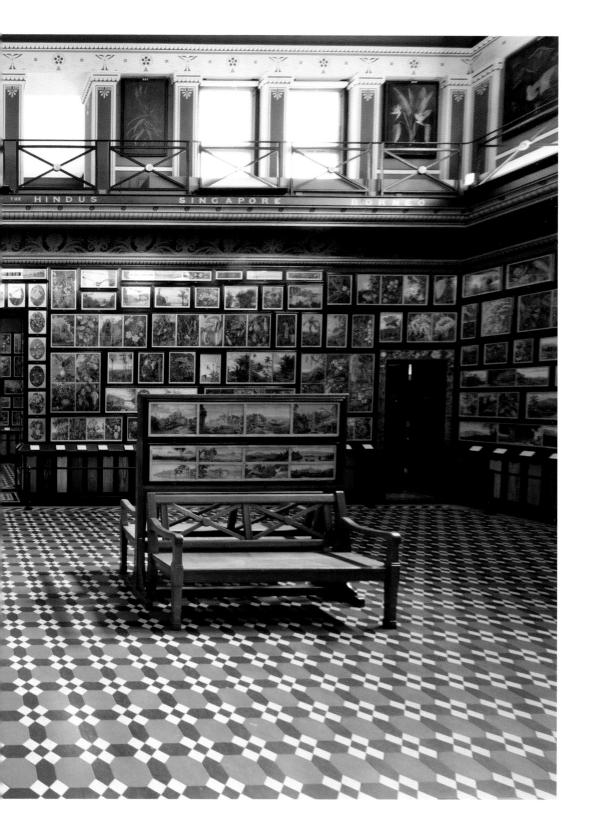

Further Reading

Introduction

Darwin Correspondence Project. Hannah Louisa Allman 1816–91. Online.

Darwin Correspondence Project. Margaret Josephine (Margaret) Shaen. Online.

Lane-Poole, S. (2012). Burnell, Arthur Coke (1840–1882), Sanskritist and Expert on Southern Indian Language and Literature. *Oxford Dictionary of National Biography*. Online.

Pollard, A. F. (2004). Allman, George James (1812–1898), Naturalist. *Oxford Dictionary of National Biography*. Online.

Royal Botanic Gardens, Kew. Papers Relating to Marianne North 1830–1890, Botanical Artist. RBG Kew.

Slinn, J. (2021). Shaen, William (1820–1887), Radical and Lawyer. *Oxford Dictionary of National Biography*. Online.

Tarlach, G. (2022). A Botanical Mystery Solved, After 146 Years. *Atlas Obscura*. Online.

Yule, H., & Burnell, A. C. (2013). *Hobson-Jobson: The Definitive Glossary of British India. A Selected Edition*. Edited by Kate Teltscher. Oxford University Press, Oxford.

1. Revisiting Marianne North's *Recollections*

Andaya, B. W., & Andaya, L. Y. (1982). *A History of Malaysia*. Macmillan, London.

Beard, M. (2007). 'She Travels Alone and Unattended': The Visit to the Eastern Cape of the Botanical Artist, Marianne North. *De Arte* 42(76): 33–48.

Brooke, M. (1913). *My Life in Sarawak*, Methuen & Co, London.

Buxton, J. '*A Vision of Eden,' Marianne North Painting in the Jungle*. Tapestry. 1.2 m sq. Reproduced in *Craft* magazine, July 1988.

Cowan, R. S. (2004). Galton, Sir Francis (1822–1911). *Oxford Dictionary of National Biography*. Online.

Dalziel, N. (2006) *The Penguin Historical Atlas of the British Empire*. Penguin, London.

Davis, M. (2001). *Late Victorian Holocausts: El Niño Famines and the Making of the Third World*. Verso, London and New York.

Driver, F., & Jones, L. (2009). *Hidden Histories of Exploration: Researching the RGS–IBG Collections*. Royal Holloway, University of London.

'The Library', *The Field,* 27 February 1892.

Ghosh, A. (2021). *The Nutmeg's Curse: Parables for a Planet in Crisis*. John Murray, London.

'The Eye of a Needle', *The Guardian,* 11 May 1988.

Hall, C., Draper, N., McClelland, K., Donington, K., & Lang, R. (2014). *Legacies of British Slave-Ownership*. Cambridge University Press, Cambridge, UK.

'A Floral Painter in South Africa', *The Illustrated London News,* 28 April 1883.

'Miss Marianne North's Recollections', *The Illustrated London News,* 2 April 1892.

IPCC (2022). *Climate Change 2022: Impacts, Adaptation and Vulnerability. Summary for Policymakers*.

Jessop, A. 'The Recollections of a Happy Life', *The Nineteenth Century,* April 1892.

Lear, E. Letter to Arthur Coke Burnell, 17 August 1877. MN1/1/4. Royal Botanic Gardens, Kew.

Lester, A., Boehme, K., & Mitchell, P. (2021). *Ruling the World: Freedom, Civilisation and Liberalism in the Nineteenth-Century British Empire*. Cambridge University Press, Cambridge, UK.

Lipscomb, S., & Carr, H. (eds) (2021). *What Is History, Now?* Epub. Weidenfeld & Nicolson, London.

Mercer, H. Colonialism: Why Leading Climate Scientists Have Finally Acknowledged its Link with Climate Change. *The Conversation*, 22 April 2022. Online.

Moon, B. E. (1978). Marianne North's Recollections of a Happy Life: How They Came to Be Written and Published. *Archives of Natural History* 8 (4): 497–505.

Morgan, S. (ed.) (1993). *Recollections of a Happy Life*. University Press of Virginia, Charlottesville.

'Recollections of a Happy Life', *The Nation*, 2 June 1892.

North, Marianne, & Huxley, A. (1980). *A Vision of Eden: The Life and Work of Marianne North*. Webb & Bower, Exeter, in association with the Royal Botanic Gardens, Kew.

'A Lady's Adventures in a Tropical Archipelago', *Pall Mall Gazette,* 21 January 1884.

Payne, M. (2011, 2016). *Marianne North: A Very Intrepid Painter*. Kew Publishing, London.

Ponsonby, L. (1990). *Marianne North at Kew Gardens*. Webb & Bower, Exeter, in association with the Royal Botanic Gardens, Kew.

The Remarkable Miss North (2016). DVD. Blink Entertainment Ltd & Warner Sisters Productions Ltd.

Rutherford, A. (2020). *How to Argue with a Racist: History, Science, Race and Reality*. Epub. Weidenfeld & Nicolson, London.

Rutherford, A. (2022). *Control: The Dark History and Troubling Present of Eugenics*. Epub. Weidenfeld & Nicolson, London.

Saini, A. (2019). *Superior: The Return of Race Science*. Epub. 4th Estate, London.

Sanghera, S. (2021). *Empireland: How Imperialism Has Shaped Modern Britain*. Epub. Penguin Books, London.

Standish, A. (2007). Representing All the Continents of the World: Marianne North, Flower Painting and Whiteness. In: L Boucher, J. Carey & K. Ellinghaus (eds), Historicising Whiteness: Transnational Perspectives on the Construction of an Identity. RMIT Publishing, Melbourne, pp. 201–210. Historicising Whiteness Conference (2006), Melbourne, Australia.

Vance, N. (2004). Kingsley, Charles (1819–1875). *Oxford Dictionary of National Biography*. Online.

Warnapala, K. C. (2008). Dismantling the Gaze: Julia Margaret Cameron's Sri Lankan Photographs. *Postcolonial Text* 4(1).

Williams, J. 'Why Climate Change Is Inherently Racist'. bbc.com, 27 January 2022. Online.

2. North America by Rail

American Museum of Natural History. Timeline: 1869 to Present. Online.

Anguiano, D. Native American Tribes Reclaim California Redwood Land for Preservation. *The Guardian*, 25 January 2022. Online.

Blakemore, E. What Was It Like to Ride the Transcontinental Railroad? history.com. Online.

Central Pacific Railroad Photographic History Museum. Chinese-American Contribution to Transcontinental Railroad. Online.

Churella, A. (2018). Railroads in US History. In: *Oxford Research Encyclopedia of American History*. Oxford University Press. Online.

US National Park Service (2021). Cliff House History – Golden Gate National Recreation Area. Online.

Devens, R. M. (1878). Completion of the Pacific Railroad – 1869. In: *Our First Century: Being a Popular Descriptive Portraiture of the One Hundred Great and Memorable Events of Perpetual Interest in the History of Our Country*. C. A. Nichols & Co, Springfield.

Dunbar-Ortiz, R. (2014). *An Indigenous Peoples' History of the United States*. Beacon Press, Boston.

Gandhi, L. (2021). The Transcontinental Railroad's Dark Costs: Exploited Labor, Stolen Lands. history.com. Online.

Harvard University, Department of Earth and Planetary Sciences. Louis Agassiz. Accessed 29 November 2022. Online.

Iqbal, S. Louis Agassiz, Under a Microscope. *The Harvard Crimson*, 18 March 2021. Online.

Jackson, J. F. (2021). Labor and Chinese Exclusion in US History. In: *Oxford Research Encyclopedia*

of *American History*. Oxford University Press. Online.

A Brief History of the Pacific Railway – The Transcontinental Railroad. Linda Hall Library. Online.

Snow Sheds: How the CPRR Crossed the Summit. Linda Hall Library, 2012. Online.

O'Hagan, S. The Swiss Mountain with a Racist Name – and the Artist Fighting to Rechristen It. *The Guardian*, 21 November 2022. Online.

Railroad Snowsheds of Donner Summit. Sierra Nevada Geotourism. Online.

Vong, S. The Impact of the Transcontinental Railroad on Native Americans. National Museum of American History, 30 May 2019. Online.

White, R. (2011). *Railroaded: The Transcontinentals and the Making of Modern America*. W. W. Norton & Co, New York.

3. Jamaica, At Last

Cundall, F., & Institute of Jamaica (1915). *Historic Jamaica: With Fifty-Two Illustrations*. Published for the Institute of Jamaica by the West India Committee, London.

Fawcett, W. (1897). The Public Gardens and Plantations of Jamaica. *Botanical Gazette* 24(5): 345–69.

Hall, C., Draper, N., McClelland, K., Donington, K., & Lang, R. (2014). *Legacies of British Slave-Ownership*. Cambridge University Press, Cambridge, UK.

Heuman, G. (2018). Map Recording the Rebellion of 1865. In: *Victorian Jamaica*, ed. T. Barringer & W. Modest, Epub edition. Duke University Press.

Hudson, B. J. King's House, Spanish Town, St. Catherine. National Library of Jamaica Digital Collection. Online.

Craighton House. Jamaica National Heritage Trust. Online.

Kingsley, C. (1871, 1872). *At Last: A Christmas in the West Indies*. Macmillan & Co, London.

Kostal, R. W. (2004). Jamaica Committee. *Oxford Dictionary of National Biography*. Online.

Mosley, R. A. (2015). Craighton Estate Great House and Coffee Company. A Tour of Jamaica's Great Houses, Plantations, & Pens (blog), 23 February 2015. Online.

Mosley, R. A. (2015). Shaw Great House. A Tour of Jamaica's Great Houses, Plantations, & Pens (blog), 28 May 2015. Online.

Munn, E. (2013). My Journey to Clifton Mount Coffee Estate. Blue Mountain Coffee. Online.

Nesbitt, M. (2018). Botany in Victorian Jamaica. In: *Victorian Jamaica*, ed. Barringer, T., & Modest, W. Epub. Duke University Press, Durham.

Paton, D. (2018). State Formation in Victorian Jamaica. In: *Victorian Jamaica*, ed. Barringer, T., & Modest, W. Epub. Duke University Press, Durham.

Rashford, J. (2001). Those That Do Not Smile Will Kill Me: The Ethnobotany of the Ackee in Jamaica. *Economic Botany* 55(2): 190–211.

Turnbull, S. Blue Mountain Rhapsody in Jamaica. *The Independent*, 6 December 2013. Online.

4. Brazil with the Baron

Agassiz, L., & Agassiz, E. (1868). *A Journey in Brazil*. Ticknor and Fields, Boston.

Bailão, A. S. (2021). The Brazilian Campos in Nineteenth-Century Landscape Art. Environment & Society Portal, *Arcadia*, no. 15. Rachel Carson Center for Environment and Society. Online.

Barnes, A. (2014). Come and Visit Peter Lund Museum. *The Washington Independent*, updated 2021.

Bethell, L. (2018). The Decline and Fall of Slavery in Brazil (1850–88). In: *Brazil: Essays on History and Politics*. University of London Press: Institute of Latin American Studies, London.

Blasenheim, P. L. (1994). Railroads in Nineteenth-Century Minas Gerais. *Journal of Latin American Studies* 26(2) (May 1994): 347–74.

Anon (1882). *Brazil and English Slave-Holders (St. John Del Rey Gold Mining Co.)*. British and Foreign Anti-Slavery Society, London.

Burton, I., & Wilkins, W. H. (1897). *The Romance of Isabel Lady Burton: The Story Of Her Life*. 2 vols. Dodd Mead & Company, New York.

Burton, R. F. (1869). *Explorations of the Highlands of the Brazil*. 2 vols. Tinsley Brothers, London.

Campbell, C. J. (2015). Making Abolition Brazilian: British Law and Brazilian Abolitionists in Nineteenth-Century Minas Gerais and Pernambuco. *Slavery & Abolition* 36(3): 521–43.

Capanema, C. (2021). Mining and Environmental Destruction in Minas Gerais: A Historical Comparison. Environment & Society Portal,

Arcadia, no. 6. Rachel Carson Center for Environment and Society. Online.

Childs, M. D. (1998). A Case of 'Great Unstableness': A British Slaveholder and Brazilian Abolition. *The Historian* 60(4): 717–40.

Childs, M. D. (2002) Master–Slave Rituals of Power at a Gold Mine in Nineteenth Century Brazil. *History Workshop Journal* 53(1): 43–72.

The Cornish in Latin America. Morro Velho. University of Exeter. Online.

Delacalle, D. (2018) NO(rth) Brasil. danieldelacalle.com. Online.

Eakin, M. C. (1989). *British Enterprise in Brazil: The St John d'el Rey Mining Company and the Morro Velho Gold Mine, 1830-1960*. Duke University Press, Durham & London.

Holten, B., & Sterll, M. (2000). The Danish Naturalist Peter Wilhelm Lund (1801–80): Research on Early Man in Minas Gerais. *Luso-Brazilian Review* 37(1): 33–45.

González-Azcárate, B. & Lund, J. (2012). Mining the Tropics: Burton's Brazil and the history of empire. *Qui Parle* 20(2): 249–78.

de Oliveira, M. T. R. (2004). The Origins of the pioneer cotton mills in Minas Gerais, Brazil, 1868–1879: a reassessment. *Enterprise and Society* 5(2): 226–53.

Romeiro, A. (2022). The discovery of gold mines in Minas Gerais, Mato Grosso, and Goiás. In: *Oxford Research Encyclopedia of Latin American History*. Oxford University Press, Oxford.

Schwartz, S. P. (2021). Gongo Soco, Brazil – the Cornish and an 'English' village in the Tropics. Cousin Jack's World (blog). Online.

Schwartz, S. P. (2021). Morro Velho, Brazil – a Cornish community in the Tropics. Cousin Jack's World (blog). Online.

Thompson, J. (2009). Burton, Sir Richard Francis (1821–1890), explorer and author. *Oxford Dictionary of National Biography*. Online.

Tiradentes-géographie (2019). The Sanctuary of Caraça, a story of men and wolves. Tiradentes-géographie (blog). Online.

Triner, G. D. (2007). Property rights, family, and business partnership in nineteenth- and twentieth-century Brazil: the case of the St. John d'el Rey Mining Company, 1834–1960. *Enterprise & Society* 8(1): 35–67.

5. Wintering in Tenerife

'£30,00 For Scholarships. Women Students'. *Daily Telegraph*, 21 March 1911.

Allan, P. (2021). Jardin de Orquideas de Sitio Litre. eTenerife Holidays. Online.

'Cochineal Cultivation in Teneriffe'. *Scientific American*, April 1858. Online.

Davies, Kate (2023). Magenta Matters, 6 January 2023. KDD & Co (blog). Online.

Fagin, D. (2013). Dye Me a River: How a Revolutionary Textile Coloring Compound Tainted a Waterway. *Scientific American*, 22 March 2013. Excerpted from *Toms River: A Story of Science and Salvation*, by Dan Fagin (2013). Bantam Books, New York.

Farrell, S. M. (2014). Ewart, William (1798–1869), politician, patron of higher education for women. *Oxford Dictionary of National Biography*. Online.

Guerra, A. S. La Orotava Acclimatization Garden. Rincones del Atlántico. Online.

Hirsch, P. (1998). *Barbara Leigh Smith Bodichon, 1827–1891: Feminist, Artist and Rebel*. Epub. Chatto & Windus, London.

Grows on You. Jardin de Orquideas, Sitio Litre. Photos and Reviews of an Open Garden in Tenerife, 2009.

North, M. (1893). *Some Further Recollections of a Happy Life*. Macmillan & Co, London.

6. Tours and Troubles in Japan

Chion-in: the monumental temple in the Hills. Kanpai! Online.

Douglas, R. K., & Roberts, J. A. G. (2020). Alcock, Sir (John) Rutherford (1809–1897). *Oxford Dictionary of National Biography*. Online.

The Far East: A Monthly Illustrated Journal, Vol. 6, 1874–1875. Reprinted Yushodo Booksellers Ltd, Tokyo, 1965.

Meiji Restoration. *Britannica,* last updated 29 September 2021. Online.

Miller, A. (2019). *The Globetrotter: Victorian Excursions in India, China and Japan*. British Library, London.

Mitani, H. (2017). Meiji Revolution. In: *Oxford Research Encyclopedia of Asian History*. Oxford University Press. Online.

Nishi Hongan-Ji: Jodo-Shinshu's Head Temple. Kanpai! Online.

The Shōguns' Tombs, Ways to Japan (blog), 16

October 2013. Online.

Walker, B. L. (2015). *A Concise History of Japan*. Cambridge University Press, Cambridge, UK.

Wells, J. (2004). Parkes, Sir Harry Smith (1828–1885), Diplomatist. *Oxford Dictionary of National Biography*. Online.

7. Singapore Stopovers

Abdullah, A. R. T. (2011). Sultan Abu Bakar's foreign guests and travels abroad, 1860s–1895: fact and fiction in early Malay historical accounts. *Journal of the Malaysian Branch of the Royal Asiatic Society* 84(1): 1–22.

Baker, J. (2020). *Crossroads: A Popular History of Malaysia and Singapore*. 4th ed. Marshall Cavendish, Singapore.

Kwa, C. G., Heng, D., Borschberg, P., & Tan, T. Y. (2019). *Seven Hundred Years: A History of Singapore*. National Library Board, Singapore, in partnership with Marshall Cavendish International (Asia), Singapore.

Lindsay, Stuart, & Middleton, D. (2018). The gardens of Singapore. *Sibbaldia: The International Journal of Botanic Garden Horticulture* 16: 169–77.

Meiyan, M. (2018). Descendants of illustrious pioneers – Hoo Ah Kay. Interview with Hoo Miew Oon, published on the Singapore Memory Project website.

Obituary: Mr Thomas Scott. *The London and China Telegraph*. 2 July 1902.

Seng, L. T. (2021). Of parks, trees and gardens: the greening of Singapore. *BiblioAsia*. National Library, Singapore. Online.

Song, O. S. (2020) *One Hundred Years' History of the Chinese in Singapore: Annotated Edition*, eds. Tan, K. Y., Devi, G. U., & Lim, K. B. National Library Board, Singapore, and World Scientific Publishing, Singapore.

Turnbull, C. M. (2008). McNair, (John) Frederick Adolphus (1828–1910). *Oxford Dictionary of National Biography*. Online.

Turnbull, C. M. (2009). *A History of Modern Singapore 1819–2005*. NUS Press, Singapore.

Waddell, R. Dr Robert Little. OrnaVerum. Online.

Waddell, R. Mr Whampoa. OrnaVerum. Online.

Webster, A. (2011). The development of British commercial and political networks in the Straits Settlements 1800 to 1868: the rise of a colonial and regional economic identity?

Modern Asian Studies 45(4): 899–929.

Winks, R. W. (1972). Jervois, Sir William Francis Drummond (1821–1897). In: *Australian Dictionary of Biography*. National Centre of Biography, Australian National University, Canberra. Published online 2006.

Wue, T. H. (2021). Memories of South China: the enchanting garden that Whampoa built in Singapore. ThinkChina. Online.

8. Sarawak and the Brookes (Malaysian Borneo)

Andaya, B. W., & Andaya, L. Y. (1982). *A History of Malaysia*. Macmillan, London.

Baker, J. (2020). *Crossroads: A Popular History of Malaysia and Singapore*. 4th ed. Marshall Cavendish, Singapore.

Bernardi, G. 'Following Alfred Russel Wallace's footsteps to Borneo, where he penned his seminal evolution paper'. *The Conversation*, 15 August 2018. Online.

Brooke, M. (1913). *My Life in Sarawak*. Methuen & Co, London.

Brooke, M. (1984). *Good Morning and Good Night*. Century, Salt Lake City. Originally published by Constable, London, 1934.

Earl of Cranbrook (2013). The 'Everett Collection from Borneo Caves' in the Natural History Museum, London: its origin, composition and potential for research. *Journal of the Malaysian Branch of the Royal Asiatic Society* 86(1): 79–112.

Helms, L. V. (1882). *Pioneering in the Far East*. W. H. Allen & Co, London.

Laverty, M. (2011). Tegora – a mercurial anthology. academia.edu. Online.

Natural History Museum. Everett, Alfred Hart (1848–1898). JSTOR Global Plants, last updated 19 April 2013. Online.

Porritt, V. L. (2012). Sarawak Proper: Trading and Trading Patterns from Earlier Times to the Registration of the Borneo Company in 1856. *Borneo Research Bulletin*. Online.

Porritt, V. L. (2013). The Borneo Company's Role in the Economic Development of Sarawak during the Early Years of the Brooke Dynasty. *Borneo Research Bulletin*. Online.

Porritt, V. L. (2014). 'The Borneo Company's Role in the Economic Development of Sarawak during the Early Years of the Brooke Dynasty: Part II. *Borneo Research Bulletin*. Online.

Press, S. (2017). *Rogue Empires: Contracts and*

Conmen in Europe's Scramble for Africa. Harvard University Press, Cambridge, Massachusetts & London, UK.

Reece, R. H. W. (2008). Brooke, Sir Charles Anthoni Johnson (1829–1917). *Oxford Dictionary of National Biography*. Online.

Reece, R. H. W. (2014). Brooke, Sir (Charles) Vyner de Windt (1874–1963), Third and Last Raja of Sarawak. *Oxford Dictionary of National Biography*. Online.

Ritchie, J. 'Majestic Hills and Mountains of Sarawak'. New Sarawak Tribune (blog), 7 December 2019. Online.

Ritchie, J. A. 'Brooke World Heritage Site'. New Sarawak Tribune (blog), 19 January 2019. Online.

Wallace, A. R. (1869). *The Malay Archipelago: The Land of the Orang-Utan, And the Bird of Paradise*. Harper & Brother, New York.

9. Volcanic Java

Ariati, S. R., & Widyatmoko, D. (2019). Botanic garden profile: Bogor Botanic Gardens. *Sibbaldia: The Journal of Botanic Garden Horticulture* 17: 11–28.

Bromo Tengger Semeru National Park. Thousand Wonders. Online.

Dieng Plateau-Indonesia. Indonesia Travel. Online.

'Indonesia's Yadnya Kasada Festival – in pictures', *The Guardian,* 7 July 2020. Online.

Hannigan, T. (2015). *A Brief History of Indonesia*. Tuttle Publishing, North Clarendon, Vermont.

Moriyama, M. (2005). *Sundanese Print Culture and Modernity in Nineteenth-Century West Java*. Singapore University Press, Singapore.

Sayoga, P. 'Inside a volcanic ritual on the Indonesian island of Java', *The New York Times*, 8 November 2021. Online.

Steenbrink, K. (1993). Holle, Hurgronje and Hazeu: tutors to 'Members of a Backward Religion'. In: *Dutch Colonialism and Indonesian Islam: Contacts and Conflicts 1596–1950*, pp. 76–97. Rodopi, Amsterdam.

Svensson, T. (1994). *The Impossibility of Liberalism and Democracy in Indonesia, 1840–1940*. NIAS Reports, no. 13. NIAS Books, Copenhagen.

Borobudur Temple Compounds. UNESCO World Heritage Centre. Online.

Prambanan Temple Compounds. UNESCO World Heritage Centre. Online.

Wallace, A. R. (1869) *The Malay Archipelago: The Land of the Orang-Utan, And the Bird of Paradise*. Harper & Brother, New York.

10. 'Complete Rest' in Ceylon (Sri Lanka)

Boulger, G. S. (2004). Thwaites, George Henry Kendrick (1812–1882). *Oxford Dictionary of National Biography*. Online.

Ford, C. (2003) *Julia Margaret Cameron: 19th Century Photographer of Genius*. National Portrait Gallery, London.

Herbert, E. Julia Margaret Cameron in Ceylon: Idylls of Freshwater vs. Idylls of Rathoongodde. *The Public Domain Review*, 9 July 2014. Online.

Matthew, H. C. G., & Harrison, B. (eds) (2004). Gregory, Sir William Henry (1816–1892). *The Oxford Dictionary of National Biography*. Online.

Olsen, V. C. (2015). *From Life: Julia Margaret Cameron and Victorian Photography*. Epub edition. Independently published. First published by Aurum Press, 2003.

Pethiyagoda, R. (1999). The family de Alwis Seneviratne of Sri Lanka: pioneers in biological illustration. *Journal of South Asian Natural History* 4(2): 99–109.

Samrasinghe, I. L. P. 'Unsung Heros of Sri Lanka'. Daily News Online. Online.

Sivasundaram, S. (2007). Tales of the Land: British Geography and Kandyan Resistance in Sri Lanka, c. 1803–1850. *Modern Asian Studies* 41(5): 925.

Sivasundaram, S. (2013). *Islanded: Britain, Sri Lanka, and the Bounds of an Indian Ocean Colony*. University of Chicago Press, Chicago.

Sivasundaram, S. (2017). Cosmopolitanism and indigeneity in four violent years: the fall of the Kingdom of Kandy and the Great Rebellion revisited. In: *Sri Lanka at the Crossroads of History*, ed. Z. Biedermann & A. Strathern. UCL Press, London.

Sivasundaram, S. (2020). *Waves across the South: A New History of Revolution and Empire*. William Collins, London.

South Asia@LSE. 'The Kingdom of Kandy in Sri Lanka: Challenging Narratives of British Colonialism', 11 February 2013. London School of Economics blog. Online.

Anon. 'The unknown de Alwises' brush with Asian

flora', *The Sunday Times Sri Lanka*, 16 April 2017. Online.

Thurman, Judith. 'Angels and instincts: a Julia Margaret Cameron retrospective'. *The New Yorker*, 9 February 2003. Online.

Trimen, H. (1881). The Lepidoptera of Ceylon. *Nature* 25(628): 32–32.

Warnapala, K. C. (2008). Dismantling the gaze: Julia Margaret Cameron's Sri Lankan photographs. *Postcolonial Text* 4(1).

11. India from South to North

Brown, F. H. (2004) Digby, William (1849–1904), journalist and social campaigner. Ed. Kaul, C. *Oxford Dictionary of National Biography*. Online.

Codell, J. (2012). On the Delhi Coronation Durbars, 1877, 1903, 1911. Ed. Felluga, D. F. *BRANCH: Britain, Representation and Nineteenth-Century History* Extension of Romanticism and Victorianism on the Net. Online.

Davis, M. (2001). *Late Victorian Holocausts: El Niño Famines and the Making of the Third World*. Verso, London and New York.

Digby, W. (1878). *The Famine Campaign in Southern India (Madras and Bombay Presidencies and Province of Mysore) 1876–1878*. 2 vols. Longmans, Green and Co, London.

Dyson, T. (2018). *A Population History of India: From the First Modern People to the Present Day*. Oxford University Press, Oxford.

'Miss North', *Hastings and St. Leonards Times,* 22 March 1879.

The Heritage Lab. 'In Paintings: Muharram and its rituals in 19th century India', 28 August 2020. Online.

Joshi, P. (2013). '1857; Or, Can the Indian "Mutiny" Be Fixed?' Ed. Felluga, D. F. *BRANCH: Britain, Representation and Nineteenth-Century History* Extension of Romanticism and Victorianism on the Net. Online.

Khilnani, S. (2017). *Incarnations: A History of India in 50 Lives*. 2nd ed. Penguin, London.

Lester, A., Boehme, K., & Mitchell, P. (2021). *Ruling the World: Freedom, Civilisation and Liberalism in the Nineteenth-Century British Empire*. Cambridge University Press, Cambridge, UK.

Live History India. The Palaces of Deeg. Google Arts & Culture. Online.

Matthew, H. C. G., and Harrison, B. (eds.) (2004).

Burnell, Arthur Coke (1840–1882). *Oxford Dictionary of National Biography*. Online.

Matthews, R. (2021). *Peace, Poverty and Betrayal: A New History of British India*. Hurst & Company, London. Epub.

'Obituary. Lieut-General the Hon. Sir Henry Ramsay', *The Times,* 21 December 1893.

'Sir Andrew Scott Waugh and the Naming of Everest'. British Library blog. Online.

Shah, A. 'Ellora's Kailasa Temple: Built from the Top', 25 April 2020. Live History India. Online.

Sourabh, N. C., & Myllyntaus, T. (2015). Famines in Late Nineteenth-Century India: Politics, Culture, and Environmental Justice. In: *Virtual Exhibitions 2015, No 2*. Rachel Carson Center for Environment and Society. Online.

Steele, D. (2004). Temple, Sir Richard, First Baronet (1826–1902). *Oxford Dictionary of National Biography*. Online.

Tolia, R. S. (2009). *Founders of Modern Administration in Uttarakhand, 1815–1884: Edward Gardner to Henry Ramsay*. Bishen Singh Mahendra Pal Singh, Dehra Dun.

Washbrook, D. (2004). Lytton, Edward Robert Bulwer-, First Earl of Lytton [*pseud*. Owen Meredith]. *Oxford Dictionary of National Biography*. Online.

12. Australian Adventures

Australian Convict Sites. UNESCO World Heritage Centre. Online.

Buckley, J. 'Flowers rare and wonderful', Royal Botanic Gardens, Kew. Online.

Crowley, F. K. (1981). Forrest, Sir John (1847–1918). In: *Australian Dictionary of Biography*. National Centre of Biography, Australian National University, Canberra.

Davis, J. '"I wished I were an Osborne": the botanical artist Marianne North at Doondale in Illawarra'. Academia.edu. Online.

Department of Communities Tasmania (2019). 'Aboriginal and dual naming policy'. Online.

Dowe, J. L. (2020). The Australian paintings of Marianne North, 1880–1881: landscapes 'doomed shortly to disappear'. *Cunninghamia* 20: 1–33.Morris, D. 'Mueller, Sir Ferdinand Jakob Heinrich von (1825–1896)'. In: *Australian Dictionary of Biography*. National Centre of Biography, Australian National University, Canberra. Online.

Port Arthur Historic Site. 'History Timeline'. Online.

Queensland Government Museum. 'Bunya Mountains Gathering'. Online.

Raabus, C. 'Tasmanian dual naming policy announced atop Kunanyi', ABC Local, 13 March 2013. Online.

Rowan, E. (1898). *A Flower-Hunter in Queensland & New Zealand*. J. Murray, London.

Tasmanian Aboriginal Centre. '*palawa kani*, the only Aboriginal language in lutruwita today'. Online.

Tout-Smith, D. (2003). Baron Ferdinand von Mueller, botanist & explorer (1825–1896). Museums Victoria Collections. Online.

Wright, I. A. Bunya pines are ancient, delicious and possibly deadly. *The Conversation*, 22 May 2018. Online.

13. A Month in New Zealand

Gardner, W. J. (1990). Hall, John. *Dictionary of New Zealand Biography*. In: *Te Ara – the Encyclopedia of New Zealand*. Ministry for Culture and Heritage Te Manatu Taonga. Online.

Keenan, D. (2017). New Zealand Wars. In: *Te Ara – the Encyclopedia of New Zealand*. Ministry for Culture and Heritage Te Manatu Taonga. Online.

McLean, G. Governors and Governors-General – changing characteristics. In: *Te Ara – the Encyclopedia of New Zealand*. Ministry for Culture and Heritage Te Manatu Taonga. Online.

Starke, J. (1993). Enys, John Davies, *Dictionary of New Zealand Biography*. In: *Te Ara – the Encyclopedia of New Zealand*. Ministry for Culture and Heritage Te Manatu Taonga. Online.

Swarbrick, N. (2007). Flax and flax working. In: *Te Ara – the Encyclopedia of New Zealand*. Ministry for Culture and Heritage Te Manatu Taonga. Online.

Wilson, H. (2007). Alpine plants – alpine rock vegetation. In: *Te Ara – the Encyclopedia of New Zealand*. Ministry for Culture and Heritage Te Manatu Taonga. Online.

14. Coastal South Africa

'The Colenso Family and Elangeni'. Amersham Museum. Online.

'South African City of Port Elizabeth Becomes Gqeberha'. BBC News, 24 February 2021. Online.

Beard, M. (2007). 'She travels alone and unattended': the visit to the Eastern Cape of the botanical artist, Marianne North. *De Arte* 42(76): 33–48.

Beyer, G. (2022). Britain's unpleasant surprise: the Anglo-Zulu War. *The Collector*, 7 July 2022. Online.

Britain takes control of the Cape. South African History Online. 2011, updated 2019. Online.

Cohen, A. (2000) Mary Elizabeth Barber: South Africa's first lady natural historian. *Archives of Natural History* 27(2): 34.

Colenso, F. E. (1884). *Ruin of Zululand: An Account of British Doings in Zululand since the Invasion of 1879*. Vol. II. W. Ridgway, London.

Colenso, F. E., & Durnford, E. (1880). *History of the Zulu War and Its Origin*. Chapman and Hall, London.

Creese, M. R. S. (2010). *Ladies in the Laboratory III: South African, Australian, New Zealand, and Canadian Women in Science*. Scarecrow Press, Lanham; Toronto; Plymouth, UK.

Du Bois, D. L. (2015). *Sugar and Settlers: A History of the Natal South Coast 1850–1910*. Sun Media, Bloemfontein.

'Our History'. Groote Post Vineyards. Online.

Hardijzer, C. (2017). An elegant lady photographed – Hildagonda Johanna Duckitt (1839 to 1905). The Heritage Portal. Online.

Hinchliff, P. (2006). Colenso, John William (1814–1883). *Oxford Dictionary of National Biography*. Online.

Koorts, W. P. (2004). The 1882 transit of Venus: the British expeditions to South Africa. *Monthly Notes of the Astronomical Society of Southern Africa (MNASSA)* 63(3 & 4): 34–57.

McCleland, D. Port Elizabeth of yore: the Van Stadens Pass and Bridges. The Casual Observer (blog), 6 February 2020. Online.

McCracken, D. P. The colonial sugar lands of Kwazulu Natal. *Veld & Flora*, September 1996.

Mudly, T. (2020) A brief history of Indian indenture in South Africa. The Heritage Portal. Online.

Naidoo, S. The cruel history of Tongaat Hulett, *The Mercury*, 16 October 2019.

Nicholls, B. M. (2006). Colenso, Harriette Emily (1847–1932). *Oxford Dictionary of National Biography*. Online.

Plug, C. Atherstone, Dr William Guybon (Geology, Palaeontology, Botany, Medicine). In: *S2A3 Biographical Database of Southern African Science*. Last updated 2020. Online.

Plug, C. Barber, Mrs Mary Elizabeth (Born Bowker) (Botany, Entomology, Ornithology). In: *S2A3 Biographical Database of Southern African Science*, 2020. Online.

Plug, C. Saunders, Mrs Katharine (Plant Collection, Botanical Illustration). In: *S2A3 Biographical Database of Southern African Science*. Last updated 2020. Online.

Pondoland. South African History Online. 2011, last updated 2019. Online.

Thompson, L. (1990). *A History of South Africa*. 4th edition, 2014. Yale University Press, New Haven.

The Zulu Kingdom and the Colony of Natal. South African History Online. 2011, last updated 2019.

15. Island Hopping in the Seychelles

Barkly, F. A. (1898). *From the Tropics to the North Sea: Five Years in the Seychelles Islands*. Roxburghe Press, London.

Bellot, S. (2020). Double coconut: the largest seed in the world. Royal Botanic Gardens, Kew. Online.

Benyon, J. (2004). Barkly, Sir Henry (1815–1898), Colonial Governor. *Oxford Dictionary of National Biography*. Online.

Ernesta, S. 4 Interesting Facts about Seychelles' Venn Town, Island's First School. Seychelles News Agency. Online.

Ernesta, S. Seychelles at 250: the history of epidemics and the Island Nation. Seychelles News Agency. Online.

'A lady's adventures in a Tropical Archipelago', *Pall Mall Gazette,* 21 January 1884.

Praslin National Park. Seychelles National Parks Authority. Online.

Seychelles Nation. 'The Mission Ruins'. 2011. Online.

Mission Ruins of Venn's Town. UNESCO World Heritage Centre. Online.

Vallée de Mai Nature Reserve. UNESCO World Heritage Centre. Online.

16. Chasing Plants in Chile

Centner, C. W. (1942). Great Britain and Chilean mining 1830–1914. *The Economic History Review* 12(1/2): 76–82.

Edmundson, W. (2009). *A History of the British Presence in Chile*. Palgrave Macmillan, New York.

Environment & Society Portal. Civilizing nature with the spade and the rifle: the engineer battalion in the Araucanía Region, Chile (1877–1891), 28 May 2020. Online.

Murray, E. (2006). Vicuña Mackenna, Benjamín (1831–1886). Society for Irish Latin American Studies. Online.

Nazer, J. R., Llorca-Jaña, M. & Navarrete-Montalvo, J. (2017). The Cousiño-Goyenechea family, 1810–1940: a big Chilean family business. *Atenea (Concepción)* 516: 49–67.

JSTOR Global Plants. Philippi, Rudolph Amandus (Rodolfo Amando) (1808–1904), last updated 19 April 2013.

Sanderson, T. H. (2004). Pakenham, Sir Francis John (1832–1905), diplomatist. *Oxford Dictionary of National Biography*. Online.

Staring, C. (2014). Rusting ruins inside Chile's largest nitrate ghost town. Atlas Obscura. Online.

Traces of nitrate: mining history and photography between Britain and Chile. University of Brighton. Online.

17. Marianne North at Home

'Home News: Conversasione of the Colonial Institute', *Australian and New Zealand Gazette,* 16 June 1877.

'Paintings of Tropical Vegetation', *The Graphic,* 12 January 1878.

'Occasional Notices', *Pall Mall Gazette,* 5 August 1879.

Parker, L. (2017) Walter Hood Fitch – an 'incomparable Botanical Artist'. Royal Botanic Gardens, Kew. Online.

Sources

Extracts

For details on the editions used, please see Note on Materials and Presentation (p. 6)

1. At Mrs Skinner's house, West Manchester, Massachusetts. In: *Recollections* Vol. I, pp. 42–43.
2. A picnic and a private tour. In: *Recollections* Vol. I, pp. 48–50.
3. The Pacific Railway Summit. In: *Recollections* Vol. I, pp. 205–07.
4. Calaveras Grove, California. In: *Recollections* Vol. I, pp. 208–09.
5. The American Museum of Natural History and Columbia University. In: *Recollections* Vol. II, pp. 207–08.
6. A home in Gordon Town. In: *Recollections* Vol. I, pp. 81–83.
7. At Craighton. In: *Recollections* Vol. I, pp. 86–88.
8. A stay at King's House, Spanish Town. In: *Recollections* Vol. I, pp. 97–99.
9. Gertrude Schalch. In: *Recollections* Vol. I, pp. 90–92.
10. Clifton Mount coffee plantation. In: *Recollections* Vol. I, pp. 94–96.
11. Observations from the Aqueduct Road, Rio. In: *Recollections* Vol. I, pp. 122–24.
12. At Morro Velho: enslaved labourers and a 'Cornish village'. In: *Recollections* Vol. I, pp. 147–49.
13. Peter Wilhelm Lund. In: *Recollections* Vol. I, pp. 166–68.
14. The Caraça sanctuary. In: *Recollections* Vol. I, pp. 178–79.
15. The emperor and the naturalist. In: *Recollections* Vol. I, pp. 184–86.
16. Jose Luis Correa and the Serra dos Órgãos. In: *Recollections* Vol. I, pp. 186–89.
17. Cochineal Gardens, Santa Cruz to La Orotava. In: *Recollections* Vol. I, pp. 192–93.
18. Rambla de Castro, Los Realejos. In: *Recollections* Vol. I, pp. 194–96.
19. At Charles Smith's, Puerto di Orotava. In: *Recollections* Vol. I, pp. 196–97.
20. From Yokohama to the English Legation, Tokyo. In: *Recollections* Vol. I, pp. 214–16.
21. A temple hotel for Europeans, Kyoto. In: *Recollections* Vol. I, pp. 221–23.
22. The Nishi Hongan-ji and Chion-In Temples, Kyoto. In: *Recollections* Vol. I, pp. 223–24.
23. The Scotts' garden and Robert Little's coconut plantation. In: *Recollections* Vol. I, pp. 232–33.
24. Hoo Ah Kay ('Mr. Wampoa') and 'a most absurd mistake'. In: *Recollections* Vol. I, pp. 234–35.
25. First impressions. In: *Recollections* Vol. I, pp. 236–38.
26. The Tegora quicksilver mine. In: *Recollections* Vol. I, pp. 246–48.
27. Tegora, 'at rest'. In: *Recollections* Vol. II, pp. 95–97.
28. Alfred Hart Everett. In: *Recollections* Vol. I, pp. 248, 249–51.
29. Buitenzorg (Bogor) Botanic Garden. In: *Recollections* Vol. I, pp. 255–58.
30. Tosari, Mount Bromo, and the Tengger Sand Sea. In: *Recollections* Vol. I, pp. 263–65.
31. Borobudur 'the beautiful'. In: *Recollections* Vol. I, pp. 279–80, 281.
32. With Karel Frederik Hölle in Garut. In: *Recollections* Vol. I, pp. 293–95.
33. G. H. K. Thwaites, Willian de Alwis Seneviratne, and the butterflies of Ceylon. In: *Recollections* Vol. I, pp. 305–06, 309–10.
34. Julia Margaret Cameron and Charles Hay Cameron. In: *Recollections* Vol. I, pp. 314–15.
35. Famine and floods in Madura (Madurai). In: *Recollections* Vol. I, pp. 323–24, 325–26.
36. In search of sacred plants. In: North to Arthur Coke Burnell, letters as dated in extract. MN1/1.
37. In Tanjore (Thanjavur). In: *Recollections* Vol. I, pp. 327–28.
38. To the Ellora Caves. In: North to Burnell, 21 March [1878]. MN 1/1/17–18.
39. Simla and the Lyttons. In: *Recollections* Vol. II, pp. 7–8.
40. Binsur and the Ramsays. In: North to Margaret Shaen, 13 August 1878. MN1/2/4.
41. A view to Mount Everest. In: North to Burnell, 7 October 1878. MN1/1/32.
42. The ruined city of Siri and the Nizamuddin Dargah, Delhi. In: *Recollections* Vol. II, pp. 44–46.
43. City of lakes. In: *Recollections* Vol. II, pp. 65–67.
44. The Bunya Mountains. In: *Recollections* Vol. II, pp. 114–15.

45. I wished I were an Osborne. In: *Recollections* Vol. II, pp. 135–37.
46. Gum tree giants. In: *Recollections* Vol. II, pp. 144–45.
47. Ellis Rowan, and a natural flower garden. In: *Recollections* Vol. II, pp. 148–50.
48. Kunanyi / Mount Wellington. In: *Recollections* Vol. II, pp. 171–72.
49. Lake Wakatipu. In: *Recollections* Vol. II, pp. 179–80.
50. John Enys. In: *Recollections* Vol. II, pp. 184–85.
51. Two baths full of wonders. In: *Recollections* Vol. II, pp. 218–20.
52. Hildagonda Duckitt: A regular Queen Bess. In: *Recollections* Vol. II, pp. 222–26.
53. A day of days at Van Stadens Gorge. In: *Recollections* Vol. II, pp. 243–44.
54. William Guybon Atherstone and Mary Elizabeth Barber. In: *Recollections* Vol. II, pp. 247–48, 252.
55. The Colensos at Bishopstowe, Natal. In: *Recollections* Vol. II, pp. 278–80.
56. Mahé excursions. In: *Recollections* Vol. II, pp. 286–87.
57. Coco de mer valley. In: *Recollections* Vol. II, pp. 288–89.
58. Nerves were never in my way. In: North to George James Allman, 4 November 1883, MN1/2/10.
59. Venn's Town. In: *Recollections* Vol. II, pp. 304–05.
60. A new world of wonders. In: *Recollections* Vol. II, pp. 315–17.
61. In the Araucaria forest. In: *Recollections* Vol. II, pp. 323–24.
62. Homesick in Santiago. In: North to Shaen, 27 November 1884, MN1/2/13.
63. The flat, Victoria Street SW1. Excerpt from Catherine Symonds's postscript to *Some Further Recollections*, pp. 314–15.
64. South Kensington Museum exhibition. In: *Recollections* Vol. I, p. 321.
65. Dinner dates. In: North to Burnell, three letters dated '16 May 1879', 'Saturday', and undated, [May–June 1879], MN1/1/39–41.
66. A 'royal' command. In: *Recollections* Vol. II, 87, pp. 214–16.
67. Much trouble and much pleasure. In: *Recollections* Vol. II, pp. 210–12.

Artworks and Illustrated Correspondence

Paintings prefixed MN are on display in the Marianne North Gallery. Those prefixed MNS are held in Kew's art collection.

1. *Foliage and Flowers of the Suriya or Portia; the Pagodas of Madura in the Distance.* MN256.
2. *Amatungula in Flower and Fruit and Blue Ipomoea*, South Africa. MN378.
3. *Forest Scene, Matang, Sarawak, Borneo.* MN545.
4. *Gate at Lahore* [Pakistan]. MNS027.
5. *On the way from Tibet near Nagkunda, north India.* MN277.
6. *Curious Plants from the Forest of Matang, Sarawak, Borneo.* MN624.
7. *The Soembing Volcano, Java.* MN623.
8. *Marianne North at Home*, photograph by Mrs Bryan Hodgson. Frontispiece to *Recollections* Vol. II.
9. *Alderley Garden, Gloucestershire, England.* MNS052.
10. Lear to Burnell, 17 August 1877. MN1/1/4.
11. *Marianne North*, drawing by Theodore Blake Wirgman.
12. *Red Sea.* MNS069.
13. *View under the Ferns at Gongo, Brazil.* MN056.
14. *Marianne North*, photograph by Julia Margaret Cameron.
15. *Road Making in the Tegora Forest, Sarawak, Borneo.* MN591.
16. North to Burnell, 7 October 1878. MN1/1/32.
17. *Marianne North painting in Grahamstown (Makhanda) Botanical Gardens.* Photograph, first published in *The Illustrated London News*, 28 April 1883.
18. *Ghost of a Big Tree, Calaveras Grove, California.* MN213.
19. *View of the Hill of Tegora, Borneo.* MN541.
20. *Tegora, Sarawak.* MNS068.
21. *View of Lake Donner, Sierra Nevada.* MN201.
22. *On the Rocks, near West Manchester, Massachusetts.* MN197.
23. *The American Fall from Pearl Island*, Niagara. MN193.
24. *An Old Red Cedar on the Rocks near West Manchester, Massachusetts.* MN207.
25. *Snow Sheds at the Summit of the Great Pacific Railway, California.* MNS004.
26. *Home of an Old Trapper in the Trunk of a Big Tree, Calaveras Grove, California.* MN205.
27. *Vegetation of the Desert of Arizona.* MN185.
28. *The Garden of King's House, Spanish Town Jamaica.* MN146.
29. *Distant View of Newcastle, Jamaica.* MN133.
30. *View over Kingston and Port Royal from Craigton, Jamaica.* MN161.
31. *View of the Sandy River at Spanish Town, Jamaica.* MN167.
32. *Bermuda Mount, Jamaica.* MN144.
33. *Coffee Plantation at Clifton Mount, and the Blue Mountains beyond, Jamaica.* MN177.
34. *Royal Palm Avenue.* MNS002.
35. *From Aqueduct Road, Rio, Brazil.* MNS053.
36. *View of the Old Gold Works at Morro Velho, Brazil.* MN79.
37. *Scene in Dr. Lund's Garden at Lagoa Santa, Brazil.* MN117.
38. *View of the Jesuit College of Caracas, Minas Geraes, Brazil.* MN035.
39. *Glimpse of Mr. Weilhorn's House at Petropolis, Brazil.* MN090.
40. *View from the Sierra of Theresopolis, Brazil.* MN824.
41. *A View of the Botanic Garden, Teneriffe.* MN515.
42. *Teneriffe.* MNS003.
43. *View in the Cochineal Gardens at Santa Cruz, Teneriffe.* MN522.
44. *Barranca de Castro, Teneriffe.* MN815.
45. *Scene in Mr Smith's Garden, Teneriffe.* MN521.
46. North to Elizabeth Morley ('Annie'), [1875]. MN1/5.
47. *From a Gate in Kyoto, Japan.* MNS079.
48. *Study of Japanese*

Chrysanthemums and Dwarfed Pine. MN661.

49. Rice Drying on the Sea-shore near Yokohama, Japan. MN642.

50. Sketches and page four in North to Shaen, 19 November [1875]. MN1/2/1.

51. Lake Biwa, Japan. MNS005.

52. Great Bell of the Cheone Temple, Kyoto, Japan. MNS006.

53. North to Joseph D. Hooker, 10 January [1876]. DC/151/842.

54. View of Singapore, from Dr Little's Garden. MN580.

55. Flowers and Fruit of the Mangosteen and Singapore Monkey. MN577.

56. View of the Maharajah of Johore's House from Major McNair's Garden, Singapore. MN535.

57. Foliage and Flowers of a Madagascar Tree at Singapore. MN343.

58. View down the River at Sarawak, Borneo. MN568.

59. Stagshorn Fern, and the Young Rajah of Sarawak, with Chinese Attendant. MN598.

60. The Quicksilver Mountain of Tegora, Sarawak, by Moonlight. MN584.

61. River from Bussa, Sarawak. MNS068.

62. A New Pitcher Plant from the Limestone Mountains of Sarawak, Borneo. MN561.

63. The Volcanoes of Merapi and Merbaboe, Java, from the Top of Boro Bodoer. MN636.

64. A Tailor's Shop in the Botanic Garden, Buitenzorg, Shaded by Sago Palms and Bananas. MN610.

65. Village of Tosari, Java, 6000 feet above the level of the Sea. MN649.

66. Smoke of Semeru Volcano and Bromo Volcano, East Java. MNS008.

67. Statue of Buddha. MNS011.

68. The Hotel, Boro Boro, Java. MNS057.

69. Tea-Drying in Mr Hölle's Establishment, Java. MN635.

70. Talipot Palm near the Botanic Garden Peradeniya, Ceylon. MN284.

71. In the Old Palace, Kandy. MNS108.

72. A View in the Royal Botanic Garden, Peradeniya, Ceylon. MN271.

73. Some of Mrs Cameron's Models, with Cocoanut and Teak Trees, Kalutara, Ceylon. MN240.

74. Marianne North, photograph by Julia Margaret Cameron.

75. North to Burnell, 20 March [1877]. MN1/1/37.

76. Mount Everest or Deodunga, from Sundukpho, North India. MN338.

77. Festival of Muharram, Udaipur, Rajasthan. MNS041.

78. Gate Leading into the Temple, Madura. MNS107.

79. The Asoka. MN312.

80. African Baobab Tree in the Princess's Garden at Tanjore, India. MN262.

81. In the Kylas, Ellora. MNS104.

82. Sketch in North to Burnell, 21 March [1878]. MN1/1/18.

83. The Bazaars, Simla. MNS092.

84. From Lady Ramsay's Garden, Binsur, Kumaon. MNS077.

85. Sketch in North to Shaen, 13 August 1878. MN1/2/4.

86. See 76.

87. Sketch in North to Burnell, 7 October 1878. MN1/1/32.

88. Tomb of Nizamuddin, Delhi. MNS036.

89. Lake of Islands, Oodipore, Guzerat, Western India. MN798.

90. View in the Bunya-Bunya Forest, Queensland, and Kangaroos. MN773.

91. Australian Bears and Australian Pears. MN735.

92. Our Camp on the Bunya Mountains, Queensland. MN768.

93. A Bushfire at Sunset, Queensland. MN787.

94. Illawarra, New South Wales. MN716.

95. Fernshaw, Victoria. MN758.

96. Wild Flowers of Albany, West Australia. MN750

97. View of the 'Organ Pipes', Mount Wellington, Tasmania. MN733.

98. Entrance to the Otira Gorge, New Zealand. MN731.

99. View of Lake Wakatipu, New Zealand. MN713.

100. Castle Hill Station, with Beech Forest, New Zealand. MN717.

101. Foliage, Flowers and Fruit of the South African Silver Tree. MN426.

102. A Medley of Flowers from Table Mountain, Cape of Good Hope. MN405.

103. Ostrich Farming at Groot Post, South Africa. MN454.

104. Giant Everlasting and Protea, on the Hills near Port Elizabeth. MN437.

105. Scene in Dr Atherstone's Garden, Grahamstown. MN445.

106. View of a Table Mountain from Bishop Colenso's House, Natal. MN364.

107. Waterfall in the Gorge of the Coco de Mer, Praslin. MN479.

108. The Six-Headed Cocoanut Palm of Mahé, Seychelles. MN491.

109. Emile's Palm House, Praslin, Seychelles. MN483.

110. Female Coco de Mer bearing Fruit covered with small Green Lizards. MN477.

111. Sketch in North to Allman, 4 November 1883. MN1/2/10.

112. View of the South Coast of Mahé and Schools of Venn's Town, Seychelles. MN480.

113. View near Quilpué, Chili. MN019.

114. The Blue Puya and Cactus at Home in the Cordilleras, near Apoquindo, Chili. MN026.

115. Seven Snowy Peaks seen from the Araucaria Forest, Chili. MN006.

116. Armed Bird's Nest in Acacia Bush, Chili. MN015.

117. The Giant and other Lilies in Dr. Allman's Garden at Parkstone, Dorset. MN329.

118. Victoria Regia. MN001.

119. Flannel Flower of Casa Branca and Butterflies, Brazil. MN067.

120. North to Burnell, 17 January 1880. MN1/1/44.

121. New Zealand Flowers and Fruit. MN721.

122. Australian Spear Lily. MN844.

123. Photograph of the Marianne North Gallery.

Acknowledgements

Many people helped shape this book. My deepest gratitude goes to Trevor Piper for accommodating this project within our shared life for several years, providing constant support and encouragement and valued comments on multiple drafts. Heartfelt thanks goes to Gina Fullerlove and Lydia White, the former and current heads of Kew Publishing, for approaching me in January 2021 with the idea of producing an anthology of North's writing. I'm equally grateful to Mark Nesbitt, Senior Research Leader for Interdisciplinary Research at RBG Kew, for his support throughout. Also at Kew, thanks goes to the Library, Archives and Illustrations team, headed by Fiona Ainsworth, for their guidance on the Marianne North holdings, in particular Kat Harrington of the archives team and Lynn Parker, Curator of Illustrations and Artefacts. My deep thanks for permission to publish extracts from North's correspondence, and to reproduce the photograph on page 26, goes to Tom North and the wider North family. Kate Teltscher, Honorary Research Associate at RBG Kew, offered expert insight and much-appreciated comments on the draft manuscript. Thanks also to Advolly Richmond, plant and garden historian, for writing a splendid Foreword. Production of this book occurred during an extended period of personal crisis. I'm indebted to Georgie Hills, Kew Publishing's Production Manager, for expertly guiding the book during this time, overseeing Ocky Murray's fabulous design, as well as James Kingsland's attentive copy-editing and Matthew Seal's proofreading.

Index

Page numbers in **bold** refer to illustrations

Flora and fauna entries refer to sightings in a given location that list names of plants and animals seen.

See pages 272–3 for a comprehensive list of artworks and illustrated correspondence.

First published in 2023 by
Royal Botanic Gardens, Kew,
Richmond, Surrey, TW9 3AB, UK
www.kew.org

ISBN 978 1 84246 795 4

Distributed on behalf of the Royal Botanic Gardens, Kew in North America by
the University of Chicago Press, 1427 East 60th St, Chicago, IL 60637, USA.

British Library Cataloguing in Publication Data
A catalogue record for this book is available from the British Library

Design and page layout: Ocky Murray
Project management: Georgina Hills
Copy-editing: James Kingsland
Proofreading: Matthew Seal

Printed and bound in Italy by L.E.G.O. S.p.A.

For information or to purchase all Kew titles please visit shop.kew.org/
kewbooksonline or email publishing@kew.org

Kew's mission is to understand and protect plants and fungi, for the wellbeing
of people and the future of all life on Earth.

Kew receives approximately one third of its funding from Government
through the Department for Environment, Food and Rural Affairs (Defra).
All other funding needed to support Kew's vital work comes from members,
foundations, donors and commercial activities, including book sales.

With thanks to Tom North for the use of Marianne North's personal letters,
and photograph on page 26.

Cover image: see page 16
Page 274–5: *Foliage and Flowers of the Cinnamon Tree*